The William S. Paley Collection

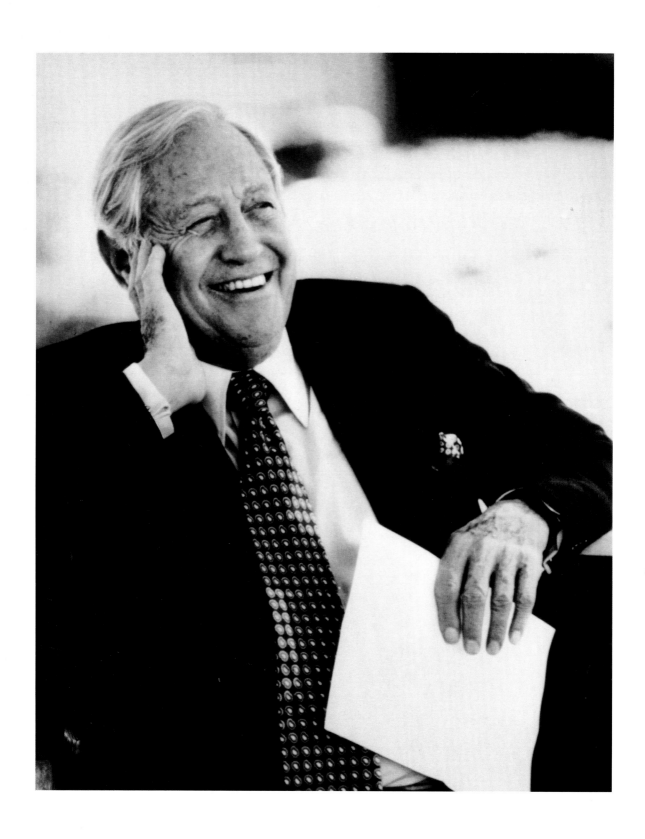

The William S. Paley Collection

William Rubin

Matthew Armstrong

The Museum of Modern Art, New York

Distributed by Harry N. Abrams, Inc., New York

Published in conjunction with an exhibition of the
William S. Paley Collection at The Museum of Modern Art, New York,
February 2–May 7, 1992, organized by William Rubin,
Director Emeritus, Department of Painting and Sculpture

Library of Congress Catalogue Card Number 91-61563
ISBN 0-87070-170-3 (The Museum of Modern Art, clothbound)
ISBN 0-87070-193-2 (The Museum of Modern Art, paperback)
ISBN 0-8109-6101-6 (Harry N. Abrams, Inc., clothbound)

Produced by the Department of Publications
The Museum of Modern Art, New York
Osa Brown, Director of Publications

Edited by James Leggio and Amy Ellis
Designed by Steven Schoenfelder
Production by Tim McDonough
Set in type by Trufont Typographers, New York
Manufactured by L S Graphic Inc., New York
Color separation by Fotolito Gammacolor, Milan
Printed by Grafica Comense, Como
Bound by Legatoria Service Beretta, Milan

Clothbound edition distributed in the United States and Canada by
Harry N. Abrams, Inc., New York
A Times Mirror Company

Clothbound edition distributed outside the United States and Canada by
Thames and Hudson Ltd., London

Printed in Italy

In this book, all photographs of works in the William S.
Paley Collection are by Kate Keller, Chief Fine Arts
Photographer, and Mali Olatunji, Fine Arts Photogra-
pher, The Museum of Modern Art. Photographs of
other works of art, reproduced as figures in the
Catalogue and Notes section, were generally supplied by
the owners or custodians indicated in the captions. The
following list applies to those photographs for which a
separate acknowledgment is due: Acquavella Galleries,
New York, fig. 44; CBS, frontispiece; Galerie Berg-
gruen, Paris, fig. 54; Galerie Beyeler, Basel, fig. 14;
Marlborough Fine Arts, London, fig. 1; Performing Arts
Research Center, New York Public Library, fig. 32;
Photo X, fig. 41; Réunion des Musées Nationaux de
France, Paris, figs. 20, 22, 68, 76; John D. Schiff,
fig. 47.

Frontispiece: William S. Paley, 1978

Contents

Foreword

William S. Paley's involvement with The Museum of Modern Art began in 1937, when he became a trustee of the young institution, founded only eight years earlier. He was an active force within the Museum for over fifty years, serving as its President from 1968 to 1972, and as Chairman from 1972 to 1985, when he became Chairman Emeritus. With perseverance and vision, he guided the Museum through periods of great changes and challenges. The Museum's expansion completed in 1984, which doubled its gallery spaces and other facilities, could not have been accomplished without his enthusiasm, faith, and persistence. He was in every way a model trustee—dedicated, informed, and responsive; and a generous donor of his time, funds, and works of art.

I had the privilege of working with Mr. Paley for twenty years; it was during his presidency and with his support that I became Acting Director and then Director of the Museum. I remember him not only with great admiration and respect, but also with very warm affection. I knew how busy he was as Chairman of the Board of CBS, and I was hesitant at first to contact him about anything less than urgent. He soon made it clear, however, that he wanted to be actively involved and well informed about all of the Museum's activities. One of his business associates told me, somewhat enviously, that it was well known at CBS that Mr. Paley always answered a call from The Museum of Modern Art, even when other matters required his immediate attention. This proved to be true, and his judgment and advice were invaluable. When I consulted him, I found his instincts invariably right. I think this was so because of his unwavering conviction that an institution such as this has an obligation to exemplify the highest aesthetic, scholarly, and ethical standards; any economy or shortcut which might compromise quality, or a course of action which was in any way misleading, carried too high a price. His advice was always an implicit reminder that institutions, like individuals, must have a strict sense of honor.

It is with pride and deep gratitude that The Museum of Modern Art welcomes the extremely generous gift of the William S. Paley Collection. During his lifetime, Mr. Paley gave the Museum *The Architect's Table*, an outstanding Cubist work of 1912, and Odilon Redon's 1914 *Vase of Flowers*. He also contributed to the purchase of many other important modern and contemporary works. In addition, he donated, while retaining a life interest, the Picasso masterpiece *Boy Leading a Horse* of 1905–06 and a Cézanne landscape, *L'Estaque*, of 1882–83. By his will, he bequeathed other major works in his superb collection, including paintings by Cézanne, Derain, Gauguin, Matisse, Picasso, Toulouse-

Lautrec, Vuillard, and others to the William S. Paley Foundation for donation to the Museum. For generations to come, the presence of these works in our galleries will testify to the lasting influence of this remarkable man on The Museum of Modern Art and, indeed, on the fabric of modern life.

This publication and the exhibition it accompanies could not have been realized without the active assistance of the officers of the William S. Paley Foundation, to whom we are most grateful. The good will and involvement of Patrick Gallagher, Executive Director, greatly facilitated the smooth transfer of these works to the Museum's care, and his continuous support has been deeply appreciated. Director John Minary's advice and recollections from his long association and friendship with Mr. Paley were invaluable, especially in the preparation of this publication, and Philip Boschetti readily made the Foundation's files available for our research. We also warmly thank Director William C. Paley and other members of the Paley family for their gracious cooperation.

At The Museum of Modern Art, many individuals deserve our appreciation for their contributions to this project. In the Department of Painting and Sculpture, they notably include Matthew Armstrong, who, with William Rubin, expertly and gracefully wrote the text of this publication, and Lynn Zelevansky, Curatorial Assistant, who skillfully helped organize all other aspects of this endeavor. Important contributions to the research for the project were made by Claire Svetlik, Sharon Dec, and, most especially, by Rosemary Hoffmann. Ruth Priever, secretary to Mr. Rubin, performed many tasks associated with the exhibition with care and dedication until her recent retirement. Special thanks are also due to Carolyn Lanchner, Curator, who assisted this project in its initial stages, and Kirk Varnedoe, Director of the department, who lent his generous support throughout.

We are most grateful as well for the expert and thoughtful advice provided by Beverly Wolff, the Museum's Secretary and General Counsel, and for the valued assistance of James Snyder, Deputy Director for Planning and Program Support. Richard Palmer and his staff oversaw the planning of this exhibition with their customary foresight and professionalism. We also owe thanks to Aileen Chuk, Administrative Manager of Registration, who took principal responsibility for the handling of the works in the exhibition, to Samantha Dunning, Registrar Assistant, and to Patricia Johnson, Senior Registrar Assistant. Karen Meyerhoff, Assistant Director of Exhibition Production, provided an excellent installation

design and, with care and ingenuity, oversaw construction of the exhibition's galleries. Appreciation is due as well to Jeanne Collins, Director, and Jessica Schwartz, Assistant Director, of the Department of Public Information, and to Osa Brown, Director of the Department of Publications.

The preparation of this publication required the expertise of many members of the Museum staff. James Leggio, Editor, Department of Publications, edited the text and catalogue with his usual intelligence and sensitivity. He was very capably assisted throughout by Amy Ellis. Eumie Imm, Assistant Librarian, greatly facilitated research for the book, complemented by the essential help of Mikki Carpenter, Photo Archivist. James Coddington, Conservator, and Anny Aviram and Carol Stringari, Associate Conservators, expertly cleaned certain key works in time to have them photographed in fresh form for this publication. The photography of all of the works in the collection was accomplished by Kate Keller and Mali Olatunji, the Museum's skilled staff photographers. We especially thank Tim McDonough, the Department of Publications' Production Manager, for the care and judgment with which he oversaw the complex production of this book, and we are grateful as well for the help of Caroline Fidanza, formerly Production Assistant.

Finally, all of us owe an immense debt to William Rubin, Director Emeritus of the Department of Painting and Sculpture, who directed this exhibition, planned this publication, and co-authored its text. After working with Bill Rubin for more than twenty years, Mr. Paley highly valued his scholarship, connoisseurship, and professional integrity. I am sure that Mr. Paley's respect for these qualities played an important role in his decision to have this extraordinary collection come to the Museum. It is therefore particularly appropriate that Bill Rubin should have guided this project; as we all knew he would, he has done so superbly.

Richard E. Oldenburg
Director
The Museum of Modern Art

Preface

In the middle 1930s, when William Paley bought his first painting, there were relatively few collectors of modern art—and nothing chic about possessing it. Whatever prestige owning art garnered then was associated with Old Masters and, with few exceptions, that is what well-to-do collectors bought. Living as we do in an age when the promotional character of the contemporary art market can make the purchase of a work by a very young artist both an investment and a public-relations event, we may find it difficult to conjure up the private, relatively disinterested nature (and virtually marginal social role) of modern-art collecting in the 1930s. Major artists such as Cézanne and Gauguin, both deceased for almost thirty years, were less well known then to the general public than are many living artists today. Few dealers handled works by the pioneer modern masters, especially in America (which is one reason why Mr. Paley's early collecting was in part a function of his European travels).

William Paley was never destined, I think, to be a collector of Old Masters, though they certainly were not beyond his reach. The taste for modernism came naturally to a young man whose achievement and wealth arose from new technologies. But in more personal terms, modern paintings, in their exploitation of liberated color and brushwork, provided a kind of emotional immediacy—what Mr. Paley called "a sensuous, esthetic delight"[1]—that sorted well with his zest for life. Old Master subjects, drawn largely from religion, mythology, and history, could never have moved him as much as the modernist celebration of the immediately perceived, especially the life of the senses as expressed in the various "vacation culture" themes of Impressionism and Post-Impressionism. Nor would the public-oriented, "collective" mode of address of Old Master painting ever touch him as did the personal voice of modernism. The latter's emphasis on the private, individual experience would mark not only the art Mr. Paley bought, but the way he lived with it.

The majority of art objects William Paley acquired—especially those destined for his apartment rather than his office or country house—were intimate in both format and character.[2] Some collectors mimic museums; they search out and acquire things with an eye on art history, specializing in this or that movement, filling their hand in regard to this or that artist, favoring the "major" picture, and taking pleasure in the prestige of showing it publicly. Paley's collecting followed no such grand strategies. It privileged the serendipitous purchase, and was entirely personal. He thought of his paintings as the most important elements of a seamless private world whose other constituents, such as his antiques—not to mention the many mementos of his professional and social life—also held great significance for him. Mr. Paley devoted enormous attention to the particular mix of these objects in his apartment, and hated to disrupt its carefully equilibrated fabric. Except, therefore, for certain loans made to enhance exhibitions at The Museum of Modern Art, his pictures rarely left their walls. Moreover, as Mr. Paley entertained few art-world visitors, and consistently rejected requests for the kind of photographic spreads long routine for homes and collections far less interesting than his, his pictures have with few exceptions been relatively little seen by critics and collectors.

William Paley enjoyed making the rounds of galleries and collections, though his profession and style of living left only limited time for it. He was first introduced to those pleasures by his friend Averell Harriman during a trip to Europe in 1933. Harriman, whose wife, Marie, had opened a gallery in New York specializing in Impressionists and Post-Impressionists, had engaged Albert Skira—later famous as a publisher—as a European agent. Among the treats Skira arranged for them was a visit to the private collection of Cézanne's son, Paul, where Paley fell in love with a small but excellent self-portrait. It was not for sale, but Skira would later negotiate a "first refusal." Back in New York, Paley began to read about the pioneer modern painters and to search them out at such dealers as George Wildenstein and Valentine Dudensing. In a short time he had decided that he wanted "to surround myself with this kind of painting"[3]—and in September 1935, the Cézanne self-portrait, having suddenly been made available, became his first acquisition.[4]

Even in the midst of the Depression "this kind of painting" was not being given away, although its cost (figured in constant dollars) was relatively low. Because there were so few buyers of modern art, a well-connected collector would be offered many fine objects of a type which rarely comes on the market today. Circumspectly, Paley began to buy. Immediately following his purchase of Cézanne's *Self-Portrait in a Straw Hat* and a superb landscape of L'Estaque by the same painter in the fall of 1935, he bought a large charcoal of dancers by Degas. Nineteen thirty-six was a remarkable year, marked by the acquisition of a magnificent Tahitian Gauguin, two superb Matisses—one bought directly from the artist—and by far the best-known work in the Paley Collection, Picasso's *Boy Leading a Horse*. Only later did Mr. Paley realize how lucky he was to have gotten a crack at that picture. It had been smuggled to Switzerland out of Nazi Germany by the dealer Justin Thannhauser, and was being hurriedly and secretly offered for sale through Skira. There was no time to wait for a Geneva visit from Paley, who was skiing in Saint-Moritz. Skira trucked the large canvas to the Palace Hotel and carried it into the lobby. Paley bought it on the spot.

Over the next three years, he added to his collection a number of very fine objects— a Cézanne still life, a Redon pastel, a still life by Henri Rousseau, and a Rouault clown. But with the outbreak of war—during which he would serve with the Office of War Information and the Psychological Warfare Division—his collecting virtually ceased. Between the purchase of Toulouse-Lautrec's portrait of M. de Lauradour in spring 1939, and the Rouault and Picasso oils acquired together in May 1946, his only recorded purchase was a small Gauguin drawing.

When Mr. Paley resumed collecting after the war, he continued to buy late nineteenth- and early twentieth-century masters. But during the forties and fifties—which saw the acquisition of a fine Arles-period Gauguin, another Lautrec portrait, a lyrical Bonnard still life, and a magnificent Derain Fauve landscape—his collecting never quite recaptured the focus and intensity of activity that had characterized it in the thirties. Like other collectors who had bought modern masters before the war, Mr. Paley may well have been put off by the avidity of multitudinous new collectors who became active in the fifties, igniting a highly speculative market that continued for decades. His participation in a group of trustees and friends organized by The Museum of Modern Art in 1968 for the purchase of the Gertrude Stein estate, from which a number of works were to be committed to the

Museum, marked his last acquisition of work by the pioneer modern masters. Mr. Paley's choices in the drawing by lot from among these paintings included Picasso's high Cubist masterpiece *The Architect's Table* and the evanescent Rose Period *Nude with Joined Hands*.

In the sixties William Paley widened his interests to include post–World War II paintings, primarily works by young and usually American artists. But he was content to continue following his predilection for quiet, contemplative images and neither the brash and sardonic qualities of Pop art nor the rigorous abstractions of Minimalism and Conceptual art held any interest for him. His tastes in contemporary art included the lyrical abstractions of the Color Field painters Morris Louis and Kenneth Noland, a stately nude by George Segal, and two powerful, haunting triptychs by Francis Bacon.

While some Paley pictures fall into areas where The Museum of Modern Art collection is already strong, others fill significant lacunae. Cézanne, for example, is already one of our strong suits—though the quality alone of *Milk Can and Apples* and *L'Estaque* makes them important additions. The self-portrait, on the other hand, fills an absolute need, and is thus a specially valued addition. Mr. Paley's *Flowers in a Vase*, by Henri Rousseau, is our only still life by that artist, and provides a foil for our two large fantasy scenes. And although the Museum is remarkably rich in Matisses up to and through World War I, and well endowed with the paper cutouts of the artist's final years, we are correspondingly weak in works from the Nice years of *entre-deux-guerres*. *Odalisque with a Tambourine* and *Woman with a Veil* provide us with two acknowledged masterpieces of that period which help redress the imbalance. The beautiful Bonnard *Still Life* strengthens what has long been, regrettably, one of our weakest suits, and Mr. Paley's two Toulouse-Lautrecs are the first of that artist's portraits to enter the collection.

The pictures I have mentioned above are enormously helpful to the collection, given our particular needs. But there are a handful of Paley pictures which could truly be called providential. The first few galleries of the collection, which provide—through an overview of late nineteenth-century painting—what we consider a necessary introduction to an essentially twentieth-century collection, have long been out of balance. Rich in Cézannes (we have eleven oils and another promised) and at least sufficient in Seurats (four oils), we are grievously under-represented in the work of van Gogh (two oils and a third promised) and Gauguin (two oils, one of them from the early Brittany period). Happily, Gauguin was one of Paley's favorite painters, and his magnificent *The Seed of the Areoi* not only gives us a second Tahitian Gauguin, but one that has retained—far more than our *The Moon and the Earth*—the original freshness and brilliance of color which characterized Gauguin's painting in Polynesia. At the same time, the Paley Collection *Washerwomen* at once adds to the collection a major Gauguin oil from that short and crucial period when van Gogh and Gauguin were working together in Arles, and provides for our public a helpful stepping stone in the visual history of Gauguin's work between the Brittany style (represented by our *Still Life with Three Puppies*) and the artist's mature Tahitian work.

Gauguin was to have, of course, an enormous influence on Fauvism, particularly in that of 1906—and especially in the work of André Derain, another of Paley's favorite artists. Despite efforts to build it up, our Fauve representation remains less satisfactory than we would like. Here, the two 1906 Derain landscapes of the Paley Collection, particularly the

resplendent *Bridge over the Riou,* not only give our Fauve collection an enormous boost, but clarify, in a way none of our other Fauve pictures do, the link between that movement and Gauguin.

In part because Picasso's work initiated or exploited so many different aspects of twentieth-century art, our group of his works necessarily forms the backbone of the collection as a whole. Every generation of curators will work further to fill in the image of Picasso's work so brilliantly established by Alfred Barr, who many years ago convinced Paley to commit to the Museum the monumental *Boy Leading a Horse.* Picasso's classicism takes a variety of forms. To some extent, the neoclassicism of the twenties was an extension of the Rose Period work of 1905 and early 1906. To be without the *Boy Leading a Horse* would be not only to be deprived of a great and popular masterpiece, but to lack a necessary foil for showing how astonishingly Picasso's art metamorphosed between spring 1906 and summer 1907—between the monumental classicism of the Paley Collection picture and *Les Demoiselles d'Avignon.* The earliest, unrepainted heads of the women in the center of the latter picture are, despite further simplification, still directly linked in style to that of the *Boy.* The rest (of the heads), as they say, is history.

I should like to end this preface on a personal note of gratitude to Bill Paley for the unstinting support he gave me in his capacity as President and then Chairman of the Museum's Board of Trustees in a variety of projects involved with both collection-building and exhibitions. Beyond material help, he injected into these situations an enormous personal effort and enthusiasm that greatly helped us realize our aims. It was a pleasure to work with him. And as regards his collection, he was, God bless him, a man of his word.

William Rubin
Director Emeritus
Department of Painting and Sculpture

NOTES

[1] William S. Paley, *As It Happened: A Memoir* (New York: Doubleday, 1979), p. 96.

[2] The only major exception to this tendency is the public-scale *Boy Leading a Horse,* which Mr. Paley wisely chose to hang in the large entrance foyer of his apartment, the only room where people remained standing. In the other rooms, intimacy and comfort were the rule, and the mix of furnishings and objects favored the possibility of smaller works.

[3] Paley, *As It Happened,* p. 96.

[4] At the time Mr. Paley wrote his memoirs, he recalled Cézanne's *L'Estaque* as the earliest of his art purchases. Both *L'Estaque* and the Cézanne self-portrait were invoiced to him in September 1935. Inasmuch as Mr. Paley himself recounts deciding to purchase the self-portrait some length of time before the picture became available (*As It Happened,* p. 97), it is clear that this rather than the landscape should be counted as the first purchase.

The William S. Paley Collection

The notes for each text appear under the relevant entry in the Catalogue and Notes section, which begins on page 145. Supplementary works referred to in the texts are illustrated in that section.

Josef Albers

American, born Germany. 1888–1976. To U.S.A. 1933

Homage to the Square in Green Frame, 1963 (cat. 1)

The present work is one of several hundred canvases painted by Josef Albers between 1949 and 1976 under the general title Homage to the Square. This exhaustive series was undertaken with the singular intention of exploring optical responses to the interactions of colors, particularly as they affect the perception of space.

The square, as a non-natural form and fundamental intellectual schema, is a dominant motif in European abstraction; it was extolled as a perfect embodiment of metaphysical beliefs and utopian ideals of balance and stability in the work of Kasimir Malevich and Vasily Kandinsky as well as the Dutch painters of de Stijl. For Albers, however, the stability of the square was a foil to the dynamic, almost playful ways in which colors affect each other. The artist referred to his Homages as "palettes to serve color," and endeavored to carry out sustained critical investigations of these mutable properties of hue, tint, and tone, transformed by the seemingly limitless possibilities of perceived positions and suggestions of spatial depth available within this precise, repetitive, economical, and consistent formal structure. The restricted design allowed the artist to concentrate exclusively on pure color, since "in visual perception, a color is almost never seen as it really is—as it physically is. This makes color the most relative medium in art."[1]

Despite the rigorously uniform, uninflected surface treatment, the geometric regularity, and the seeming impersonality of such a format, the Homages nonetheless retain an active, inexplicably fluid quality; hues of varying pigments never cease generating alternative perceptions and never settle into the merely decorative. The artist himself insisted that this sense of endless interplay allied his work with aspects of ordinary life: "Art problems are problems of human relationship. Note that balance, proportion, harmony, [and] coordination are tasks of our daily life, as are also activity, intensity, economy and unity. . . . Behavior results in form—and, reciprocally, form influences behavior."[2]

M.A.

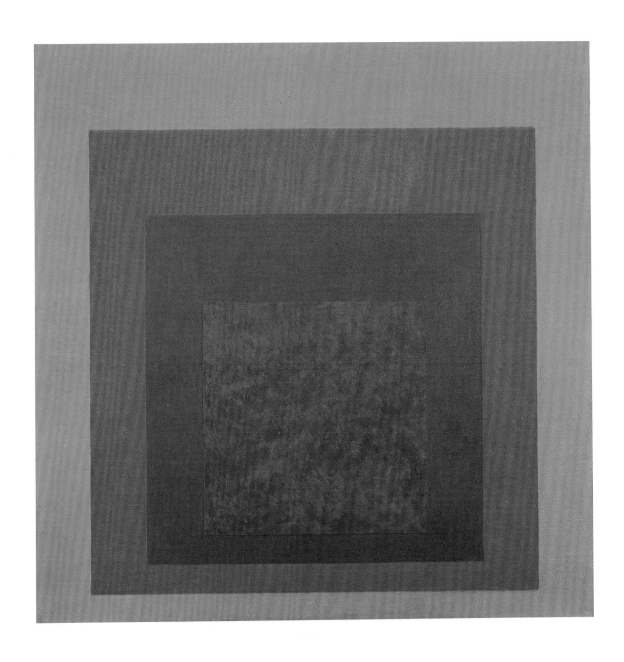

Armand P. Arman

American, born France 1928. To U.S.A. 1963

Almost Japanese, 1970 (cat. 2)

Compared to the accumulations of shredded musical instruments, clocks, rubbish, knick-knacks, and mangled auto parts with which Arman had established his reputation on both sides of the Atlantic, *Almost Japanese* provides a far more pacific, less abrasive image. As the leading figure in the postwar French movement that the critic Pierre Restany labeled *nouveau réalisme,* Arman intended to reevaluate the material aspects of modern quotidian life—especially consumer culture—through non-traditional presentations of ordinary objects gathered in large numbers.

The shock value of Arman's early "accumulation" reliefs and sculptures greatly depended on the objects used (gas masks, bottles, knives), the violence done to them (Chippendale armchairs charred to a turn, violins after an unfortunate duet with an axe, the scattered, flattened remnants of a much abused rubbish dumpster), and sometimes the implication of human brutality (collections of glass eyes or the tiny, severed hands of dolls). But in the late 1960s, Arman began to construct his accreted, fetishistic objects almost exclusively from more mundane commodities: cheap cutlery and alarm clocks, hammers, coffee mills, paintbrushes, pliers—objects that could be purchased easily at a local hardware store or supermarket. Moreover, the treatment of the objects shifted from the blunt prose of savage destruction to a peculiar, discordant poetry of creation and paralysis—of a certain futility or frustration asserting itself through the tools of art-making.

"I work with tools because I see them as human extensions,"[1] Arman has said, and despite the Duchampian overtones of such a statement,[2] Arman consistently seeks to make *art,* not anti-art. The *nouveau réalistes,* he said, "differ from the Dada artists because we search for beauty . . . being artists in a much more conscious way than were the Dadaists."[3]

In 1964, Arman began to make works in which artists' tools are suspended in clear polyester resins; like dragonflies in amber, tubes of oil paint spew long-tailed jets of unmixed color, and pristine satin brushes ooze bright, fat blobs of enamel. *Almost Japanese* is one of these works, an accumulation of several hundred unused sculpting tools packed, row after row, into a transparent block of solid polyester resin. With their function as modeling tools thus obliterated, a hitherto undiscovered expressiveness emerges. The result is an image more pictorial than sculptural, one which owes as much to "all-over" American abstract painting, in its dispersal of forms, as it does to Dada and Surrealism's romance of the object.[4] At the same time, *Almost Japanese* can be seen as amalgamating several strains of the art-making of the 1960s, including Pop art's affirmation of the mass-produced article and the repetitive, self-declarative objecthood of Minimalism.

M.A.

4

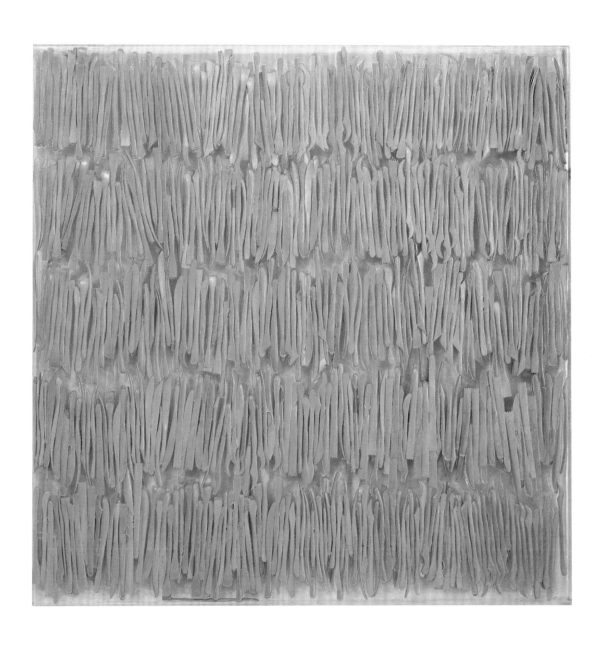

Francis Bacon
British, born 1909

Study for Three Heads, 1962 (cat. 3)

The triptych, a format whose origins can be traced back to Byzantine icons, has been used by Francis Bacon in such a way that in addition to its time-honored intimations of immortality and devotion, it can embody a specifically modern kind of estrangement: isolation, in this case, takes the form of compartmentalization.[1] This baffling sense of separation is complicated by the urgency and violence—what the painter calls his "exhilarated despair"—with which Bacon handles his materials. The flat black paint of the background suggests an indeterminate, funereal space wherein vigorously worked skeins of color and slurred trails of paint congeal into figures. Built up from creams and pinks, coal black, vein blue, and blood red, these Titianesque flesh tones twist within a Surrealist space and convey a sense of propriety betrayed into a web of angst. Bacon invigorates this application by using begrimed brushes, bare fingertips, rags soaked in turpentine, metal scrub brushes, and paint otherwise daubed, smeared, and flung. And still, the balanced, tripartite placement of these ripe, vital faces retains powerful implications of fervent, if distraught, homage.

On the opening day of his 1962 retrospective exhibition at the Tate Gallery, Bacon received word that his closest friend, Peter Lacey, had died unexpectedly in Tangier. The artist soon thereafter painted this eulogistic triptych along the lines of *Three Studies of the Human Head* of 1953 (fig. 1, p. 146),[2] his only previous attempt at creating a triptych since his 1944 *Three Studies for a Crucifixion,* which had brought him to international attention. In the Paley Collection work, the artist presents himself facing forward in the central panel, flanked left and right by two images of Lacey. We are confronted not so much with likenesses as with a mournful rendering of the spirits of the persons analyzed and presented, an actualization of the pain and wonder of having known and lost another.

M.A.

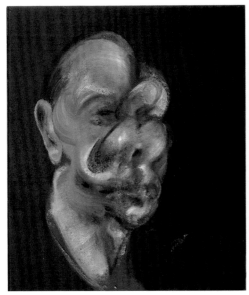
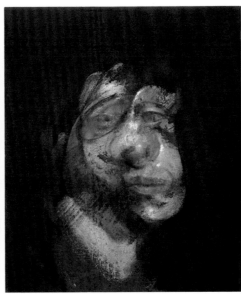
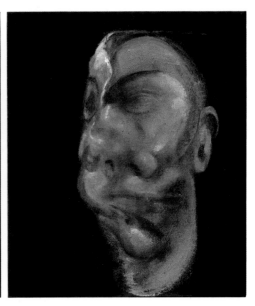

Francis Bacon

Three Studies for the Portrait of Henrietta Moraes, 1963 (cat. 4)

Francis Bacon's most challenging task has always been to devise in paint equivalents for precise physiognomic traits as well as visceral expressions of empathy with pain—a difficult, contradictory fusion perhaps best understood not as a variant on Surrealism or Expressionism but as a kind of private, modern realism.[1] The portrait-triptychs of the early 1960s, initiated by the *Study for Three Heads* (p. 7), all attempt this complex incorporation of strong, personally felt emotion and psychological truth into physical, material fact, the contrary qualities of which fascinated the artist: "I have just finished three portraits of a friend and the problem, as usual, was how to make an image and keep the likeness. To combine the two is what creates tension and excitement."[2] On another occasion Bacon stated more specifically: "What I want . . . is to distort the thing far beyond the appearance, but in the distortion to bring it back to a recording of the appearance."[3]

Adapted from pictures taken by Bacon's friend John Deakin, a London photographer, the present work is one of several of the artist's friend Henrietta Moraes, the wife of the Indian writer and poet Dom Moraes.[4] The triptych format in this case stresses the multiple aspects of a single person and the variegated qualities of flesh. Bacon's vivid handling here exudes a lyric, almost luscious quality, and his daring, incomparable melding of colors— who but Bacon would saturate his underpainting with burning scarlets?—is as expressive as his unique and spontaneous re-creation of space. The forehead twists down to the chin and both sides of the back of the head come around alongside the jaw, forcing the whole roiling mass onto the frontal plane, into the viewer's face. As in the earlier *Study for Three Heads*, this disrupted countenance is as disturbing as it is revealing; the immediate comprehensibility of the sitter yields to something riven with complexities.

M.A.

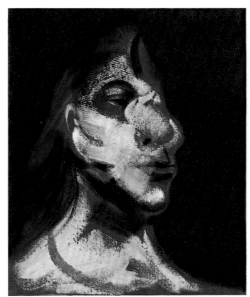
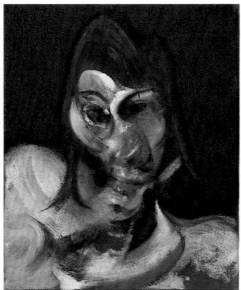
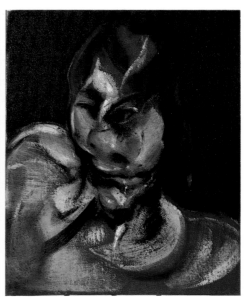

Pierre Bonnard
French, 1867–1947

Reclining Nude, 1897 (cat. 5)

The two works by Pierre Bonnard in the Paley Collection illustrate two of the principal themes of the artist's career—the nude and the still life—as well as documenting the fundamental evolution of his style from an intimate to an opulent sensibility.

As had his friend Édouard Vuillard, Bonnard initially specialized in quiet interior scenes of domestic activity, usually involving the women of the household. Both artists gracefully blended pictorial components as disparate as the spatial constructs of Japanese woodblock prints and of pastels by Degas, the rich planar patterning used by Gauguin, even the slightly eerie qualities associated with the interiors of Edvard Munch.[1] About 1895, Bonnard began investigating the expressive potential of the female nude, only a year or so after he met Marthe Boursin, who became his model, lover, and, much later, his wife. She inspired him to undertake a series of paintings of the nude, and the theme so engrossed him that he was never to relinquish it, though its treatment varied remarkably.

The 1897 Paley *Reclining Nude* is more direct than Bonnard's Degas-inspired images made twenty years later, wherein the figure receives less emphasis than do the bright colors and complex spatial arrangements which dominate his late work. (In the early twenties, Bonnard's nudes were often part of an attempt to create monumental figural compositions in the manner of Renoir, Cézanne, or Matisse.)[2] His late nudes are, like his late still lifes (p. 13), essentially pretexts for experiments in color and decorative splendor, utterly devoid of the guileless eroticism at the heart of his early work.

Bonnard's almost obsessional fascination with Marthe's body extended to the use of photography; the artist often photographed her and, it has been suggested,[3] possibly used the developed plates as "working drawings" for his compositions in oil. On this small wood panel, Bonnard moves away from his marvelously complex interiors to concentrate solely on the sleeping figure of Marthe, whose slight twist at the hips complicates her otherwise chaste somnolence with erotic overtones. The pointillist application of paint—the dots of white, beige, and brown surrounding the figure—adds an odd counterpoint to the more closely valued hues and tighter brushwork that describe her loosely gathered hair, her sleeping face, and her torso. The "unfinished" quality of the right-hand side of the panel may be an acknowledgment of similarly treated works at the turn of the century by artists as dissimilar as Cézanne and Whistler wherein the unfinished areas of the canvas greatly intensified expression. In any case, the light touch and the warm tones of this image balance Bonnard's predilection for the strongly sensual.

M. A.

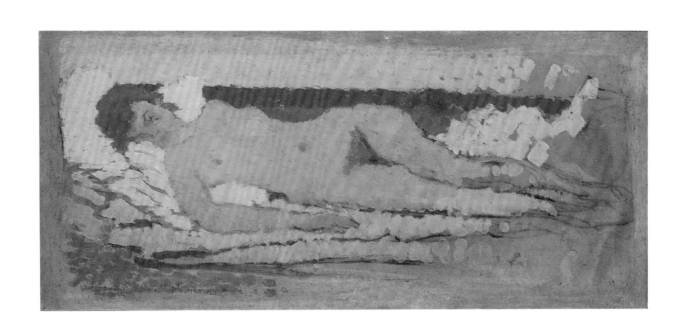

Pierre Bonnard

Still Life (Table with Bowl of Fruit), 1939 (cat. 6)

In his early work, Bonnard blended his colors in the creation of essentially private, isolated enclosures—noiseless, expectant, and suffused with muted tones. By the time of this late still life, he had imbued the earlier quiet domestic calm with visionary color and dispersed the focus of his arrangements so that the entire surface of the canvas became an active display of chromatic harmony and pattern combinations.

In this still life of 1939, the idiosyncratic perspective and the varied, incessant, and ever-present patterning force everything—the background furniture, the carpet, the wallpaper, even the table and its fruit—onto the same plane, demanding the attention of one's eye. There are no recessional depth cues or attempts at three-dimensional modeling except in the dominating motif of foreground fruit, which has all the weight and strong volumetric quality of Cézanne's apples. Without a proper vanishing point, the elements converge.

By equalizing the quality of the light throughout the composition, including the incidental decor, Bonnard allows color to achieve a consistent luminosity that is striking and vividly complex. Indeed the balance of the composition derives as much from color as from design, while one's reading of space is based almost entirely on color. At the lower-right corner, for example, part of the purple and white striped cushion of a chair is seen, wedged between the gleaming, pearly white of the table and the blue diamond pattern on the red carpet. The carpet in turn is surrounded by a series of gold armrests and black chair legs and the orange and yellow of the receding wall. Above the backrest of the left-hand chair, striped brown and black, appears a series of large white blotches, and below it a triangle of red, accents of which can be found throughout the entire canvas. The organization of the whole is such that every area is enlivened and displayed with equal attention; light seems to emanate from the objects within the room rather than streaming in from the outside.

The radiant transformation of an everyday interior through the expressive potential of color may be due in great part to Bonnard's interest in similar treatments by Matisse, an artist whom he respected greatly and with whom he often exchanged ideas. Matisse had certainly known of Bonnard's *intimiste* paintings in the first decade of the century, and Bonnard was greatly intrigued by the work of Matisse just at the waning of the Fauve period.[1] When Matisse moved to Nice in 1917, he was a frequent visitor to Bonnard's villa, near Cannes. Their friendship, and their mutual admiration and influence, flourished until Bonnard's death thirty years later.[2] The sumptuousness of Matisse's Nice paintings during the early 1920s is clearly indebted to Bonnard's innovations in the decorative treatment of space and use of pattern; and for his part, Bonnard appears to have been inspired by Matisse's daring with large expanses of luminous, scintillating color.

M.A.

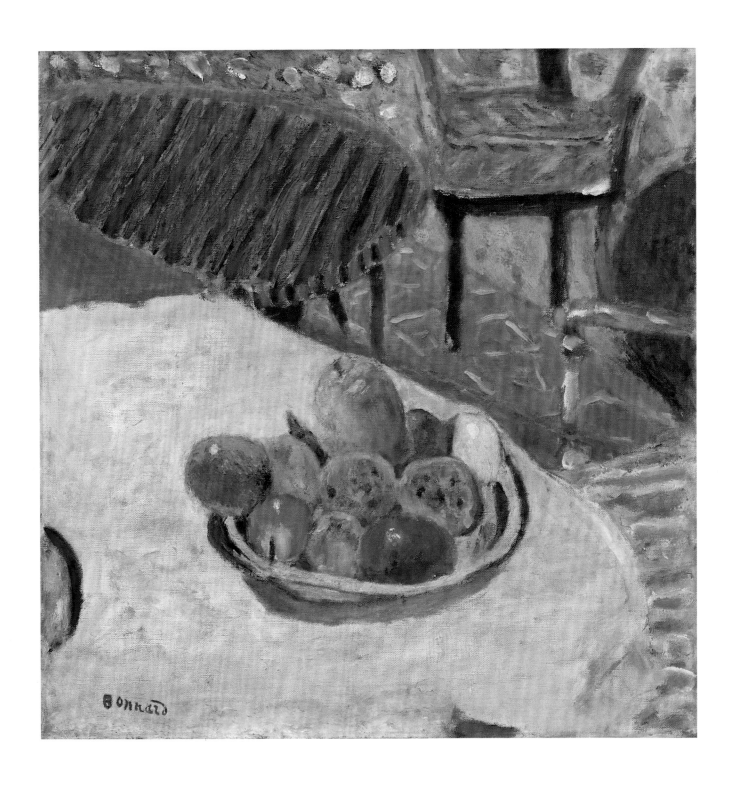

Émile-Antoine Bourdelle

French, 1861–1929

Hand, 1888 (cat. 7)
The Warrior's Hand, 1889 (cat. 8)

What the human torso had been to Michelangelo, the human hand was to Antoine Bourdelle; throughout his career it remained a focus of thought and work. Bourdelle found its wide range of expressive potential compelling and all of his large-scale works, such as his monuments to Beethoven and to Rodin, were preceded by numerous studies of hands, the energetic, uneven surfaces of which are often the principal carriers of the strong emotions his work invariably expresses.

The Paley Collection *Hand* is one of several works in bronze completed at the time of the freestanding figure of Adam (fig. 2, p. 147) exhibited at the Salon des Artistes Française in 1888 and for which this may have been a study. *The Warrior's Hand* is a fragment of Bourdelle's imposing *Great Warrior of Montauban* (fig. 3), the central component of his first major commission, the *Monument aux combattants et défenseurs du Tarn-et-Garonne, 1870–1871*.[1] Whereas the restrained naturalism of the *Hand* stakes a claim on Rodin's ground, *The Warrior's Hand* attempts to create a new expressiveness through means ignored by Rodin. The completed monument exhibits an energetic and expressive quality that signals both his affiliation with and departure from the work of Rodin. Yet in its impetuous conglomeration of disparate actions, the monument's overall effect is somewhat marred, ultimately rendering the isolated gestures—particularly this taut, outstretched hand—more capable of evoking the intended pathos and heroism than is the work as a whole.

Knowledge of Bourdelle's early development is incomplete since the sculptor sent his work to be cast in Brussels rather than Paris, where such procedures were for him prohibitively expensive; unfortunately, the Belgian foundry returned Bourdelle's plaster originals by train and, because of improper packaging, they broke into fragments, most of which could not be restored. Many of the original parts and variants for his Montauban monument as well as smaller works were thus inadvertently destroyed; others exist only in single casts.

Though the early work of Bourdelle walks a fine line between realism and expressionism, his mature style is noted for its success in vigorously resuscitating architectonic aspects of the art of the past, such as seen in the portal figures of Romanesque churches in Toulouse, Moissac, and Saint-Bertrand de Comminges. He cherished what he felt to be a spiritual approach to form and volume that he detected in these holy places as well as in the sculpture of ancient Greece and Egypt. Nonetheless, the two works by Bourdelle in the Paley Collection shed light on his youthful endeavors and reveal the artist at his most Rodinesque.

M. A.

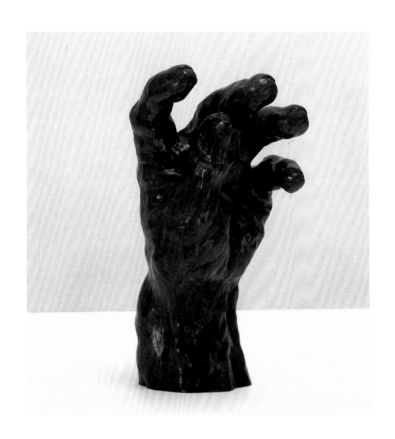

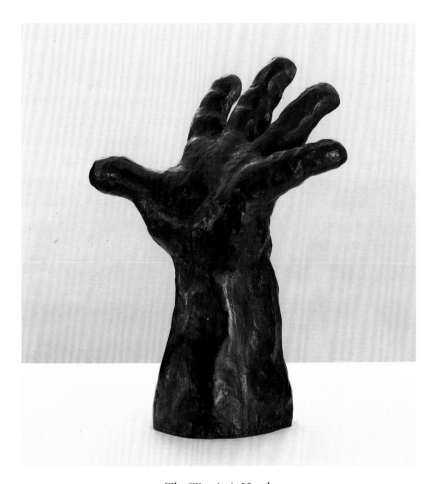

The Warrior's Hand

Georges Braque
French, 1882–1963

Still Life on a Mantelpiece, 1920 (cat. 9)

After recovering from injuries suffered while serving in the French Army during World War I, Georges Braque returned to Paris in 1917 to resume his career as an artist. By then, Cubism—the revolutionary language of form he and Picasso had developed at the beginning of the decade, and which had already been adopted by several aspiring artists—was threatening to become formulaic and staid. Nevertheless, Braque found himself increasingly drawn to the work of those artists who continued to experiment primarily with Cubist forms, Juan Gris and Henri Laurens in particular, rather than to that of Picasso, who was then exploring the expressive potential of a neoclassical style. Moreover, unlike Picasso— whose mercurial temperament and prodigious inventiveness enabled him to use or discard the components of any imaginable style with great abandon—Braque respectfully and exclusively applied Cubism's constructs the rest of his life. For him it was a limitless language the fundamental grammar of which, once firmly established, could never be exhausted.

Still Life on a Mantelpiece is one of several works Braque assiduously undertook between 1919 and 1922 on the unvarying theme of the guitar and the mantelpiece. Braque's forte had always been the still life, and in this ethereal watercolor he exploits all conceivable formal interactions between elements in order to see how far he can go in "an alliance between volume and color."[1]

The motif was one which Braque would expand and adapt throughout the early twenties, finding its greatest expression in the monumental *Mantelpiece* of 1921 (fig. 4, p. 148). As with prewar Cubism, in the Paley Collection work multiple aspects of an object are brought flat to the picture plane whereby its decorative features are displayed. Two flat white rectangles indicate the front planes of the fireplace; they hover below the gray and white painted *faux-marbre* elements indicating the side and top of the mantelpiece and onto which a forward-facing scroll is inscribed in pencil. Both mantelpiece and guitar have been divided into two zones—one dark, one light—reduced signs that stand for the presence of a three-dimensional object, a compositional device Braque was to use repeatedly throughout the 1920s. The ubiquitous guitar, its multiple aspects denoted by multiple planes, rises like a phantom while behind it uneasily rests a clarinet. The fragmented, multilayered mosaic of planes and lines which makes up the front and the back of the guitar as well as the shadow it casts is set against the simplified outlines of the compote and the grapes and pear within it. The stasis of the foreground mantelpiece is counterbalanced by the rising, apparitional qualities of the objects above it, and the composition throughout is enhanced by the variety of pencil traces which add refinements of placement and movement. Few painters—notably Chardin—have so successfully instilled such warmth, poetry, and vitality in household objects.

M.A.

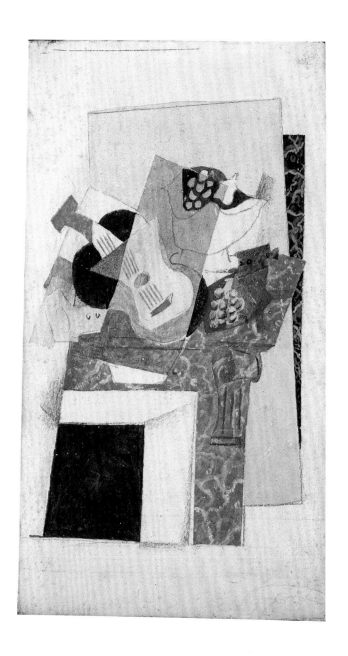

Paul Cézanne

French, 1839–1906

Self-Portrait in a Straw Hat, 1875–76 (cat. 10)

In his catalogue raisonné of Cézanne's paintings, Lionello Venturi dated this picture 1873–76, squarely within what is generally called the artist's "Impressionist" period. During those years, Cézanne largely moderated his darkling palette and taste for Romantic, fantastical, and psychologically strained subjects, in favor of lighter colors and more detached, impersonal themes. Landscape and still life tended increasingly to crowd out narrative and anecdotal motifs and, under the influence of Camille Pissarro, Cézanne tried to be objectively true to his visual sensations, using them as the basic building blocks of his pictures. Nevertheless, even the most Impressionist-looking works from these years little resemble the painting of his friends Pissarro and Monet. Cézanne's forms are heavier and more architectural, his impasto more substantial, and his brushwork less disengaged from contouring and structuring.

Of the various subjects Cézanne painted during his so-called Impressionist phase, portraits in general and self-portraits in particular lent themselves least to the Impressionist-influenced "objectification" his art was undergoing, as they were inherently more psychologically charged than still life or landscape. Nevertheless one has only to compare the Paley Collection self-portrait with one from the artist's more youthful, Romantic phase (fig. 5, p. 148) to see how much Cézanne had succeeded in achieving this objectification even here, by internalizing his psychic energy, and representing it in a potential rather than active state. In the Paley Collection picture, the artist's mood is controlled and philosophical, as he takes the measure of the spectator. The dark blue of his jacket and the near black of his beard and hair provide an anchoring weight to the picture, with which the artist contrasts the lighter flesh tones and the shaded and modulated yellow of the straw hat. The brim of the hat provides an extended arabesque that Cézanne echoes in fragmentary form in the large comma-like forms of the background wallpaper.

One other self-portrait placed by Venturi in these same "Impressionist" years, a picture in the Hermitage (fig. 6), shows Cézanne from the same angle, this time wearing a cap. However, the more impetuous brushwork and heavier impasto of that work suggest a date at the very beginning of Cézanne's "Impressionist" development, that is, toward 1871–73. The Paley picture, on the other hand, is more meditative and constructive in its facture, and thus probably dates from 1875–76, when Cézanne was beginning to move toward his mature style by selecting out of Impressionism only those elements of style that could contribute to order and solidity.

W.R.

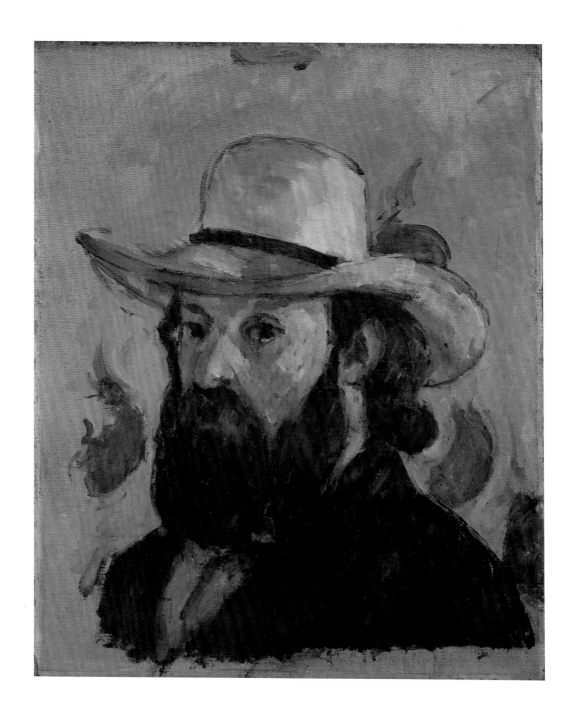

Paul Cézanne

Portrait of Mme Cézanne, 1877–80 (cat. 11)

Unlike his contemporaries Degas or Toulouse-Lautrec, Cézanne seems to have had little interest in directly revealing character. The solemn, heavy-lidded eyes, square jaw and broad nose, the somber expression and indefinite physique with which he drew and painted Hortense Fiquet, his mistress and later his wife, need not be seen as aspects of her persona but the results of Cézanne's unyielding pursuit of the rendering of volume, a study which conferred upon all he depicted a certain weight and gravity. Ultimately Cézanne's images of Hortense reveal more about his pictorial concerns—and hence his general sense of the order of experience—than they do about his wife.

There is little ephemeral or "Impressionistic" in the Paley Collection drawing of Mme Cézanne; immobile and inalterable, she looks as if she were in the process of being cut from granite. Each line has been laid down with such distinctness and sense of purpose that the image can be seen as a kind of primer of Cézanne's approach to the massing of form and the treatment of space. Light, chiseled patches of hatching, slightly smudged, suggest areas of depression or planar shift in her face; her hair, piled up on her head like boulders on a hillside, is rendered in increasingly crepuscular touches as it recedes toward the back of the head. These masonry-like patches of pencil and muffled lines are conjoined with bowed and broken, angular strokes that adumbrate the sides of her head and the projecting features of her face: her chin, her lips, the tip of her nose. Cézanne's treatment is especially striking when compared with that of his contemporary Degas, whose *Portrait of a Woman* (p. 33) evokes far greater interest in both personality and closely valued tones from an unvarying application of purified line.

Little is known of Hortense Fiquet. She was, however, known to have disliked sitting for her husband—to whose genius she was seemingly oblivious—but was nevertheless, between 1874 and 1892, his most frequent model.[1] She was also acutely aware that her husband's inordinate shyness made it nearly impossible for him to approach models and other prospective sitters with whom he was not closely acquainted. Moreover, posing for Cézanne was an experience that rarely proved pleasant: his irascible temper was quick to flare if his model so much as trembled.

Cézanne rarely dated his drawings but on stylistic grounds this work was surely produced in the late 1870s, as a comparison with the 1877 *Mme Cézanne in a Red Armchair* (fig. 7, p. 149) would suggest.[2]

M.A.

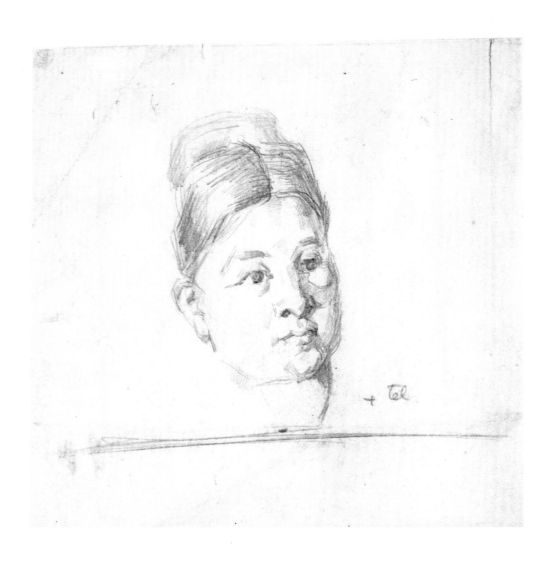

Paul Cézanne

Milk Can and Apples, 1879–80 (cat. 12)

This picture is one of a group of eleven still lifes, all containing a similar floral wallpaper in the background, which together may be said to mark Cézanne's transition out of his personal variation on Impressionism into his own, "mature" style. Lionello Venturi, who first grouped these works together, dated them all 1879–82,[1] under the assumption that the leaf pattern on the wallpaper was either in Cézanne's house in Melun, where the artist spent eight months in 1879, or in his Paris apartment in rue de l'Ouest, where he lived throughout 1880 with his wife, Hortense Fiquet, and his eight-year-old son, Paul. John Rewald has narrowed the dating of the series to 1879–80.[2] (Among the other paintings in this series is one with a compotier, glass, and knife [fig. 8, p. 149], which had belonged to Gauguin and appears in the background of two of that artist's pictures; it is now a promised gift to the Museum's collection.)

Milk Can and Apples is among the earliest pictures in which Cézanne achieved not only a luminous but a transparent kind of color—especially in the blues that dominate throughout the background, the milk can, and the tablecloth. The antinaturalistic patterning of the latter virtually forms a monumental "landscape" of its own in the center of the picture; less like cloth than a mountain range, it locks the forms of the fruit in place at its feet, much as Mont Sainte-Victoire does in many of Cézanne's landscapes where the mountain unites at its base the nearby houses and trees. From the cool blues of the background and drapery the artist moves through the browns and greens of tabletop, *petit pain*, pears and foremost apple to the picture's warmest tones—the tans, yellows, and reds which dominate the fruit. If, in the massing of the drapery, Cézanne's so-called "constructive" brushstroke is used in a loose, painterly, and—at moments—almost cavalier manner, his touch is more restrained in the fruit, particularly the central apples, where the strokes elide more with one another and where the build-up of modeling creates a rotundity charged with an enormous sense of plastic weight and mass. That illusion of literal gravity becomes the vehicle of the emotional *gravitas* of the image.

The sense of concentration established by the fruit and milk can is set off by the "random" appearance and openness in the configuration of the drapery. To be sure, the distribution of the fruit in this still life strikes us at first sight as casual, almost haphazard. And yet, as we contemplate the picture, we realize that painstaking thought has been given to their groupings and spacings. A particular piece of fruit may be linked to one neighbor by

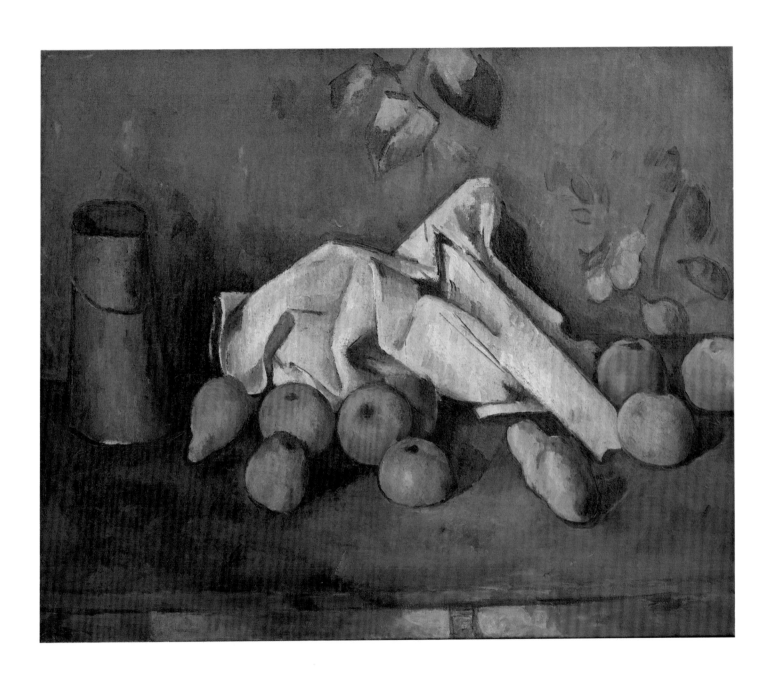

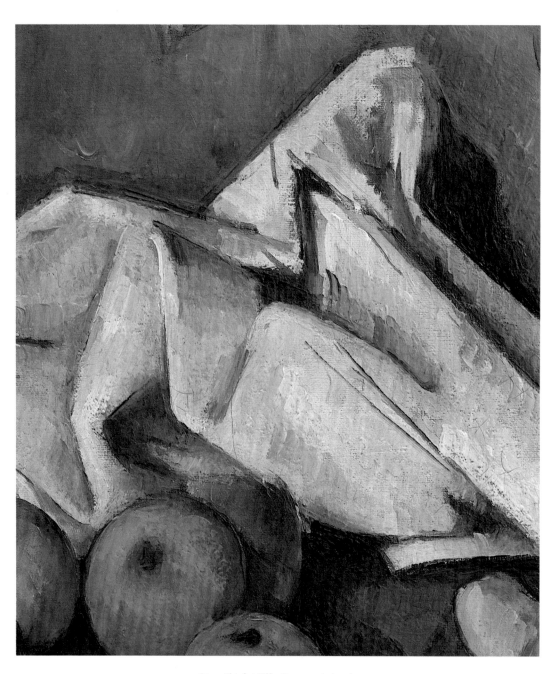

Detail of *Milk Can and Apples*

some aspect of contouring, to another by a shared color, to a third by a parallelism of shape. This typically Cézannian multiplication of analogies creates a complex network, an unfathomable number of connecting visual threads, between the many forms, and thus endows the image—which in its seeming randomness had accepted much of Impressionist "accidentality"—with that sense of ineluctability which would characterize Cézanne's composition for the rest of his years.

While Cézanne was trying consciously to invest Impressionism with the sense of weight, fixity, and solidity that he associated with the art of the Old Masters, the monumentality that distinguishes paintings such as *Milk Can and Apples* is very different from that of the sixteenth- and seventeenth-century painters the artist admired. We might at first take Cézanne's overall composition as typical of Old Master models: i.e., the pyramid (tablecloth) against the post (milk can). But fundamental to those older pictorial structures was a stable, solid base at the bottom of the pictorial field, from which the elements of the pyramid were built up, and upon which they rested. By opening a view of the lighter colored background wall under the brown tabletop, Cézanne purposely destabilizes the old pyramid. If *his* monumental forms are to hold their place, it will not be because they build up, as in older art, from a solid base—thus reenacting the laws of gravity—but because the compositional analogies he multiplies between the forms lock them so firmly in place. Their stability is thus purely aesthetic in its terms, rather than dependent, as in the Old Masters, on recalling in the viewer's mind a stability experienced in the world outside the picture. This, finally, permits Cézanne to invert the compositional structures of older art. While the pyramid of the Old Master builds toward its apex from a solid base that anchors the picture, Cézanne's composition locks to its surface at the apex of the pyramid, and "spills" down from there.

W.R.

Paul Cézanne

Reeds at Jas de Bouffan, 1880–82 (cat. 13)

The Jas de Bouffan ("Habitation of the Winds") was the summer home owned by the artist's father, Louis-Auguste Cézanne, about a mile from Aix.[1] While Cézanne was generally indifferent to his surroundings, save for the ways in which they affected his work, he seems to have been genuinely enchanted by the grounds of his parents' estate. Its handsome buildings and the lengthy avenues of immense chestnut trees behind the house appear in scores of his works from 1866 until 1899, when the house and land were sold.[2]

This delicate composition is centered on a cluster of bushes from which thin yellow reeds project, forming a V-shaped lattice, and surround the dark blue trunk of a tree.[3] The foliage is rendered in convex and angular planes of blue and green. In the middle ground is a low blue wall, a gate is at left and, to the right, two trees; in the background, a low retaining horizon of smokey blue. The dynamic biaxial arrangement of the foreground reeds gives the composition a solid foundation as well as movement.

While the motif is straightforward, the treatment is complex. Almost invisible touches of pencil provide a matrix onto which watercolor has been applied. While the pencil indicates direction and charts out the picture, color alone implies mass and space, suggesting more than is actually shown. The force of the composition is predicated on the audacious limitation of colors to only two or three hues, a system—if it can be called such—which creates a greater sense of volume than would the more highly chromatic touches of complementary shades in the prevailing Impressionist fashion. Moreover, much of the power and delicacy of the image is created by the areas left blank on the white paper and the extreme transparency of the watercolor medium, elements which were to be strongly felt in Cézanne's late masterpieces executed in extremely thin washes of oil and broad areas of unpainted canvas.[4]

As Götz Adriani has written on the construction of Cézanne's watercolors: "The color comes to triumph over the drawing, but this does not mean that the drawing, in part still visible, in part obscured by color, can be dismissed as only a preliminary medium providing structural support, necessarily obliterated as the colors are fully realised. . . . The artist insisted that color and drawing are actually inseparable, that 'one also draws to the same degree that one paints, that is to say the drawing is all the more precise the more harmonious the colors become; for when the color attains its greatest richness the form reveals its greatest fullness as well.'"[5]

M.A.

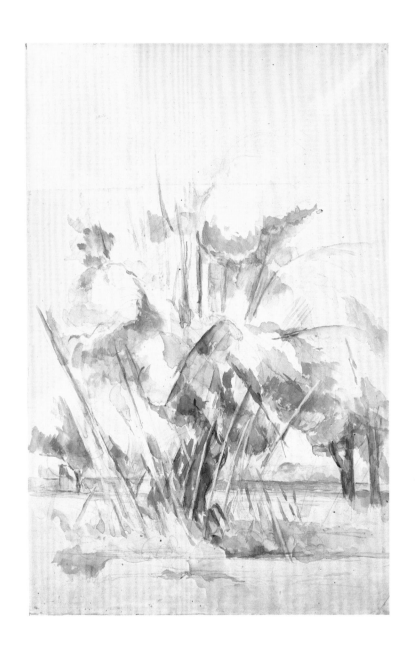

Paul Cézanne

L'Estaque, 1882–83 (cat. 14)

Comparing this densely composed and demanding picture with Cézanne's other views of L'Estaque, Lionello Venturi noted not only its sobriety—it was the least highly colored of the group—but characterized it as having "more force and less abandon" than the others.[1] Perhaps it was precisely this structural power, which for Claude Monet would have represented a kind of "otherness," that led the great Impressionist to choose this picture for himself from among the many Cézanne canvases available in Ambroise Vollard's stock: Monet purchased it from the dealer in March 1896, and it was to hang at his home in Giverny until it was sold by his son, Michel Monet, in the mid-1930s.

In selecting his motif for this painting, Cézanne set his easel on a hillock which gave a view of the rooftops of the town on the left and the bay of L'Estaque in the distance. The great stone cliffs which rise abruptly on the right of the canvas suggest that Cézanne's location was just above the house he had rented in 1882. In May of that year the artist wrote to his friend Émile Zola in Paris that he had taken a house situated up from the level of the railroad station "at the foot of the hill where behind me there are pines and the cliffs begin."[2]

Unlike most of the landscapes Cézanne painted from high vantage points, which are primarily vistas that open onto unenclosed and often vast spaces, the artist chose here to emphasize compression and tautness both in the closure that marks his composition and in the limited morphological range he gives his angular "constructive" brushstrokes. The large pine and the rooftops at the left, and the startlingly angular ascent of the stone cliffs on the right, serve to drive the eye back constantly to the space of the center foreground rather than inviting it to browse through the depth of the pictorial field. Two roughly diagonal lines of pictorial force formed by the cliff on the right and the pines and rooftops on the left come together to suggest a pyramid balancing on its apex—a typically Cézannian inversion of Old Master compositional principles.

It is instructive to compare this landscape with one by Renoir (fig. 9, p. 150) executed during his own brief stay at L'Estaque in 1882. Renoir, who found the area "certainly the most beautiful place in the world,"[3] was painting side by side with Cézanne, until he fell ill with pneumonia. His *Rocky Crags at L'Estaque* absorbs some of Cézanne's method in the

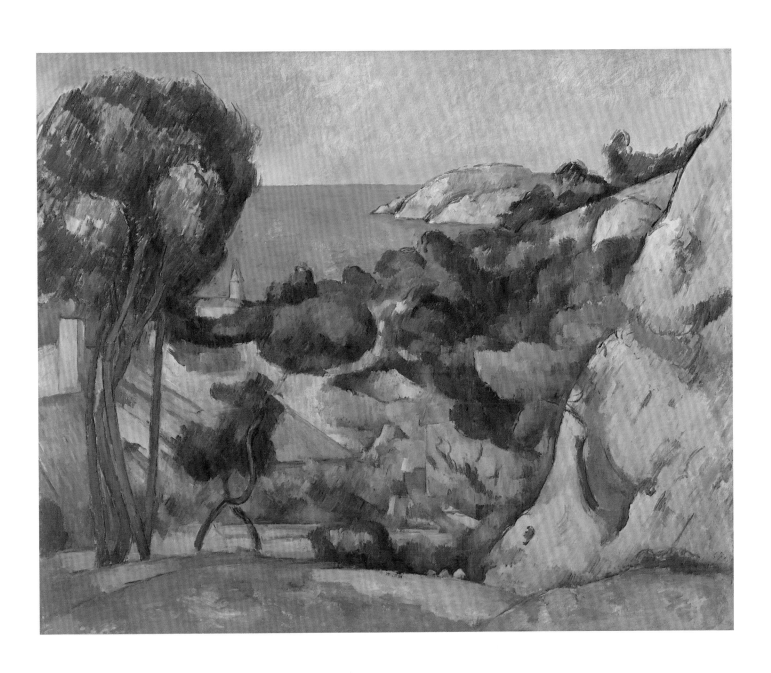

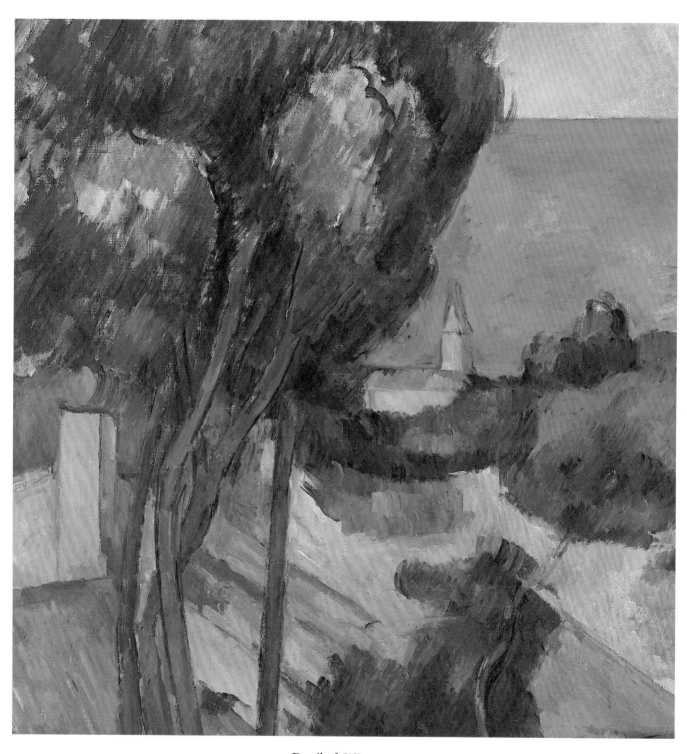

Detail of *L'Estaque*

representation of the mountains. But in the trees—indeed, in the foreground in general—Renoir's touch is light and airy, almost rococo in spirit; Cézanne's is all earnestness and will throughout. Renoir's landscape tends to dissolve the objective nature of the foliage into pure luminosity. Cézanne finds a consistent painterly counterpart to the world's solidity and density.

The Impressionists had conceived the canvas as something of a counterpart to the retina, whose screen of rods and cones reacted to the myriad *petites sensations* of colored light focused on it by the eye's lens. In recapturing for painting something of the pictorial architecture the Impressionists had excised from it, Cézanne nevertheless made use of the Impressionists' own optical building blocks, "becoming classical again through nature," as he put it, "that is to say, *by way of sensations*."[4] But Cézanne's particular transformation of their formula depended on rejecting the Impressionist notion that in the mosaic of retinal sensations which make up the visual field, each tessera, so to say, was of equal value. Rejecting Monet's and Renoir's art as too exclusively dependent on the passive eye, Cézanne gave the mind equal emphasis, so as to guarantee "the logic of organized sensations."[5] In practice, this meant selecting out and elaborating upon those *petites sensations* that lent themselves to the artist's bent for construction.

W.R.

Hilaire-Germain-Edgar Degas

French, 1834–1917

Portrait of a Woman, 1866–68 (cat. 15)

The most prolific portraitist and the finest draftsman among the Impressionists, Degas introduced a strong current of classicism into virtually everything he produced. This rare and beautiful drawing, datable to the late 1860s, is one of the least-known gems in the Paley Collection.[1] It embodies the primary tension that characterized Degas's oeuvre as a whole: classical stasis and precision despite a disarmingly straightforward presentation of the particular, rendered primarily through line.[2]

Degas's ability to convey the solidity of this genial, unassuming woman, her forward-leaning posture and her calm eyes, through such delicate means indicates a consummate draftsman, as does his ability to suggest variations in texture and light while never altering his firm and fluid handling. Few lines are emphasized at the expense of others, save those describing the sides of the head near the ears, the lines of the jaw, and the slight crook of the mouth. All else is formed by an elaborate network of thread-like lines and long, unwavering crosshatchings that almost inexplicably find themselves transformed into the planes of her face. Distinct from the work of such fervent admirers of his as Toulouse-Lautrec (pp. 135, 137), Degas's portraits are more detached, expressing a less acerbic consciousness.

The high degree of finish suggests that this drawing was a study for a canvas, yet too many physiognomic differences exist between the drawing and any of the oil portraits of the same period, and thus the identity of the sitter remains unknown.

M.A.

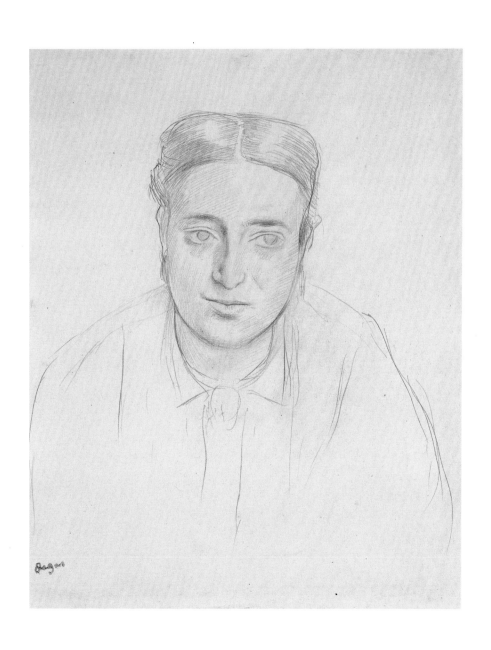

Hilaire-Germain-Edgar Degas

The Jockey, 1866–68 (cat. 16)

This drawing is one of several Degas undertook between 1866 and 1868, when the French fascination with steeple-chasing, and Degas's own interest in the racetrack, was at its zenith.[1] Degas was neither an equestrian nor a particularly committed racing fan. But depicting the interaction of horse and rider was part of his interest in the specific physicality of professional activity—the "positions" of ballet dancers or the patterns made by the repetitious work of laundresses. Yet his visits to Longchamp or Epsom were no less important for these images than his knowledge of the art of antiquity and the Renaissance.[2] The racetrack provided an otherwise unavailable opportunity to combine the classical tradition he cherished with his mordant observations of modern life and the particularities of the personalities involved. The subject so enthralled him that from 1860 to about 1900, Degas made hundreds of such drawings, only a small percentage of them as studies for subsequent oils. Moreover, these drawings were undertaken in Degas's studio, far from the noise and confusion of the track, allowing him to pose and rearrange his models with ease.[3]

This jockey—the model is unidentifiable, but Degas employed him often—is shown in three-quarter view, sporting muttonchops and a waxed moustache and seated on an English saddle. Compared to contemporaneous jockey drawings (fig. 10, p. 150) wherein horsemen are shown riding or actively subduing their horses, the Paley Collection jockey is seen in a moment of tranquility, free from hints of any more than incipient action or psychological strain. The hands and the foot—its position in the stirrup incorrect for a professional jockey—are indicated with a less explicit network of lines than in most of his drawings. The harder edges of the contours describing the jacket and the buffed graphite making up the gloss of its satin suggest that Degas's investigation here was to lend character to the jockey by concentrating on the shape and volume of the torso, the jacket, and the peculiar way in which being on horseback affects the distribution of weight. The horse is indicated by no more than the three horizontal lines that lead out from the hands of the jockey, which, pressing into the withers, hold a riding crop, itself suggested by a few rapid, deft pencil strokes.

M.A.

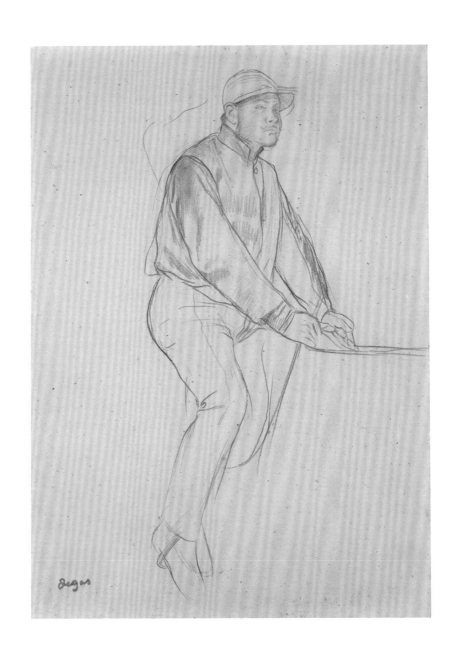

Hilaire-Germain-Edgar Degas

Two Dancers, 1905 (cat. 17)

Degas never used his sophisticated control of line to achieve the kind of instantaneousness one finds in most Impressionism. His reluctance to do so may have stemmed in great part from his wish to adjust and reform the human body so that in immediate impact its representation would be actual and tangible, and yet remain an engaging, elaborate abstract design. No subject afforded him the complexity and expressive potential of the human body better than the world of ballet. Balletic motifs provided a way to investigate predetermined or habitual patterns of movement, and the artist continually created poses that would emphasize the tension between the abstract discipline of drawing and the natural form of the body, a challenge that surely aroused his latent classicism. Degas had virtually to invent the ballet genre himself,[1] but, once he had established it, his output was astonishing: half of all Degas's paintings and pastels are of dancers. When asked why he drew such an exceptionally large number of them, Degas replied, "It is only there that I can discover the movements of the Greeks."[2]

The *Two Dancers* in the Paley Collection can be dated to about 1905,[3] though the artist had used its composition, with modifications both minor and major, throughout the 1890s, by which time his graphic production had completely overtaken his work in oil.[4] A large, vertically oriented charcoal drawing, it depicts two young ballet dancers, dressed in tutus and sleeveless bodices, sitting on a low banquette with fluted legs, preparing themselves. Exhibiting more graphic force than do the artist's scintillating color pastels of the same period, this image displays an attentiveness to the sculptural qualities of the dancers' limbs as well as a more modernist interest in the interstices. Strong modeling lines and modulations of tone center on the arms and heads of the two dancers, and the intricate play of their positions and gestures constitutes a pictorial analogue for musical movement. One dancer bends down with extended arms to tie the ribbons of her toe shoe, her skirt spread out rather fancifully around her. The other bends to the side, arranging her hair. Their attention appears concentrated on the shoe of the foremost dancer, who points her toes.

Of this late series of preparing dancers, Robert Gordon and Andrew Forge observe: "The dancers' heads and shoulders and arms dominate the picture space. We are very close to them, as if among them. Faces are hardly differentiated. It is the arms that matter above all. . . . This sense of anatomy—to be expected of any painter as learned as Degas—is more than knowledge. It is heightened, cathected, the expression of a special order of feeling. Simply to follow along its length the implied section of any single arm in one of these late pastels is immediately to taste the quality of Degas's mind as a painter, the flavor of his awareness, his sense of being in the world, his eros."[5]

<div style="text-align: right">M. A.</div>

36

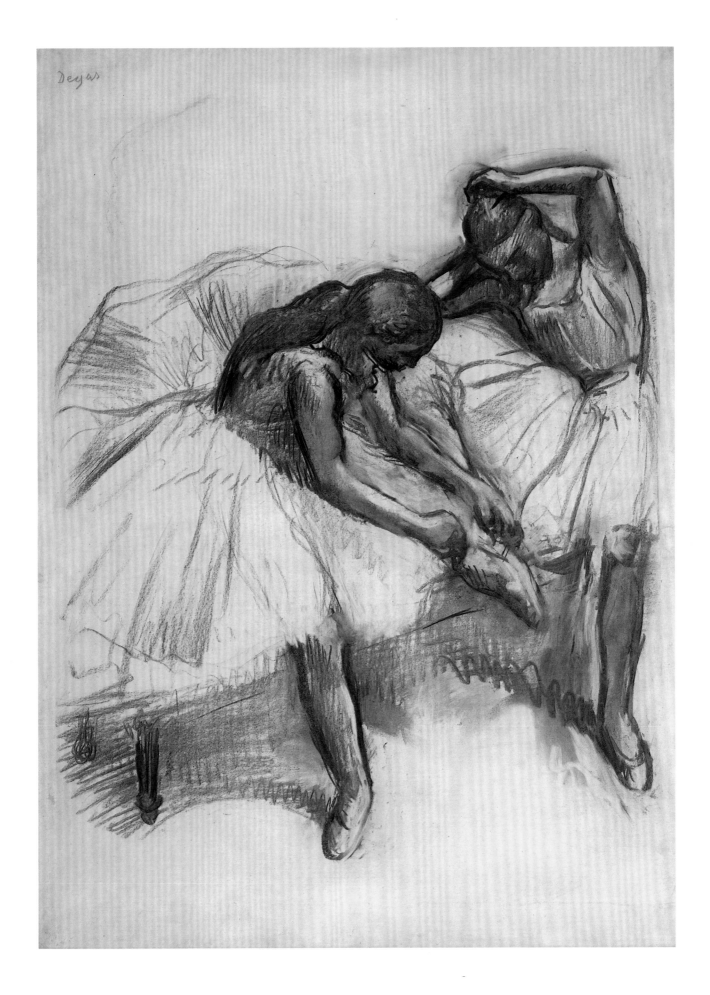

André Derain
French, 1880–1954

Bridge over the Riou, 1906 (cat. 18)

During the first decades of the century, André Derain enjoyed a reputation as a vanguard hero. Picasso hailed him as the co-founder of Fauvism; Apollinaire exaggeratedly described him as one of the inventors of Cubism;[1] and the pioneer dealer D.-H. Kahnweiler insisted that there was "no question" of the "aesthetic worth of his austere and mighty art; he is one of the greatest of French painters."[2] By the 1920s, however, Derain—while still painting in a somewhat modernist manner—had become more a conservative than a vanguardist. Today, in retrospect, his years at the actual cutting edge of modernist style are seen by most historians to have been limited to 1905–07—precisely the glorious if very brief period into which the two most important Paley Collection Derains fall.

Derain became a major figure in French modernism in 1905, the year in which the nascent Fauvist movement created a *succès de scandale*. But Fauvism was to be short-lived, and its two successive phases—roughly speaking, Neo-Impressionist and Synthetist (or Gauguinist) in inspiration—each lasted little more than a year. Fauvism sought to fuse the very different stylistic possibilities proposed by the Impressionists and Post-Impressionists, all the while pushing those innovations to new levels of intensity. Only Matisse, the doyen of the group, was more influential in this Fauvist endeavor than Derain.

Derain's first Fauve paintings of 1905 were heavily invested with a kind of staccato brushwork that owed much to Neo-Impressionism, and they often give an appearance of particular transparency and brightness due to the quantity of unpainted primed white canvas visible between the brushmarks. More perhaps than is the case with paintings by other Fauves, their color schemes are anchored to the primary hues. By contrast, in Derain's work of the following year, when he executed the earliest of the Paley Collection pictures, his palette had become more tonal—dependent on deeper though equally saturated secondary and tertiary hues—and his compositions more Synthetist in their melding of color accents into larger shapes. Although these 1906 pictures distance themselves more from the style of Matisse than had earlier been the case, they nevertheless share with his work a renewed interest in the art of Gauguin, many of whose paintings Derain had a unique opportunity to see at Daniel de Monfreid's home at Corneilla-de-Conflent in the Midi. Indeed, it was Gauguin's synthesis of color accents into *cloisonné* shapes that became, for Derain, the model for overcoming the Neo-Impressionist atomizing of color into complementaries, which he now considered the weakness of his earlier Fauve style.

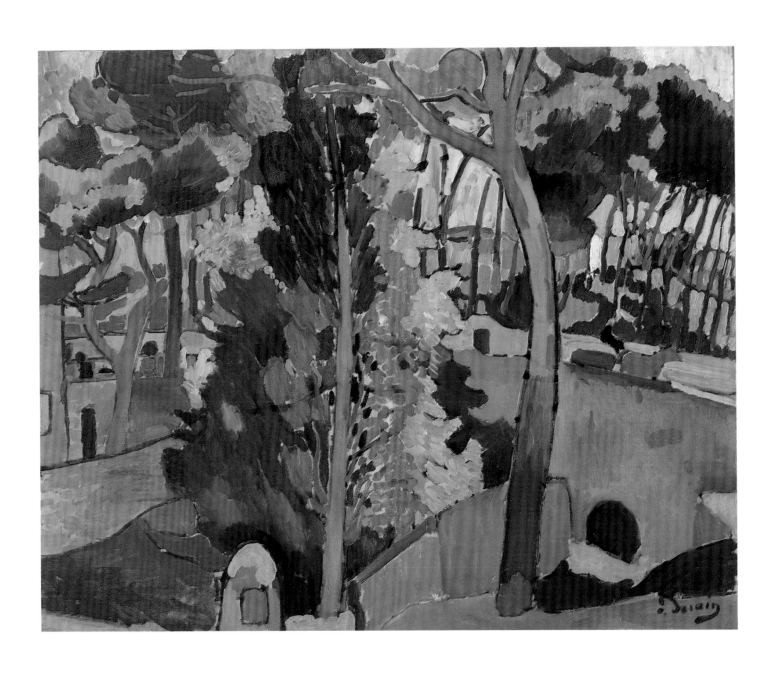

Detail of *Bridge over the Riou*

The Paley Collection's large and luminously hued L'Estaque canvas is one of three unusually large (for Fauvism) and magisterial landscapes made during Derain's "Gauguin-esque" phase. All three (see figs. 11, 12, p. 152) were painted during the summer of 1906, and their images draw variously on the components of a single pastoral motif which shows a road whose masonry bridge carries it over the Riou river. Long mistitled "Wild Landscape" or, alternatively, "Landscape at L'Estaque," the Paley Collection picture must certainly be identified as the one which Derain showed in the 1906 Salon d'Automne under the title *Bridge over the Riou*.[3] The masonry bridge of the title, with its small arch through which the little river passes, is visible at the right of the painting, an ox-drawn cart passing over it. A small cabin—clearer in other versions of this same motif—is visible down in the ravine through which the Riou passes, as is the familiar beehive-form of a masonry-covered well. A good-size building and other houses are visible where the hill rises on the other side of the river (the left side of the picture) behind the many trees that dominate the scene. The vista that actually inspired Derain no longer exists. Decades after the picture was painted, the painter told its then owner that the site had been destroyed to make way for a large canal.[4]

Were we able to compare the painting's motif to its actual site, we would no doubt be impressed by the degree to which the picture's recessional space—from the high foreground bank, through the valley of the river bed, to the higher ground beyond—has been compressed. Such spatial compression is understandable as a function of the Synthetist tendencies of the picture as a whole, by which the separated strokes of color, so frequent in Derain's 1905 paintings, have been subsumed into larger colored shapes. This Gauguin-esque tendency is also highlighted by the manner in which these areas—an indian red or pink used for a tree trunk, for example—are given distinct outlines of exotic blues or lavenders.

The resultant composition is of a complexly patterned order that testifies to extensive reflection and reworking on the part of the painter. Unlike Derain's more improvisational paintings of 1905, which seem to accept the "gestalt" of the motif largely as given, *Bridge over the Riou* is built up by a process of altering and reconfiguring the artist's own preceding versions of the motif. Hence, art rather than nature was the starting point for this picture.

Derain had been deeply troubled by the fact that earlier Fauvism had uncritically accepted from Impressionism the idea that the picture's structure was essentially given by nature; he had also begun to question Impressionism's taste for the passing moment of specifically contemporary life—the bustle of the street and the recreational activities of the

"vacation culture." Like the Impressionists before them, the Fauvists had tried in 1905 and early 1906 to capture this spontaneity by painting only before the motif. Derain's growing desire to create a more "enduring" imagery—one that would "belong to all time" as well as to "our own period"—had led him by the summer of 1906 not only to elaborate what he now characterized as "compositions" extensively in the studio, but to choose their motifs from "timeless" rural sites. The presence of the ox cart and the well in the Paley picture were characteristic steps in a direction away from the kind of Impressionist subject matter that had dominated earlier Fauvism. This was now a landscape in which people both lived and worked, as opposed to that of the Impressionists, where the countryside was seen as a place of enjoyment for urbanites. Indeed, in the larger version of the same panorama Derain painted shortly afterward, *The Turning Road, L'Estaque* (fig. 12), the cast of rural characters was enlarged to include a man carrying a jug, and a number of peasant women.

Derain's very first paintings at L'Estaque in the summer of 1906 retained some of the staccato brushwork and white "breathing spaces" between strokes that characterize his 1905 Fauve pictures, and they therefore give the impression of being oil sketches made before the motif. A small picture titled *Trees, L'Estaque* (fig. 13) shows what was probably his first confrontation with the paired large poplar and tall pine that would subsequently dominate *Bridge over the Riou*. Already the color choices, such as the orange and green for the tree trunks, are entirely independent of nature for their cues, although they remain more contrasting in their light/dark relationships than would be the case as Derain's art progressed through the summer. *Trees, L'Estaque* is so sketchy in execution and its color so antinaturalistic that the forms of the masonry bridge and the archway through which the Riou flows are virtually unreadable. We can be sure of their identification only by reading backward, as it were, from the more clear later versions of the motif such as *Bridge over the Riou*.

A good-size landscape usually titled *L'Estaque* (fig. 14), also painted early in the summer of 1906, shows a more ambitious segment of the same Riou vista as *Trees, L'Estaque*, opening as it does to encompass more of the panorama on the right. The same poplar and pine that we have seen in *Trees, L'Estaque* occupy the left of this canvas, though their drawing here is more developed and their color entirely changed. Two more large trees have filled out the vista on the right, and behind them the Riou bridge is, comparatively speaking, more readable than in *Trees*. More than in any other work of summer 1906, the bold contrasting of light and dark colors—yellow against violet, orange against blue—and the broken brushwork of *L'Estaque* evoke the instantaneousness and sense of the improvisational that had characterized Derain's 1905 Fauvism. These were precisely the qualities that Derain would squeeze out of his renderings of this motif in the course of the summer as he devoted at least three more large canvases to it.

Of these three, the Paley picture, *Bridge over the Riou*, was painted subsequent to *Three Trees, L'Estaque* (fig. 11) but prior to *The Turning Road, L'Estaque*. All three canvases qualify as what Derain called "compositions" in the sense that they were elaborated in the studio on the basis of earlier pictures rather than from the motif itself. Each is in turn larger and more complex in structure than the last and each subsumes progressively larger segments of the Riou vista; each also absorbs more purely invented anecdote as well. Viewers will differ as to whether the last and largest of the three compositions, *The Turning Road, L'Estaque*, makes up in its ambitious color orchestration and impressive size for its almost distracting multiplication of this anecdotal incident, of which the Paley picture has little, and *Three Trees* none at all. All three of these "compositions," however, share the splendor of a superbly inventive palette which, while arbitrary in relation to nature, forms convincing color chords of an astonishing richness.

<div align="right">W. R.</div>

André Derain

The Seine at Chatou, 1906 (cat. 19)

Sometime in the late summer or early fall of 1906, after having executed the three great Synthetist "compositions" based on the Riou bridge motif, Derain returned to Paris, where he leased a studio at the famed Villa des Fusains, 22 rue de Tourlaque, a building which had for some time been a popular site for artists' studios. During his few months in the Paris region, he began some figure sculptures by carving "blocks of building stone" from the front steps of his family's house in Chatou. [1] The blocky, structurally compact character of these works (fig. 15, p. 152), which reflect an interest in solidity of form not yet seen in his painting, was in part inspired by Derain's interest in tribal art, but was also symptomatic of his new interest in Cézanne, which would culminate in the monumental *Bathers* (fig. 16), painted early in 1907 and shown in March/April of that year at the twenty-third Salon des Indépendants. [2]

With the exception of this 1907 *Bathers*, there are very few works assigned to the months of late 1906–early 1907, a lacuna explained by the fact that, as Derain's dealer D.-H. Kahnweiler reported, the painter went through a spell of dissatisfaction and depression in 1907 during which he destroyed all the immediately preceding work still in his possession; [3] the *Bathers*, like the few other extant works, survived because it had already passed into Kahnweiler's hands. It is this writer's view, however, that the Paley Collection *Seine at Chatou*, traditionally assigned to one of Derain's stays in Chatou in 1905 (as per both Jean-Paul Crespelle and Pier Carlo Santini) [4] is actually another escapee, as it were, from this act of mass destruction. To be sure, it was executed at Chatou, but in the fall of 1906, after the artist's return from L'Estaque, rather than, as the literature has it, in 1905. As all the work of 1905 is divisionist in its color, it is hard to imagine—except for its having been painted at Chatou—how the misguided tradition for dating the Paley picture in that year ever got started.

Unlike the work of 1905, in which the artist generally looks down on the landscape from a high position, *The Seine at Chatou* is laid out in the traditional manner of Impressionist views of the Seine, showing a horizontal segment of the river viewed from ground level, and is set off by a *repoussoir* in the form of a large tree. The latter motif is distinguished by the exceedingly long reach of one of its principal branches which, stretching into the upper left-hand corner of the canvas, draws attention to the unusual (for Derain) and emphatic horizontality of the format. The grasses in the foreground are loosely brushed, but not at all in the Neo-Impressionist vein of the 1905 and early 1906 compositions. Indeed, the brushwork in *The Seine at Chatou*—especially in the leaves of the trees and bushes—has close affinities with what is usually described as the "constructive" brushstroke of Cézanne. The Cézannist influence in this Derain is also felt in the block-like small patches and touches which Derain has used to build up the image of the town in the background. But perhaps the most Cézannist aspect of the work is its palette, whose axis is a gamut of greens that lead to cooler blues on the one hand and to warmer rusts, roses, and terra-cottas on the other.

W. R.

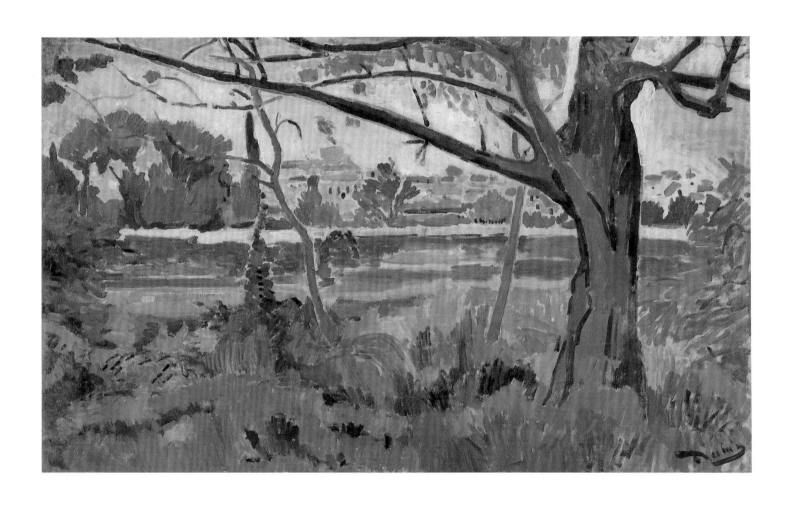

André Derain

The Rehearsal, completed 1933 (cat. 20)

It is not easy to believe that *The Rehearsal* was the work of the same painter who executed *Bridge over the Riou* (p. 39). But almost thirty years had passed, and during that time Derain's art and his convictions in regard to it had changed, relatively speaking, more than those of any of the other pioneers of Fauvism or Cubism. Immediately following World War I, and during the years of the twenties that responded to Jean Cocteau's "call to order," the Paris art scene as a whole witnessed a renewed interest in conservative idioms, especially neoclassicism; it was as if the trauma of the war had become associated with various supposed "excesses" of its eve—most notably vanguard art, Cubism in particular.

In the twenties, Derain was considered a leader in this conservative retrenchment, though its effects were clearly visible even in the painting of Picasso and Matisse. The critic André Salmon characterized Derain as the "regulator," the man who tried to keep extremes in balance. In fostering his tendency toward classicism, the artist's trip to Rome in 1921 was to play an important role, as did his growing emphasis on the French tradition, particularly the work of Corot. Rome and the Italian Comedy—indeed, the theater in general—were to become as important in Derain's art as in Picasso's, and like his Spanish friend, Derain increasingly interested himself in designing decors for the stage.

It is in this context that we must situate the Paley Collection *Rehearsal,* clearly inspired as it is (if only generically) by costume drama. The rhetorical poses and theatrical gestures obviously locate the action on a stage; the figure on the left seems to be delivering a *tirade,* while his companion turns his back to the audience in operatic fashion, better to "spotlight" the speaker. Despite its dependence upon the spoken word, the theater was associated in Derain's mind with a method of fighting against overly cerebral art—the very kind of excessive intellectualism that the now aging Derain identified, however wrongly, as the fault of such prewar styles as Fauvism and Cubism. "The theater," he wrote, "is an art in which intellectualism has no place: all is mystery in its expression."[1]

The Rehearsal was purchased by Mr. Paley from out of Derain's studio on one of his visits there. He recounts in his memoirs that the picture had been left unfinished some years before, and that under his urging, Derain completed the lower parts of the two figures.[2]

W. R.

46

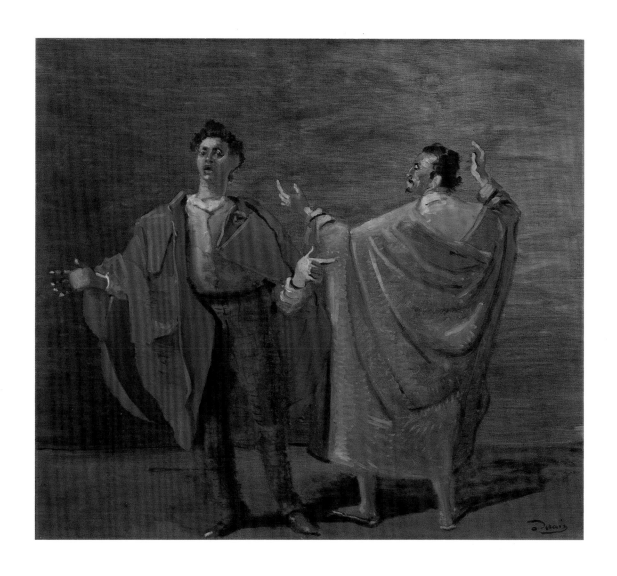

47

Paul Gauguin

French, 1848–1903. In Tahiti and the Marquesas Islands 1891–93, 1895–1903

Washerwomen, 1888 (cat. 23)

Gauguin's two-month stay with van Gogh in Arles at the end of 1888 was marred by the strain of having to adjust to the Dutch painter's unstable personality, by continued anxiety on the part of both men about money, and, surprisingly, by Gauguin's immediate dislike of Provence. His mind more than ever filled with visions of lush tropical paradises, he would write to Émile Bernard of dry, Mistral-swept Arles: "I find everything [here] small, paltry, the landscape and the people."[1] Notwithstanding, Gauguin had a productive sojourn, and executed works in a variety of mediums, among them two very different oils on a theme essayed by van Gogh the previous June, the washerwomen at work in their Arlesienne costumes on the banks of the Roubine du Roi.

Gauguin does not mention either version of *Washerwomen* in his extant correspondence, but there are two references to these pictures in letters by van Gogh, although we cannot tell which versions are in question. On November 25, he writes his brother Theo that "Gauguin is working on a very beautiful picture of women washing";[2] and on about December 4, again to Theo, he says "[Gauguin] has a good canvas of women washing, even very good I think."[3]

Gauguin's two versions of *Washerwomen* could not represent more contrasting approaches to the motif. Whereas in the painting now in the Museo de Bellas Artes, Bilbao (fig. 17, p. 153), the artist closes in on the subject, eliminates the horizon line, and allows his arabesques to create a sense of a vertiginous space, in the Paley Collection picture the major forms are classically distanced, and the structure of the composition is tranquil. Four women are shown on their knees, scrubbing in the shallows of the river, while another, laundry in hand, stands at the left. The orderliness of the arrangement is disturbed only by the two heads in the lower left, whose truncation by the frame implies a sense of the momentary somewhat inconsistent with the almost hieratic poses of the other figures. (It is interesting to note that these heads constitute the major elimination Gauguin made when executing a finished watercolor based on the painting, in effect, a rethinking of the composition; fig. 18.)

If Gauguin has not—as was often his wont—superimposed a symbolic meaning on the picturesque scene of *Washerwomen*, he has nevertheless treated his laundresses with something of that quasi-religious sanctity with which he had earlier endowed his Breton peasant women. This primitivizing tendency, which discovered new social values in the rural traditions and dress of *la France profonde*, is evident in the motionless, archaic stance of the woman at the left and perhaps elliptically, in an analogy between the laundresses' postures and those adopted by figures in prayer in some Eastern art. Thus washing clothes becomes for Gauguin less a casual, anecdotal activity than a ritual which attaches the women performing it to the cycle of life.

W.R.

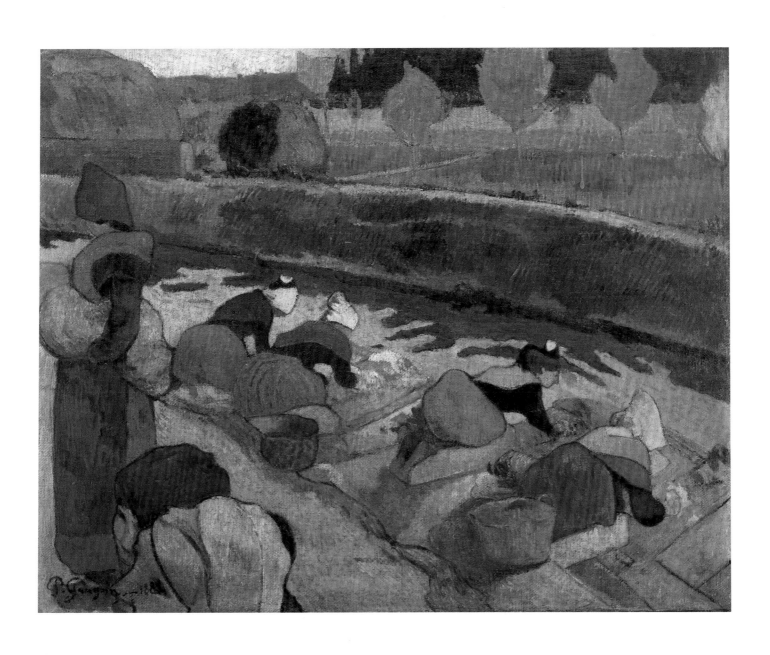

Paul Gauguin

The Seed of the Areoi (Te aa no areois), 1892 (cat. 24)

This picture has sometimes been published as "The Queen of the Areois,"[1] a mistranslation of Gauguin's pidgin Tahitian title inscribed on the lower left of the canvas.[2] But the painter's title, which means the seed, not the queen, of the Areoi—a Polynesian secret society that had disappeared long before Gauguin's stay in Tahiti—refers directly to the principal poetic symbol in the picture, the flowering seed that the young girl holds in her hand.[3] This motif stands for the procreative potential of the girl herself, less in her real-life role as Tehura, the painter's thirteen-year-old native mistress, than in the form Gauguin has imaginatively envisioned her: as Vaïraümati, the mythic earth-mother of the Areoi sect.[4]

The myth of the origins of the Areoi clan is the Polynesian equivalent of an almost universal kind of genesis story wherein a male sun god (or war god), in this case, Oro, mates with the most beautiful of all female earthlings (Vaïraümati in the Maori tale) to found a new and more perfect race. In his writings and statements, Gauguin led one to believe that he learned about such Maori legends directly from Tehura, thus implying that he was painting these subjects in the context of a living tradition.[5] But with one or two aged exceptions, to whom Gauguin did not have access, the last of the "storytellers" who knew these legends had died generations before Gauguin's trip to the Society Islands, and the old religions had long since been displaced by Christianity.[6] In fact, Gauguin discovered the myth not through personal contacts but in an early travel book he had borrowed, Jacques-Antoine Moerenhout's *Voyages aux îles du Grand Océan*—a text replete with mistaken accounts and anthropological errors.

That Tehura herself was in the first instance surely ignorant of the story in which Gauguin cast her in the starring role takes nothing away, however, from the poetry of the image the artist constructed. Gauguin started by equating the great beauty of his young *vahine* with that of the goddess Vaïraümati, who may be considered a Maori version of Isis or Venus. As the artist retells the myth in his *Noa-Noa*:

> Oro, the son of Taaroa, and after his father the greatest of the Gods, resolved one day to choose a mate from among the mortals. He wished her to be a virgin and beautiful, to the end that he might found with her, among the multitude of men, a race superior and favored above all others. . . . His glance did not remain long on any of the daughters of men; in not a single one did he find the virtues and graces of which he had dreamed. And after many days had been consumed in vain search, he decided to return to heaven, when he saw at Vaïtape on the island of Bora-Bora, a young girl of rare beauty. . . . She was tall in stature, and all the fires of the sun burned and shone in the splendor of her flesh, while all the magic of love slept in the night of her hair. . . . [Oro's sisters are called upon to negotiate with the young girl, Vaïraümati, on the god's behalf:] "If your brother is a chief [she replies], if he is young and beautiful, let him come. Vaïraümati will be his wife. . . ." Vaïraümati had prepared for his reception a table weighed down with the most beautiful fruit. . . . [Later, when she is pregnant, Oro says to her of her offspring:] "These men shall be the Areois. To thee I give their prerogatives and their name."[7]

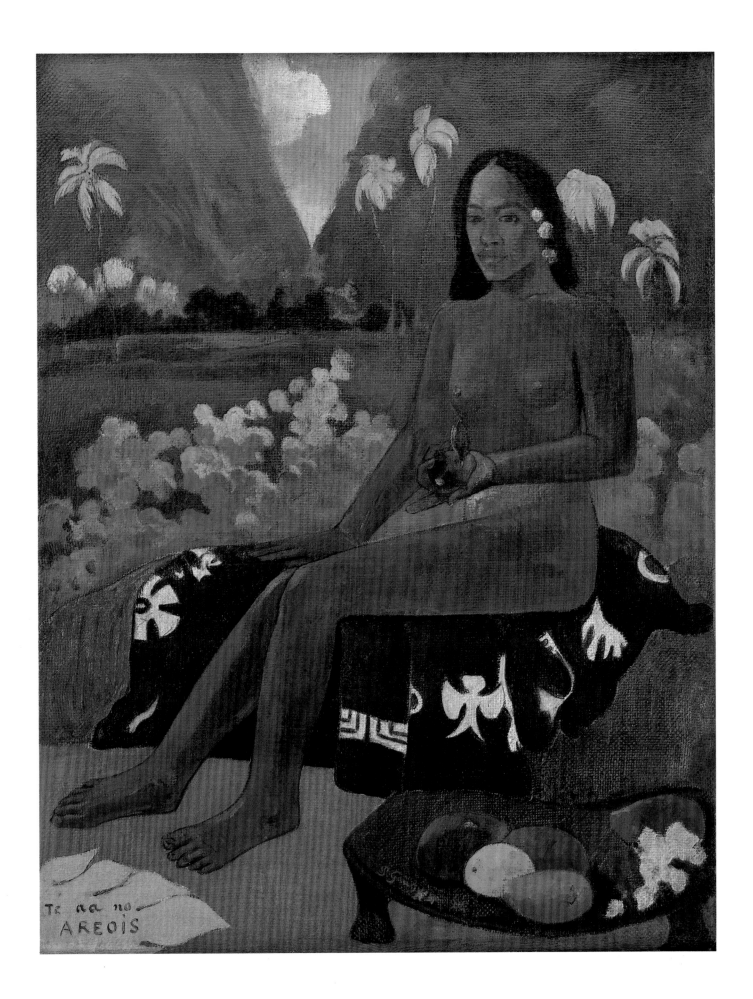

Detail of *The Seed of the Areoi (Te aa no areois)*

By painting Tehura as Vaïraümati, Gauguin implies that the way of life of the Tahitians of his day was still part of a continuous cultural cycle though, in fact, it had been profoundly altered by the advent of colonialism. He clung to this idea because his willfully anachronistic vision of Tahitian society provided him an ideal alternative model against which to set the supposedly debased European culture that he abhorred. Describing himself often as a *sauvage,* and asserting that he could not find happiness except in a "state of nature" (which he wanted to believe could still be found in Polynesia), his casting of Tehura as the mother-goddess of the Maori people placed him by extension, as her real-life paramour, in the role of the creator-god Oro. This poetic parallelism between the artist and a deity was not new to Gauguin's psychology; during his Brittany period, he had painted a self-portrait which posited a parallel between himself and the crucified Christ.[8] The reference there was to the artist as sufferer; here the allusion would be to his role as a creator.

The idea of a "dual-track" image of a young girl—at once an individual from Gauguin's immediate world and a mythological cult mother—was the source of two closely related paintings by Gauguin, both versions of which date from the spring of 1892, during the artist's first stay in Tahiti. Although a few commentators consider *The Seed of the Areoi* to be the earlier of the two versions, it is assumed by most writers (and seems clear to this one) that the painting titled *Her Name Is Vaïraümati* (fig. 19, p. 154), in the Hermitage Museum, Leningrad, was the first version of the scene.

In the Hermitage picture, as in the Paley Collection work, the goddess is seated on a mound partially covered by a decorative blue and white *pareu,* before an *umete,* or three-legged Polynesian wood table, which displays sumptuous mangoes, the fruits referred to in Gauguin's account of the legend. Only minor differences may be noted in the still lifes of the two versions, and the patterns of the *pareu* cloths are similar in color if somewhat different in design. But while the legs and arms of Tehura/Vaïraümati in the two paintings are also very similar, there is a major difference in the handling of her head, which is shown in absolute profile in the Hermitage picture but in three-quarter view in *The Seed of the Areoi.* It is in the space behind the goddess, however, that the two pictures differ most. In *Her Name Is Vaïraümati,* a standing man, his gesture and facial expression displaying some shock or wonderment, fills the upper right of the canvas,[9] while in the background landscape, there is a hut and a monumental double "Tiki" sculpture.[10] None of these motifs are to be found in the much simplified Paley Collection picture, where the landscape background is made much deeper and a piece of sky is visible between the mountains.

As Gauguin did not usually make more than one version of a subject,[11] the probable explanation for his repetition of this one is that he was dissatisfied with his first essay and felt the theme important enough to warrant getting right. Indeed, it is not hard to be critical of the way in which the motif was managed in *Her Name Is Vaïraümati.* The conflict there between the experiential poles of present-day activity and timeless mythic stasis is too exaggerated—and also at once over-symbolized and trivialized. Given the lively movement and momentary expression of the standing man, the Egyptianizing perfect profile of the goddess appears excessively abstracted and otherworldly, too timeless to meld with his instinctive gesture and, above all, with her both casual and contemporary act of smoking a cigarette. (Indeed, the facial expression of the man, certainly intended to convey the shock

of his sudden awareness of finding himself in the presence of a deity, might all too easily be misread today as a reaction to her unwonted smoking.)

Gauguin's solution, in his second try, *The Seed of the Areoi*, was to reduce the *dramatis personae* and combine the themes of ritual timelessness and contemporary reality in the single figure of Vaïraümati. He accomplished this by moving her head to a three-quarter view while nevertheless retaining a fixed, otherworldly stare, and by replacing the cigarette in her hand with the flowering seed of the mango fruit sacred to the tribe she would mother. The association of a seed flower with the theme of sexual procreation is a familiar one, and the literalness with which Gauguin thought of it is evident in one of his watercolor illustrations for the texts in his *Ancien Culte mahorie*, where the petals of what looks to be a mango flower open to reveal minuscule figures of a man and woman in the act of making love (fig. 20).

The somewhat abstracted, "Archaic" glance with which Gauguin endowed Vaïraümati in *The Seed of the Areoi* is essential to the hieratic dignity and, by extension, the religiosity of the image. And yet, for many years—and indeed, in most reproductions of the picture— the eyes of Vaïraümati were shown clearly glancing provocatively at the spectator (fig. 21). This was probably the result of a dealer-directed restoration, a bit of hyping up which— along with some lesser changes such as the addition of a necklace—was removed in a cleaning subsequent to Mr. Paley's purchase of the painting, though photographs of the disfigured work continued to proliferate.[12]

The eclecticism of Gauguin's Tahitian style made room for a variety of both "primitive" (i.e., Egyptian, Japanese, Javanese, and Polynesian) and Western influences. The primary Western source in *The Seed of the Areoi* is a painting of 1872 by Pierre Puvis de Chavannes titled *Hope* (fig. 22). This work—a favorite of Gauguin, who made a drawing after it (fig. 23) and also carried a photograph of it with him to Tahiti—provides many aspects of the pose. It shows a very young but nubile girl with a budding sprig in her hand who sits upon a drapery spread across a mound surrounded by flowers; her legs are slightly parted below the knees and she has one arm extended. Although Puvis conceived this figure as an allegory of hope, the nascent sexuality of the girl, and the allusion to germination implied by the surrounding bed of flowers, made it easily assimilable to Gauguin's theme of procreation. Less widely known today than many other late nineteenth-century masters, Puvis never- theless exerted an enormous influence on the Post-Impressionists and Symbolists. During Gauguin's stay with van Gogh in Arles in 1888, he would write to Émile Bernard: "It's curious; here Vincent feels bound to paint like Daumier while what I see instead is colored Puvis mixed with Japan."[13] If we translate "Japan" as the strong silhouetting and flat colors of Japanese woodcuts, we can see that Gauguin carried this amalgam of Puvis and Eastern art with him right into *The Seed of the Areoi*.

One of the aspects of the pose of the young girl in Puvis's *Hope* which probably most interested Gauguin was that, while her head is shown from the front and her upper body turns only slightly, her right leg is virtually in profile. It is easy to see how Gauguin could assimilate this suggestion—still naturalistic in Puvis—to the highly stylized Egyptian "memory image" representation of seated females as in a famous ancient frieze in the British

Museum (fig. 24), a photograph of which he also took with him to Tahiti. The Egyptian component of Gauguin's stylistic syncretism is less evident in the Paley picture than in *Her Name Is Vaïraümati*, where Tehura's head is shown in perfect profile, her shoulders absolutely frontal, and her legs in profile. But even though Gauguin turned her head to a three-quarter view in *The Seed of the Areoi*, he retained much of the stiff, archaizing, and hieratic posturing typical of Egyptian art. Indeed, the bright, flat, and shadowless colors characteristic of Egyptian wall painting in general provided an anti-Western model as pertinent as Japanese woodcuts for the *cloisonnisme* of Gauguin's mature style.

Gauguin's synthesizing of styles drawn from different cultures had yet another dimension in *The Seed of the Areoi* insofar as the positioning of Tehura's arms owes something to a series of standing figures executed by Gauguin in watercolor and charcoal (figs. 25, 26), which were derived from the pose of an Ajīvaka-monk in the celebrated relief from the Javanese temple of Borobudur (fig. 27). Here again, we will not be surprised that a photograph of that relief was among the images Gauguin took with him to Tahiti.

The eclecticism of Gauguin's pictorial sources sometimes disturbs the unity of his canvases. But if this can be argued to some extent of *Her Name Is Vaïraümati*, it is certainly not the case with *The Seed of the Areoi*, where the bold and exquisitely decorative layout is not burdened by an excess of imagery or anecdote. The low-relief modeling of the figure and fruits and the slightly shaded coloring of the plants, trees, and mountains assimilate easily into the flat, ornamental patterning of the ground under Tehura's feet and the *pareu* on which she sits. Contrary to popular assumptions, the exquisite designs of that *pareu* and other such draperies in Gauguin's Tahitian pictures have nothing whatever to do with Polynesian handicraft. They are therefore sometimes said by scholars to be the designs of the English manufacturers from Manchester who regularly sold *pareu* cloth to the islanders. But no instances of this sort of decorative floral design exist in any samples, records, or catalogues of such cloth, and it may well be that these decors (which Gauguin certainly wanted to have his public associate with the cultural ambience of Oceania) were actually among his own most striking bits of aesthetic invention.[14] These *pareu* designs form a microcosm of the opposition of pure, virtually flat colors deployed in flat, decorative patterns that Gauguin pursues throughout the work as a whole.

In *The Seed of the Areoi*, the resonance of complementaries (purple against yellow) in the background, and neighboring tones (red, yellow, and brown) in the foreground, forms an exquisite color chord, but of a kind that nevertheless struck the turn-of-the-century public as shocking. Perhaps to "rationalize" his work and thus make it more acceptable, the artist liked to claim he discovered this palette in the Tahitian landscape: ". . . the landscape with its bright, burning colors dazzled and blinded me . . . it was so simple to paint things as I saw them, to put on my canvas a red and a blue without any of the calculation [of his earlier work]."[15] But even at their brightest, the visual realities of the Polynesian village and landscape are far from the palette we see in Gauguin's paintings, and his suggestion that his color was merely—or even primarily—a transposition of what he *saw* ironically denies us the full measure of his genius.

W. R.

Paul Gauguin

Tahitian Landscape, 1899 (cat. 26)

This small landscape from the artist's second sojourn in Tahiti is a rarity in Gauguin's painting in view of its suppression of both figures and animals—to say nothing of the absence of any symbolic overlay. In a wild but utterly benign pastoral world, only the thatched hut betrays the presence of human civilization.

Gauguin has used a deep and saturated blue-green palette here in a manner less circumscribed by the firm contouring that had obtained in his earlier Tahitian works. Indeed, the softer and more disengaged brushwork and the delicate nuancing within each hue combine to make a pictorial fabric that at once recalls Gauguin's sources in Cézanne and reminds us of the influence he would later wield on Matisse. (One critic has, in fact, argued affinities between the Paley Collection picture and Matisse's 1912 *Moroccan Landscape.*)[1]

W.R.

Alberto Giacometti

Swiss, 1901–1966. In Paris 1922–42, 1945–66; Switzerland 1942–45

Annette, 1950 (cat. 27)

Following World War II, Giacometti's most sought-after goal was to evoke the vivid actuality of another's being as perceived within a single, momentary, all-consuming glance.

Annette is one of several portraits the artist painted of Annette Arm, whom he had married the year before. Restricted by the compressed space of her environment, looking as if she were a complacent ghost in the midst of shedding her corporeality, she sits—fully clothed, hands clasped and legs crossed, eyes straight ahead, keenly aware of her observer. An interior frame, made up of gray bands and black lines parallel to the sides of the canvas, functions as a transitional zone between the actual and the re-created world. Within, the elongated proportions of the figure are the result of the artist trying to create an image unencumbered by the imposed constructs of Western perspective. Verticality, which Giacometti claimed to be the visual quintessence of another person, takes precedence over all other discernible aspects.

Almost exclusively preoccupied with the rendering of phenomena perceived at a distance, whether model, wife, friend, faceless stranger, empty room, or landscape, Giacometti's canvases analyze the immense gulf between observer and observed. Jean-Paul Sartre concluded that Giacometti "puts the fact of distance within reach of your hand; he thrusts before you a distant woman and she remains distant, even when you try to touch her with your fingertips. . . . What must be understood is that these figures, who are wholly and all at once what they are, do not permit one to study them. As soon as I see them, they spring into my visual field as an idea before my mind; the idea alone possesses such immediate translucidity, the idea alone is at one stroke all there is."[1]

M.A.

Juan Gris (José Victoriano González)

Spanish, 1887–1927. To France 1906

Mandolin and Grapes, 1922 (cat. 28)

The Cubism of Juan Gris differs fundamentally from what had been initiated by Picasso and Braque. With an aestheticism alien to Picasso and a license that distinguishes him from Braque, Gris gave less emphasis to the dislocation and complex fragmentation of objects and increased consideration to the decorative possibilities inherent in Cubism, through greater simplicity. D.-H. Kahnweiler, the artist's friend, dealer, and biographer, asserted that Gris "never looked on Cubism as a system but as a way of feeling and thinking which left him free to choose his own technique. He had scruples of another sort—he wanted manifest simplicity."[1]

"The essence of painting," said Gris, "is the expression of certain relationships between the painter and the outside world, and that a picture is the intimate association of these relationships with the limited surface which contains them."[2] In this 1922 gouache, *Mandolin and Grapes,* the motif is unadorned; a mandolin, an empty goblet or compote, some grapes, a glass, and sheet music are laid out on a tabletop, which is set against a flat background from which these forms appear to project forward, toward the viewer. Gris has dispensed with the aggressively clashing colors, the inclusion of newsprint, and the elaborate verbal and visual punning of his prewar Synthetic Cubist paintings to produce a less disquieting study of color harmonies, restricting his palette to somber shades of brown, beige, black, and gray. The use of limited tonalities and less demanding configurations was shared by many former Cubists in the postwar years, both in revamped versions of Cubist pictures and in the figural, "neoclassical" images begotten by Picasso and taken up enthusiastically by the Parisian avant-garde.

Kahnweiler, who had known Gris's prewar Cubist pictures, was highly impressed with the Spaniard's pictorial innovations when he saw them after returning to Paris in 1916. Of these relatively late works (the artist died in 1927), Kahnweiler said: "I had left behind a young painter whose works I liked. I returned to find a master."[3]

M.A.

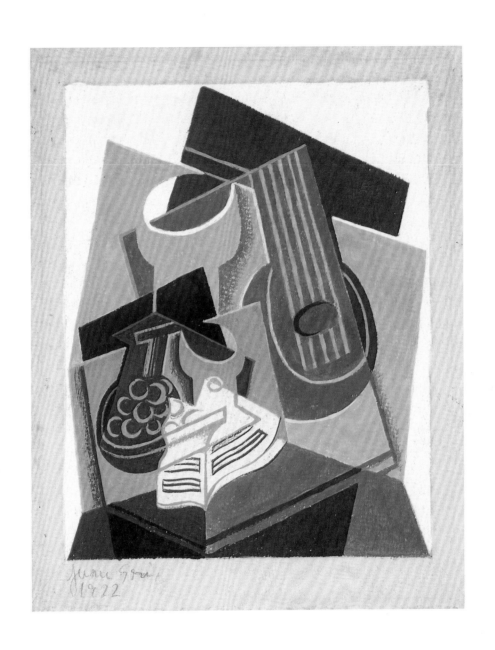

Al Held

American, born 1928

Black/White Roman XVII, 1968 (cat. 29)

After a number of years devoted to large, richly colored paintings, the American painter Al Held embarked on a series of monochromatic canvases of which *Black/White Roman XVII* is an early example. By relinquishing surface incident and composing his field entirely of interlocking geometric shapes, painted exclusively with black lines on a white ground, Held reintroduced many of the structural and conceptual concerns he felt had been central to early modern art. He felt that this reapplication of essentially Cubist ideas of space was an antidote to the malaise of the predominant contemporary styles of abstract art, whether in "action painting," Minimalism, or in the hard-edge abstraction with which he had become associated.

Moving toward new developments built on the lessons of Picasso's Synthetic Cubism, Held was also interested in the work of the early modernists Fernand Léger and Kasimir Malevich, as well as in the sharp-focus realism of the fifteenth-century Flemish painter Jan van Eyck. Moreover, he became acutely aware of the history of architecture; this knowledge informs much of his art, lending it a sense of firm construction, and of permanence.

In *Black/White Roman XVII*, its title bearing overtones of Piranesian weightiness, heavy black bands of varying widths abut, collide with, or are transformed into triangles, cubes, rectangles, and other simple, clarified geometric shapes. As Irving Sandler notes, in much of Held's painting of this period "the components . . . are perceptually passing through each other, and this *passing through* becomes the primary sensation of Held's work."[1] The monochromatic palette and restricted space suggest the influence of Cubism here—but by now that branch of Cubism seen in the architectonic work of its American practitioners Patrick Henry Bruce and Stuart Davis more than the work of Picasso and Braque. The geometric formal organization creates great dynamism and energy: the intricate, oscillating vantage points and the intimations of reversible perspectival illusion encourage a reading that shifts from above to below, from left to right. This simultaneity of multiple events reflects a complete rejection of the prevailing notions of Minimalism, which was founded on a reductive, literal, and unambiguous reading of the surface. Of this effect in the black and white series, Marcia Tucker writes that "the perspective vantage points are oblique and changeable; they can be entered optically from above, below, or to either side depending upon what portion of the painting is focused upon. The impact of these and subsequent black-and-white canvases is one of contradictory, counterbalanced information. The multiplicity of vantage points, the impossibility of selection, the complete absence of a gestalt or holistic reading are in striking contrast to the previous work."[2]

M.A.

Edward Hopper
American, 1882–1967

Ash's House, Charleston, South Carolina, 1929 (cat. 30)

Ash's House, Charleston, South Carolina is one of a small number of watercolors Edward Hopper made while vacationing with his wife, Jo, in May 1929. An avid traveler whose wanderlust led him throughout the United States, Hopper sought out the curious, idiosyncratic poetry of commonplace motifs buried in environments—Cape Cod, Gloucester Harbor—usually known only for mere prettiness, a quality he rejected completely. Hopper worked almost exclusively in watercolor when on the road, a medium he had begun to use with greater frequency by 1923 and which he would pursue for the rest of his life.

Ash's House does not exude the sense of loneliness so often ascribed to Hopper's best-known images, whether urban or rural, nor does it display their degree of geometric simplification. The construction of this watercolor is instead a forceful and dynamic interplay of intersecting vectors of freshly brushed color. A white clapboard two-storey house is seen from above, somewhat obliquely, thereby accentuating the angular complexity of its veranda and porch and the patterning of its four green shutters. The image is cast in brilliant hues—the glaring white light of the atmosphere, the blue sky, and blue/gray shadows—counterbalanced by the red roofs and chimney.

Hopper understood that the speed with which watercolors could be painted, and the resulting sense of instantaneousness perceivable in their unmixed colors and direct application, created an alternative aesthetic to that of his oil paintings, wherein stasis and a disquieting feeling of frustration, even entrapment, can seem all-pervasive. As a result, his watercolors were almost never preparatory studies for subsequent works in oil.

The motif of *Ash's House* surely appealed to Hopper in part because of his interest in the intricacies of indigenous American architecture. Hopper believed that "a nation's art is greatest when it most reflects the character of its people,"[1] and his lifelong fascination with what was particular to America—an attraction especially strong during the Depression—and his seemingly antimodernist stance set the stage for the wide approval of the so-called Regionalist painters of the 1930s, notably Thomas Hart Benton and Grant Wood.

M.A.

John Kane

American, born Scotland. 1860–1934. To U.S.A. 1880

Industry's Increase, 1933 (cat. 32)

"For subjects to paint," wrote John Kane, "I can honestly say I have found nothing too lowly. I have found inspiration in every conceivable thing. Sometimes an illustration in a newspaper will send my mind to far-away places. Mills, factories, coal barges, trains, tracks, sheds, sheep, cattle, plow horses, hills, valleys, meadows, streams—in all I find a beauty that I long to set down."[1]

John Kane, born in Scotland in 1860, arrived in America in 1880 and worked as an itinerant miner, carpenter, house painter, steel worker, and street paver. He often lived in dire poverty and could only dream of attending art school, but sketched in his free time and later taught himself to paint. He achieved no recognition until he was sixty-seven years old, when a painting of his was shown in the 1927 Pittsburgh International Exhibition of Contemporary Painting and Sculpture. The unusual inclusion of an untrained painter, especially a man nearing seventy, caught the attention of the press and the art world. In 1930, his work was included in The Museum of Modern Art's exhibition "Living Americans." Throughout the Depression, Kane occupied a curious position in regard to the development of modernism in the United States; on one hand he was hailed by those who rejected recent European art in favor of representational images of common life in America—so-called Regionalist painting—yet on the other hand, his work was championed by connoisseurs of European Post-Impressionism, who recognized Kane as a true original with innate abilities and achievements comparable to other self-taught painters such as the Douanier Rousseau (see p. 127).[2]

Unlike the Precisionist painter Charles Sheeler, for example, Kane invigorates American industrial subjects with a highly sympathetic and personal sensibility. The Paley Collection painting, known also as "Prosperity's Increase," shows the South Side of Pittsburgh and the Tenth Street Bridge as it crosses the Monongahela River. Sidney Janis, an early admirer of Kane's work, wrote at length on Kane's inventiveness before the site and enumerated the artist's creative rearrangements in representing the motif: the span of the bridge, for example, was narrowed in order to bring the particulars of the other shore within sight; despite billowing clouds of industrial smoke, no detail is obscured; foreground and background are fancifully conjoined, giving the viewer an encyclopedic account of the area. Kane virtually re-created each building, every piling and street, brick by brick. Writes Janis, "In *Industry's Increase*, not only is everything fully controlled but it is integrated into a design as compact as it is intricate. Streets, tracks, trains, figures, the boats, the bridge and factories, everything, including the well-settled hills, is touched with the love and understanding that can come only from an artist whose mind is keenly charged with knowledge of his subject."[3] And indeed Kane painted only that which held personal meaning for him: "I paved Carson Street, the very street I painted in *Industry's Increase* for the Carnegie Institute International Exhibition of Paintings. I never thought in those days that I would show in an art exhibit a picture of the street I paved. But even at the time I had my pencil in my hand."[4]

M.A.

Gaston Lachaise

American, born France. 1882–1935. To U.S.A. 1906

Reclining Woman, 1924 (cat. 33)

Throughout his life, Gaston Lachaise concentrated almost exclusively on perfecting his vision of the female nude. Often hovering or floating, always ample, unquestionably imposing, Lachaise's women are nonetheless endowed with a gaiety and exuberance usually lacking in figures which so forcefully convey a sense of regenerative power and fecund vigor.

Rarely giving so much as a hint of the massive and vital heroines of the Acropolis or the Sistine Ceiling, Lachaise's figures are related instead to Stone Age sculptures such as the Venus of Willendorf or the Woman from Lespugne, artifacts of prehistoric cultures which the artist prized above all others. In combining their primal simplification with the stylizations from the popular *art moderne* of his own time, Lachaise wished to reintroduce the "barbarian impulse" he valued as fundamental.[1]

In this *Reclining Woman* of 1924, however, satiety and ebullient well-being play a witty counterpoint to Lachaise's presentation of the female as a primordial being, for though monumental, the figure nevertheless exudes an odd sense of weightlessness, even mirth. The treatment of her delicately tapering limbs, for instance, belies the bulky materiality of her torso and of the overstuffed armchair in which she sits. This contrast extends to the opposing gestures of her arms, one upraised in the airy pose of a ballet dancer, the other, comfortably resting on her stomach. Paradoxical combinations of such qualities—modern and Paleolithic, lithe and overabundant, noble and mundane—are the constituent parts of Lachaise's contrary yet always high-spirited and affirmative work.

M.A.

Morris Louis
American, 1912–1962

Number 4–31, 1962 (cat. 34)

Few of the alternatives to the dominant Abstract Expressionist aesthetic of the 1940s and 1950s were as successful as the Color Field painting of Morris Louis. Living in Washington, D.C., and for the most part isolated from the New York art world, Louis pursued an independent course in strong opposition to the frankly gestural qualities championed by Jackson Pollock and Willem de Kooning, proposing—more in the spirit of Mark Rothko and Barnett Newman—a rich body of work based primarily on color. The artist's achievement in handling color is in great measure dependent upon his unprecedented technique, in which thinned acrylic pigment—rather than oil paint—was poured directly onto unstretched, unprimed canvas hung loosely over a tilted wooden framework, a method which allowed for no subsequent alteration of the work. The combination of radiant, intensified color, unencumbered by modeling or impasto, and a highly absorbent ground, freed the painting from the implications of shallow space and figure/ground bifurcation that had been the mainspring of post-Cubist abstraction.

Number 4–31 is a superior work of the so-called Stripe paintings, the last series the artist undertook before his death in 1962. As compared to his more Romantic paintings known as the Veils, these suggest that he was looking at the paintings of his Washington friend and colleague Kenneth Noland out of the corner of his eye. *Number 4–31* displays several shoots of color—ranging from khaki to lemon yellow—soaked into the weave of the canvas, vertically arrayed and wavering together like elongated flames. These deeply saturated colors are extolled while depth, texture, suggestions of movement, and allusion are expunged. In orienting color vertically, as John Elderfield has argued, Louis purposely "abandoned anything that would pull the eye laterally across the canvas, lest it slide too rapidly across the colors which compromise its subject,"[1] an arrangement which nonetheless was undertaken at the expense of losing the "epic" quality of his earlier works, the two series called the Veils and the Unfurleds.

A comparison between the Paley Collection *4–31* and the Museum's *Third Element* (fig. 28, p. 158) demonstrates how the greater number of colored striations produces a far more forceful composition, but also how much of the effect of a work depends on the particular color combinations. Moreover, much of the design of the Stripe paintings was not simply a matter of color choice and arrangement, but of cropping: the artist took great pains to determine precisely how much "breathing space" to give the paintings at the sides and top and at what point they were to be cropped at the bottom. The Stripe paintings reveal Louis's success in fusing light, color, and drawing so inextricably that it is virtually impossible to speak of one without also referring to the others.

M.A.

Aristide Maillol

French, 1861–1944

Two Women, 1900 (cat. 35)
Seated Woman with Chignon, 1900 (cat. 36)
Seated Nude, 1902 (cat. 37)

Aristide Maillol realized a new level of achievement in the formation of twentieth-century classicism, commencing shortly after Renoir had begun his series of Bathers and anticipating entirely the voluptuous nudes of Henri Matisse. Gauguin and Rodin were among the first to hail Maillol, and his sculpture can, in a way, be seen as an amalgam of their work.

Maillol originally intended to become a painter and attended the École des Beaux-Arts, where he studied under the academic painters Alexandre Cabanel and Jean-Léon Gérôme. His awareness of the work of Pierre Puvis de Chavannes and the Nabis—a circle of young artists who rallied under the banner of Gauguin's "Synthetism" and whose images insisted on symmetry and simplified modeling—made him increasingly discontent with what he felt to be the artificial predilections of the École. The most powerful influence on the young artist was the work of Gauguin: "Gauguin's painting was a revelation to me. The École des Beaux-Arts, instead of leading me to the light, had led me away from it. When I looked at Gauguin's pictures of Pont-Aven, I felt inspired by the same spirit which had prompted his work and I told myself that what I was doing would be all right once Gauguin approved of it."[1]

Gauguin was to do precisely that in 1887, urging him to rebel against what Maillol felt was his stifling education. Maillol's production thereafter consisted primarily of tapestries and paintings executed in a Gauguinesque manner. On occasion, he ventured into wood sculpture. Due to the increasing strain on his eyes, Maillol abandoned his work in tapestry design around 1900 and, nearing forty, turned exclusively to work in sculpture.[2] Shifting from wood to terra-cotta, his output quickly matured from hieratic and solemn figures into sensual and recumbent female nudes. His friend Édouard Vuillard enthusiastically urged the dealer Ambroise Vollard to see Maillol's work, and upon doing so, Vollard bought several pieces and had them cast in bronze, greatly easing the sculptor's financial situation and enabling him to work on an increasingly monumental scale.

Maillol's 1902 *Seated Nude* was produced during the year of his first one-man show at the Vollard gallery. The pose is based directly on Hellenistic Tenagra statuettes and its influence can be traced from classical antiquity through Michelangelo's *Night* and to the canvases of Puvis de Chavannes right up to the graphic and sculpted works of Maillol, where, with elaborate modifications, it appears again and again. Seeking beauty rather than character, Maillol eschews distracting particulars and focuses on the harmony of the mass, producing a

Seated Nude

Two Women

feeling of delicacy and chaste, quiet strength. Neither this nor either of the other two Paley Collection Maillols exhibits the highly stylized musculature of his monumental works and certainly none of the comparatively architectonic qualities of the works of the 1930s.

Maillol's lifelong obsession with the energy latent in stasis is evident in his *Two Women* of 1900. "For my taste," said the artist, "there should be as little movement as possible in sculpture . . . the more motionless Egyptian statues are, the more they seem to move about."[3] The balance of these two figures establishes a classical calm which belies the implied movement of their forward-thrusting combatants' stances. Just as Gauguin painted his Tahitian women with both Javanese and Egyptian art in the back of his mind, Maillol sought out models from Banyuls whose forms embodied the perfection of antiquity. His innate understanding of feminine grace resulted, however, in figures more clearly seductive than the Greek art he admired.[4]

Seated Woman with Chignon can be seen in relation to Maillol's *Mediterranean* (fig. 29, p. 159), which was received with great enthusiasm at the 1905 Salon d'Automne. Both works share the same general pose and the same recumbency, but the Paley Collection piece shows the model drawing even deeper into herself, and interest in the sensual surface of her torso is

Seated Woman with Chignon

suspended. While Maillol's primary interest throughout his career was that of the specifically female nude, he was nonetheless fascinated with the stratagems by which Greek sculptors treated clothing. His *Crouching Woman with Pointed Chignon* (fig. 30), apparently contemporaneous, shows a figure in an identical pose to the Paley Collection's small, careful *Seated Woman with Chignon*, but the exposure of her diminutive limbs lacks the confidence of her draped counterpart; she looks more naked than nude. The gown worn by the figure in the Paley piece clings to her torso with all the lightness of silk, but falls around her waist and thighs in heavy, deeply fluted folds of columnar mass. Consequently, the effect of the gown is not only to provide the figure with a greater sense of privacy and introspection but to successfully engender a quality of *gravitas*.

This Greco-Roman ideal of stability and poised beauty was central to Maillol's work; the key to his oeuvre is precisely the balance between quietude and muscular self-assertion. His nudes are antithetical to the idiosyncratic tensions and personal qualities of much twentieth-century figurative sculpture, which, taking its cue from Rodin, manifests detailed expressions of pathos, outrage, or grief. Maillol's figures live in an eternal idyll.

M.A.

Édouard Manet

French, 1832–1883

Two Roses on a Tablecloth, 1882–83 (cat. 38)

Though Manet was mortally ill in the winter of 1882–83, he summoned up the strength necessary to undertake one last remarkable series of paintings of which this exquisite work from the Paley Collection is an example. The painter drew solace from the visitors to his sickbed and inspiration from the bouquets given to him, transforming them into emblems of simple sensual delight.[1] Their scale is small—the present work is less than eight inches high—and Manet even asked the advice of a miniaturist while painting them.[2] They have none of the symbols or overt art-historical references Manet employed in his earlier still lifes of 1864–65 and are remarkably straightforward, bold in color and lively in handling.[3]

Nearly all of the other late still lifes (for example, fig. 31, p. 160) were conceived in a vertical format and with far more complex color schemes, invariably displaying groups of flowers—lilacs, tulips, pinks, and roses—in a huge, clear rectangular vase. The strength of the Paley Collection *Two Roses*, however, resides not in such affirmative declaration but in a muted, valedictory sobriety. No vase holds this pair of flowers; they are two, not a teeming, multicolored group; and their casual, horizontal arrangement suggests a greater passivity and quietude. Within this relative austerity, the lusciousness of Manet's brushwork and the close-valued hues seem even more articulated, less distracted by complex color arrangements. Rapidly yet confidently laid down, Manet's creamy impasto of peach and yellow and white captures the essence of the flowers—a beauty that is frankly acknowledged as ephemeral.

M.A.

Henri Matisse
French, 1869–1954

Lucien Guitry as Cyrano de Bergerac, 1903 (cat. 41)

Matisse may have begun this portrait of the celebrated actor Lucien Guitry (in the title role of the immensely popular *Cyrano de Bergerac*)[1] in the spirit of Courbet and Manet with the hope that such a genre picture would be more acceptable to the art-buying public than the complex, demanding work which had so far brought him neither approval nor sales.[2] But Matisse's more characteristic interests nonetheless come to the fore, and while the picture fails if taken as the kind of academic exercise that may have inspired him, it is a brilliant modernist transformation of the long-standing European tradition of actor portraits and carries unmistakable intimations of what soon became central to his mature work—the communication of sentiment through an analysis and representation of space and form primarily by means of color relationships.

Matisse's understanding of the spatial properties of color, and of the mutability of those properties through painterly application, unquestionably came from his impassioned study of recent work by Cézanne, as does the assertively constructional character of the brushwork. The bright strokes of tangerine, yellow, and russet which make up Guitry's piebald doublet and boots read as indicators of volume, yet their brick-like application asserts their resolutely planar quality. The unresolved face—neither a portrait of the notorious Guitry (fig. 32, p. 160) nor a representation of the legendary Cyrano—is the young artist's attempt to make the same kind of daring fusion of linear design and flat color that is the hallmark of Cézanne's late figure paintings, one of which the impecunious Matisse had only recently purchased.[3]

Matisse's mastery in creating volume without sacrificing the expressive qualities of pure color served him throughout his career, and the Museum's *Male Model* of 1900 (fig. 33) demonstrates how his almost obsessive fascination with Cézanne had begun. But while the solid, Cézannean treatment of the figure and the dominant *fin-de-siècle* blue tone of the earlier picture remain key components of his *Lucien Guitry,* the later picture, in turn, also anticipates the compelling color values that would be wrought by Matisse himself in just a year or two. The wild, arbitrary traces of purple and green in Guitry's face, for example, are wholly devoid of spatial reference, as is the expressive handling of the shadowy background which—split into vigorously brushed zones of blue, green, rust, and gray—relays no information about environment but instead energizes the picture and signals a manifestly new attitude toward surface treatment.

Edmond Rostand's *Cyrano,* conceived as a rejection of nineteenth-century theatrical realism, was premiered in 1898 and continued to be played with unabated success for decades. In deciding to treat a subject as conventional as a popular stage figure in such a determined and unusual new way, Matisse shares an odd kinship with Rostand's hero, who asserted that true elegance is based on probity, not foppery.[4] Disdaining pointless convention and dandified pomp, both of them embody an integrity lacking in the models against which they were wrongly measured.

<div align="right">M.A.</div>

Henri Matisse

Landscape, 1918 (cat. 42)

In December of 1917, Matisse returned to the Côte d'Azur, the region where he had, in the preceding decade, painted many of his most innovative Fauve pictures. After several winters in the north, during which he had incorporated aspects of Cubism into his increasingly austere work, Matisse was especially receptive to the radiant light of the south. Indeed, the brilliant, silvery light of Nice proved so much to his liking that he remained there, more or less, for the rest of his life. Almost immediately after he arrived, the character of his compositions was transformed: the darker, geometric aspect of his recent canvases was replaced by sinuous lines and—most important—a new luminescence.[1] Matisse's move to the south also coincided with, perhaps even prompted, his renewed interest in the work of the Impressionists: a correspondence he had begun with Monet in 1914 reached its height in 1917, just when Matisse began to visit the aging Renoir, who continued working, despite his infirmities, in nearby Cagnes.[2]

A large number of the Nice landscapes were painted in the Paillon Valley, often looking from Mont Boron or Mont Alban, and usually toward small villas or the Mediterranean coast itself (see figs. 34, 35, p. 161). In the Paley Collection *Landscape,* we are looking up into a copse of twisting hilltop trees which, silhouetted against the sky and leading to no distant vista, have a strangely quiet and isolated quality. That this work was painted *en plein air,* rather than being produced in the studio as many landscapes of this period were,[3] may account for its intimate scale and fresh application. The picture is saturated with the crystalline tones of gray and silver which Matisse felt to be synonymous with the environs of Nice.[4] These neutral shades highlight the several rich hues of green from which the picture is otherwise almost wholly constructed.

M.A.

Henri Matisse

Woman with Anemones, 1923 (cat. 43)

After moving to Nice in 1918, Matisse seemed to spurn many of the modernist advances he himself had fostered in the years before World War I. Flatness was replaced by recessional space, vivid colors became soft, his preferred environment the quiet interior, his chosen subject the solitary woman. *Woman with Anemones* is a delicate work of 1923 and, though modest, is representative of the artist's early Nice-period style. A sunny, decorative interior is governed by a rich silvery hue which unites smaller, subtler color harmonies of varying tones of turquoise, ocher, pink, and white. Modeling is kept to a minimum and the woman, whose face is mask-like and impenetrable, seems more a pretext for exploring muted color values than an occasion of psychological truth, as compared to say, Matisse's enigmatic *Woman with a Veil* of 1927 (p. 89).

The artist's fascination with arrangement and presentation is evident throughout the picture. The thin white curtain at the far right and the light blue wall framed by gray draperies at the back, for example, give a theatrical edge to a picture wherein almost every object is artfully positioned and displayed. The two paintings on the back wall—one a portrait, the other a floral still life—are carefully paired with their counterparts: the foreground sitter and the vase of anemones behind her. A small oval mirror next to the vase echoes the curve of the woman's armchair and gives the composition its nucleus. The saturated reds in the flowers, though isolated bright accents that lift the picture, are nonetheless easily absorbed into the prevailing silver tones.

M.A.

Henri Matisse

Odalisque with a Tambourine, 1926 (cat. 44)

Between 1920 and 1925, Matisse devoted most of his attention to the painting of almost suffocatingly rich interiors, elaborately crowded with wall hangings, potted plants, decorative screens, rococo furniture, and musical instruments, and presided over by an *odalisque*—a female, half nude, with "Oriental" clothing and accoutrements (fig. 36, p. 162).[1] Matisse's style in the early 1920s was well suited to these images of indolence and sensuality, having become softer, more atmospheric, and more "rococo" than it had ever been or would subsequently be. The lyrical yet powerful *Odalisque with a Tambourine,* however, signals a rude break in both form and spirit from the prevailing tendencies of his previous work in Nice.[2]

That the Paley Collection picture is a radical departure can be demonstrated by comparing it to a more typical painting of the same subject, title, and year (fig. 37) which shows the model gaily swaying before an elaborate North African screen on a Moroccan carpet. The linear rhythms of this picture and its sinuous, elastic balance of patterns and figure are nowhere to be found in the Paley Collection Odalisque; in the latter, the model comports herself with none of that self-abandoning coquettishness, but instead is seated in an angular pose that makes her seem more physically self-contained. One arm is up and cocked over her head, the other down and clasping her calf; her right leg is drawn up onto the seat of the chair, the toes hooked into the crook of her left knee, while the left leg is pressed against the picture plane and planted like a pike into the floor and framing edge. But the vitality and newness of the Paley canvas cannot be ascribed merely to the arrangement of the figure. The pose had, with varying success, been used for years—but never with such boldness, conviction, and enigmatic power.

Odalisque with a Tambourine traduces almost every expected aspect of its own motif by exhibiting a flagrant contradiction between the supposedly languorous pose and the treatment, which emphasizes throughout a vigorous muscularity. This tendency toward greater corporeality, decidedly pronounced in paintings of 1925–26, can be seen with equal vividness, though in a manner far more rococo, in the hypnotic *Decorative Figure on an Ornamental Background* (fig. 38), in which a similarly bold female form is set commandingly into an elaborately patterned environment.[3] This new insistence on mass is due almost exclusively to Matisse's rediscovery of sculpture, a medium he had all but ignored since 1912.[4] As it had at earlier junctures in his career, working in sculpture provided Matisse with solutions to the treatment of volume in painting; but more particular to the crisis years of 1925–26[5] was the culmination of the artist's seven-year obsession with the androgynous figures of Michelangelo. (Plaster casts of them were available for study at a local art school, and Matisse had moved a copy of the *Dying Slave* [fig. 39] into his studio in 1924.)[6] The indebtedness to Michelangelo—joined with a mercurial yet lifelong interest in Cézanne's construction of human form—is powerfully evident in the first major sculpture undertaken in Nice, the monumental *Large Seated Nude* of 1923–25 (fig. 40). The relation between this and the Paley Collection Odalisque is also vividly apparent; Matisse himself

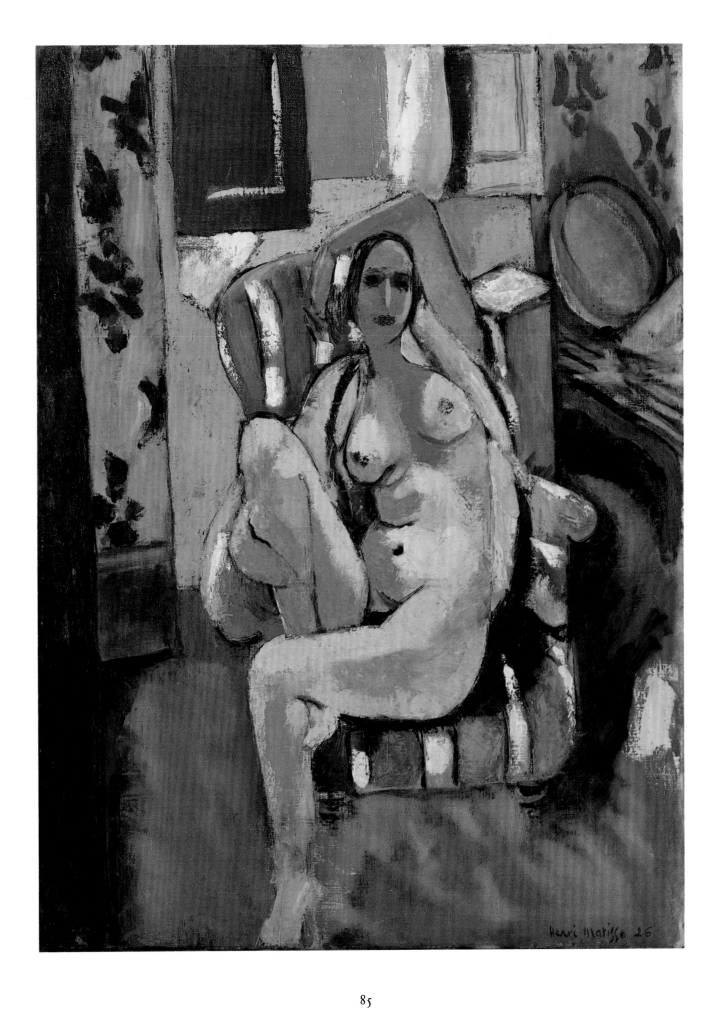

Detail of *Odalisque with a Tambourine*

found the two works so compellingly complementary that he displayed them in his studio side by side (fig. 41). Both the bronze and the canvas have as their immediate focus a long, resilient physique, the tautness of which denies the compliance implicit in the pose. The decorative lassitude of the preceding Odalisques has been replaced by a brute physicality.[7] The particulars of features such as the heads, the hands, and the feet are unencumbered by distinguishing features which would draw attention away from the unyielding stretch running from the lower knee up the torso to the elbow bent over the head.

But working in sculpture helped to transform more than simply the muscularity of the figure; weight and force have also been infused into other pictorial concerns. The biting, opaque hues of the *Odalisque with a Tambourine* belie atmospheric depth and the softness of the preceding Odalisques without sacrificing suggestions of luminous Mediterranean light; the dynamism of the modified Cézannean brushwork dominates vestiges of luxuriance while ridding the picture of fussy equivocations and anecdotal description. The face, for example, is given the kind of simplified treatment of a sculpted head and incidental information is denied: two single strokes form the planes along her nose, a third, darker shade her cheeks, and a deeply saturated daub of red is the mouth.

This rediscovered freedom to apply color with greater caprice is aided by the liberal use of black—which isolates and intensifies the individual colors—and by the abstract resonances of these shades throughout the composition: the acidic yellow and green of the armchair are echoed in the turquoise-green of the walls and the yellow on the left shutter; the flaming red of the rug has its counterpart in the band of the tambourine and the speckles on the model's open lavender kimono, itself picked up by small, vibrant touches beneath the model's left knee and thigh and in small flecks above her left foot. The back wall is a crazy quilt of colors—a small azure patch of sky seen through the open window, the closed brown and the open gray shutter, a white curtain, and the floral wallpaper, muted green on the right and tart turquoise on the left. The arbitrary treatment and geometric organization of the wall are unlike anything previously undertaken in Nice and, in a work centering on such a robust, athletic female figure, suggest that Matisse was determined to give this languorous motif the rigor often absent from his work since the end of the war.

Odalisque with a Tambourine is a daring and unique work, at once a crowning achievement and adamant repudiation of the theme of the studio nude. In confounding the acquiescence of the supine model, Matisse reveals the core of physical self-assertion which the greatest figural images of the West have traditionally acknowledged.

M. A.

Henri Matisse

Woman with a Veil, 1927 (cat. 45)

Despite Matisse's assertions to the contrary,[1] most of the women depicted during his Nice period are almost entirely subsumed by decorative considerations and accorded the status of accoutrements within his fanciful, theatrical environments. When William Paley bought *Woman with a Veil* directly from the artist, he was well aware that he was acquiring not only one of the most powerful images the artist produced in the 1920s but one which was strikingly anomalous in its forceful presentation of character.[2]

Woman with a Veil is the last major picture for which Henriette Darricarrère posed, Matisse's favorite and most imaginative model.[3] She is shown sitting in a brilliant peach and yellow armchair before a screen of indistinctly brushed blue and rose. The contours of the armchair seem to follow the curves of her body, which, firmly and centrally positioned, conveys a certain weight of authority. The solid colors of the chair enhance the airy, pastel patterns on the wall and separate them spatially and coloristically from the yellow diamond pattern which envelopes the woman, a pattern that draws its power from strong color opposites, a vigorous use of black, and sharp incisions of white.

Matisse had used the same foursquare format for portraits of forward-gazing women on various earlier occasions. When in 1913, for example, he was experimenting with aspects of "primitive" art, he showed his wife seated in an armchair and adumbrated with the symmetrical, simplified features of a tribal mask (fig. 42, p. 163).[4] Four years prior to the Paley Collection *Woman with a Veil*, at the height of his presentation of the female as coquette, Matisse painted Henriette as the demurely erotic *Odalisque, Half-Length* (fig. 43). The genial *Laurette* of 1917 (fig. 44) also gazes with her cheek resting on her hand, and the perspicacity of her character overrides any consideration that would reduce her to a pretext for stylistic innovation. But the amiable, Modiglianiesque linearity of this *Laurette*, the harmonious docility of its color and gentle handling, are polar opposites to the *Woman with a Veil*'s areas of raw, almost scarified surface, its combative hues and warring propositions of rounded volume and absolute flatness. More to the point, where *Laurette* is a series of graceful, serpentine lines, *Woman with a Veil* is a complex fusion of disparate schema, possessing both the clarity of a Periclean Athena and the contrariness of a Cubist guitar.

The focus of the Paley Collection picture is the woman's gaze. Indeed, much of the composition is built around her eyes; they are framed by the strongest, darkest lines in the picture, lines which Matisse seems to have borrowed indirectly from Cubism, traces of which he had largely banished from his work for almost ten years. Henriette's high forehead and pensive expression are locked into place by the strongly modeled plane of her face, overlaid with scumbled paint and a vortex of abstract lines, the most immediately arresting of which is the strange diagonal (to our left) which joins the top of the head to the plane of the face, abutting as it does a curving vertical line, representing the side of her head, and two scalloped lines—one that makes up the young woman's widow's peak and another, the ridge of her brow. A powerful horizontal lower edge frames the shadowy, abstracted veil and

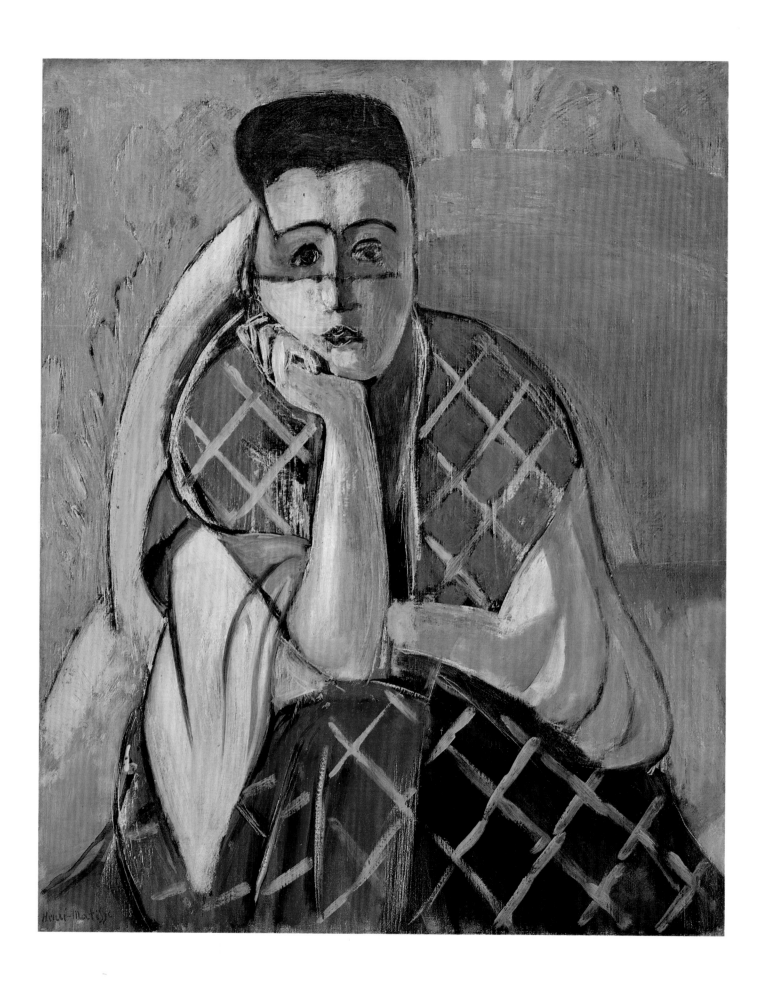

Detail of *Woman with a Veil*

unifies the otherwise disjunctive aspect of her eyes—one open and straightforward, the other slightly distracted, dreamy.[5]

No less conspicuous than these jolts of "Cubist" drawing is the imposition of a central core that coordinates the smaller parts with the overall composition. The scalloped line of the brow, which points down to the long, straight nose, is the crest of a massive, sculptural shaft aligning the nose and head to the wrist, forearm, and knee. About this central axis, several layers of richly scumbled colors have been laid down only to be scraped off and scratched out, repainted, then again carved with a palette knife, exposing a support as white as bone. This abrasive treatment of the surface is especially evident in the scratches that define the small particulars of her fingers or her lips, which, in disavowal of Matisse's roseate Odalisques, are a muddy black.

Despite its seeming immobility, the vast pyramidal bulk of the model is animated by an abundance of abstract design and jarring colors. The volumetric gray and flesh tones of her head give way to the flat quadrants and highly polarized hues of her gown: red on the left, green in the upper right, and, in the lower right, black. Imposed over these highly distinct areas is an arbitrary yellow diamond pattern which obliterates inferences of fold or depth and is interrupted by areas of white and gray which describe her full white sleeves. Again much of the surface is abraded and again there is a diagonal black line—the right upper arm as it comes out of the sleeve—which here joins foreground and mid-ground. The attempt seems not to unify form through light but to risk its dispersal through the use of dissonant color and contradictory depth cues.

Woman with a Veil can be profitably compared with Picasso's compelling *Girl Before a Mirror* of 1932 (fig. 45). Both images present the theme of intense scrutiny through quasi-Cubist constructs dovetailed with decorative feats of color and geometric patterning. But while Picasso anatomizes his figure's multi-layered sexuality as well as intimations of her psyche, Matisse refuses any such evisceration. Suggestions of Henriette's body and thought are shielded by a matrix of line and pattern so dense that the only salient feature of her persona remaining is the unrelentingly intense confrontation of her (paradoxically veiled) eyes. It is as if Matisse had decided to reverse his relationship with the model, so that he, and by extension the viewer, is now the object of *her* scrutiny. Set behind the scrim of a veil— a psychologically distancing and self-protecting device—her hypnotic gaze allows no entry. It is the revenge of the observed.

M.A.

Henri Matisse

Seated Woman with a Vase of Narcissus, 1941 (cat. 46)

This charming picture of 1941 unites several of Matisse's notable accomplishments in one of his favorite subjects. One need only compare *Seated Woman with a Vase of Narcissus* to the earlier image of a woman with a vase of flowers in the Paley Collection, the *Woman with Anemones* of almost twenty years earlier (p. 83), to see the variety Matisse could instill in this subject. Much of the charm of the picture depends on the mercurial pairings of its elements: fictive white flowers on the red screen behind the sedate young model are set against the printed black flowers of her dress; both are then counterposed to five huge and elaborate narcissuses showing white, red, black, and yellow (all colors found elsewhere in the room) and which are arrayed within a purple vase that also contains voluminous green trumpet vines. The geometry of the inanimate objects—the black floor tiles, overlaid with white diamond patterns, the flat rectangles of the red screen and yellow walls, the square pink and green table—balances the serpentine lines of the natural forms of the flowers, the fruit, and the woman.

Matisse's mastery of color, his daring use of black, and his series of imaginative pairings and oppositions transform this sedate motif into an image teeming with energy. They attest to his continued ability to compose a sensual yet intellectually engaging arrangement—to take a motif which he had used since beginning his career half a century earlier and invest it with new life.

M.A.

92

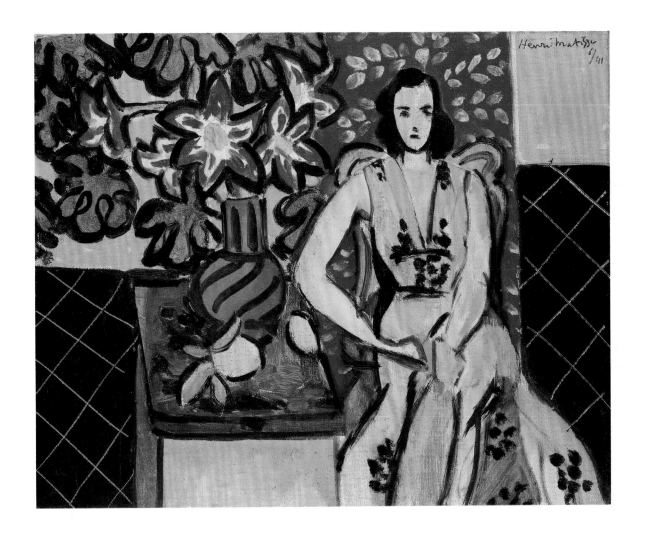

93

Robert Motherwell

American, 1915–1991

In Black with Pink, 1966 (cat. 48)

The expressiveness of Robert Motherwell's *In Black with Pink* arises largely out of its sheer painterliness. A band of creamy pink is laid on thickly across the upper zone and, though it is itself invested with intense gestural activity—flecks of black and violent scratches from the back of a brush—the band buffers the larger turmoil below in which white, gray, and blue are overlaid with strokes of black: imposing, gesturally spontaneous strokes characteristic of Abstract Expressionism but also reminiscent of Chinese calligraphy. To this Motherwell added a small, jagged scrap of blue paper, a delicate bit of whimsy to offset the otherwise tumultuous, monumental character of the composition.

Motherwell created a unique and compelling body of images by combining the spatial and coloristic traditions of European modernism with the American predisposition toward painterly gesture on an heroic scale. Whether in vast canvases or small, concentrated works on paper, Motherwell's art sought something of Matisse's pensive equation of color with space, and, at the same time, strove for the vital, immediate charge essential to the painters of the New York School.

M. A.

Kenneth Noland

American, born 1924

Sounds in the Summer Night, 1962 (cat. 50)

Kenneth Noland's sonorous *Sounds in the Summer Night* is a composition whose components—disks and rings set into a vaporous, ethereal blue—are deceptively simple. At a time when the often difficult, complex configurations of Abstract Expressionism set the standard against which all other abstract art was to be judged, the candor of Noland's paintings came as a blast of cool air, for they relied on symmetry, thin washes of color, and repetition, and steadfastly repudiated strong light/dark contrasts, impetuous paint application, and asymmetry.

Moreover, Noland and Morris Louis (see p. 71) strove to create images that would deny the implication (seemingly ever-present in paintings) that configurations, no matter how abstract, inevitably suggest entities existing within fictive space. These artists believed that the only space a work of art inhabits is the actual, ascertainable space of pigment and its support. By directly staining the canvas, both artists fused pigment and support and made color inextricable from surface; everything became a celebration of purified, unencumbered color. "The thing is color," said the artist, "to find a way to get color down, to float it without bogging the painting down in Surrealism, Cubism or systems of structure."[1]

But unlike the work of his friend Louis, Noland's compositions from the early 1960s have a centrality which rarely interacts with the framing edges, a pictorial decision the artist made after studying the works of Jackson Pollock. Said Noland, "After that allover painting that covers the whole surface, the only thing to do would be to focus from the center out—it is the logical extension—almost an inevitable result."[2]

Much of the impact of the august *Sounds in the Summer Night* comes from its scale. Indeed, the canvas appears not so much to frame a disembodied design as to encompass a field into which one gazes; its tactile qualities disperse into a concentric expanse and its coloristic qualities become increasingly attenuated as they radiate away from the roseate center, passing through olive and kelly green, shades enclosed by a more gesturally brushed fog of blue within a finer, vaporous blue that stops short of the framing edge.

Compared with the Museum's *Turnsole* of 1961 (fig. 46, p. 165), this canvas gives some indication of Noland's inventiveness in what might appear to be a restricting format. In the Paley Collection painting, the blue mist runs, though waveringly, parallel to the frame, whereas the "rings" of *Turnsole* have no such buffer and interact more baldly with the framing edge. The Paley picture generates a greater centripetal concentration and this in turn allows for a more buoyant celebration of both the pulsating color and lightness for which the painter is best known.

M.A.

96

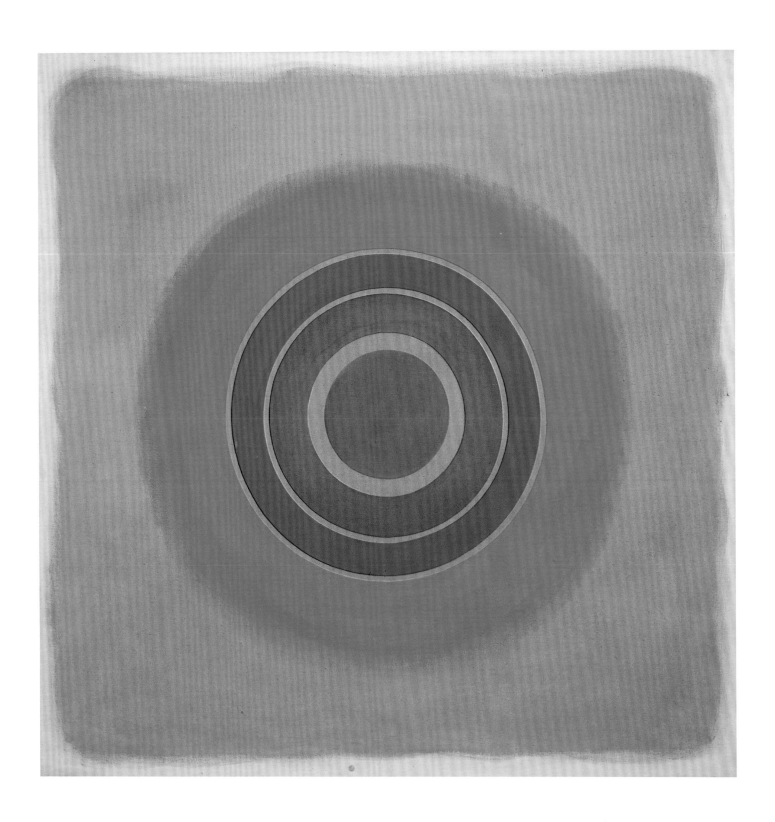

Pablo Picasso

Spanish, 1881–1973. To France 1904

Boy Leading a Horse, 1905–06 (cat. 53)

Unlike such aesthetically broad terms as "Cubist" or "Surrealist," the appellation "Rose Period," by which Picasso's works of 1905–06 are normally characterized, refers only to the prevailing tonality of the pictures. In common with Picasso's pictures of the immediately preceding "Blue Period," these works are governed by a *fin-de-siècle,* quintessentially Symbolist principle: that of unifying the painting by a single dominating hue, which sets its mood. Picasso's gradual substitution of rose for blue in this role in the work of winter 1904–05 reflected, broadly speaking, a shift from pessimism to optimism[1]—an optimism that would gradually permeate every aspect of the painter's subject matter and style. In the first instance, the change bore witness to a happier life—his love for Fernande Olivier,[2] and his initial financial success.[3] But it also signaled, especially in the picture we are considering, his increasing awareness of his own singular power and authority as a painter. *Boy Leading a Horse,* both as image and painting—that is, in its subject matter as in its pictorial realization—is Picasso's monumental paean to the theme of mastery.

The sense of dejection and forlornness that pervades Picasso's Blue Period begins to be challenged in early 1905 as the tonality of his pictures brightens. The circus people, who dominate his subject matter of those months, seem at first unaware of the change overtaking them. While no longer shown as social outcasts, these entertainers nevertheless display a wistful, passive air as they are discovered in the isolation of their backstage world. By the fall of 1905, however, this same cast of performers—one of whom would provide the principal source for the majestic and classicizing *Boy Leading a Horse*—have moved from their tents into the arena, from the passivity of private melancholy and contemplation to the activity of rehearsal and performance. As this happens, more than just the tonality of the pictures changes: compositions become bolder and simpler; drawing becomes firmer; physiologies and psychologies shed their lassitude.

Nothing better illustrates the contradictions of this transition in later 1905 than *Boy with a Pipe* (fig. 47, p. 166), which started out as a languidly poetic reverie. It also happens to provide our first important image of the actual Parisian *gamin* (remembered years later by Picasso as "P'tit Louis")[4] who would ultimately become the boy that leads the horse. *Boy with a Pipe* remains essentially Symbolist in its mood of nuanced sensibility and *ennui.* The boy's blue circus costume implies a surrogate for the artist's smock (Picasso continually analogized performer and painter as magicians of visual fascination), and he is crowned with a laureate's wreath of flowers that seems almost to have materialized out of the pastel Redonesque bouquets of the background wallpaper.

These Symbolist qualities belong to the "soft" phase of Picasso's Rose Period style of 1905. But *Boy with a Pipe* also contains some discordant notes that betray the transitional spirit of late 1905, traits which anticipate a second, more classicizing phase of the Rose Period in 1906. Rather than the sort of sensitive, languorous facial expression modeled with

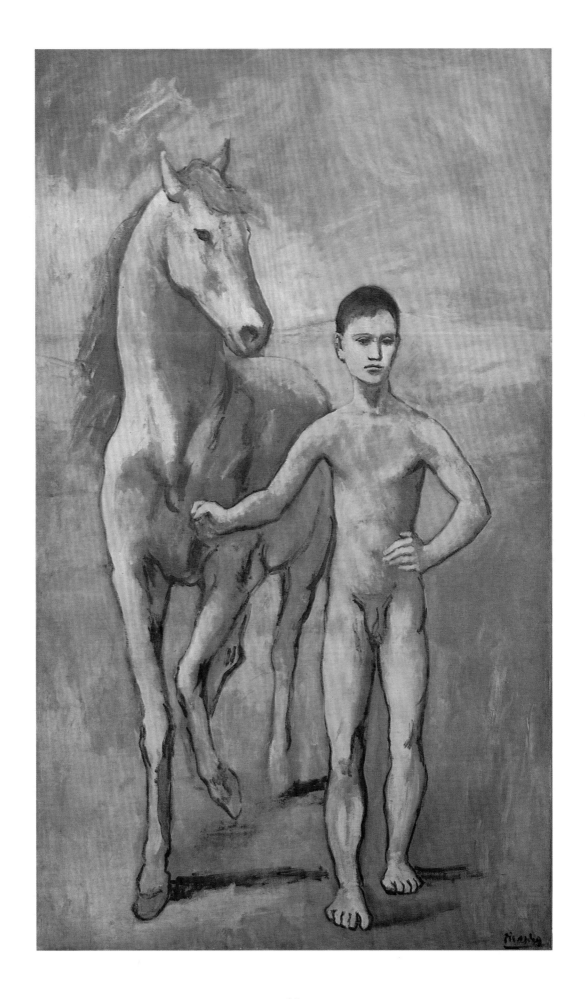

Detail of *Boy Leading a Horse*

soft shadows that the picture's broader aesthetic would lead us to expect—a visage in the spirit of Puvis de Chavannes or Redon—Picasso portrays the boy's face very sculpturally through a raw kind of relief that gratingly sets it off from its nuanced Symbolist background. He also endows P'tit Louis (whom he later characterized as a "delinquent")[5] with a notably contentious expression, as if visualizing himself in the role of a scamp or doubter through this boy. Indeed, the *mèche* of hair hanging down over Louis's forehead alludes to this personal identification, for it was a central feature of Picasso's own appearance. Coupled with the motif of artist-as-laureate, the *mèche* confirms that we are not wrong in taking the subject of *Boy with a Pipe* as Picasso's surrogate, as one of his many personas. This proposition is further reinforced by the most discordant note of all, the pipe which Louis holds—a property that belongs less to otherworldly Symbolist laureates or circus people than to Picasso's studio (he was an avid pipe aficionado and collector).[6] P'tit Louis's facial expression, in combination with the "proto-Cubist" motif of the pipe, suggests that, consciously or not, the artist is instinctively signaling the end of his patience with Symbolist morbidity, sensitivity, and over-refinement. Henceforth, he will be less "poetic"—more robust and direct.

Boy Leading a Horse was adapted from the central motif of an unrealized mural-size project of 1905–06 called *The Watering Place* (fig. 48). Here Picasso had transported into a remote pastoral Arcadia, probably inspired by Gauguin's *Riders on the Beach* (fig. 49), the figures and horses associated with the circus environment of the previous year.[7] The project may well have been intended, both in its particular spirit and its ambitiousness, as a competitive riposte to Matisse's Golden Age image *Bonheur de vivre*, completed early in 1906.[8]

We can identify the germination of what was to become the central motif of Picasso's large project in a watercolor that shows a young female circus rider on a white horse which turns toward a standing young boy whom we recognize immediately as P'tit Louis (fig. 50). Louis's right arm is bent and the hand is over his heart; his left arm is also bent with that hand on his hip, a positioning which would survive into the Paley Collection picture. *Boy and Horse* (fig. 51), a watercolor executed not long after, advances the motif toward its assimilation into the pastoral *Watering Place* project by both suppressing the female rider and much foreshortening the horse's body; the placement of the animal's legs now suggests a virtually frontal view, which may well have been prompted by Picasso's recollections of El Greco's *Saint Martin and the Beggar* (fig. 52).[9]

Two important further changes in the motif occur in a pencil and watercolor drawing (fig. 53) of the boy and horse that is clearly contemporaneous with the first of two extant studies for the entire composition of *The Watering Place*, a watercolor formerly in the Alain de Rothschild collection (fig. 54). Most important here is that the boy is no longer in his circus costume—the nudity that displaces it accords with the "classical" atmosphere of the large project—and his right arm is raised to stroke the neck of his steed. Some time following the watercolor study for *The Watering Place*, Picasso refocused on its central motif, destined to become the Paley Collection picture, and made two crucial changes. In

two new drawings (figs. 55, 56), the boy no longer turns to stroke the horse, but strides determinedly forward, his right arm now stretching horizontally as if leading the horse by the reins.

At this point Picasso seems to have had some doubts about the overall composition of *The Watering Place*. As he had first conceived it (in the watercolor sketch, fig. 54), the foreground contained four nude boys (two standing, two riding) and three horses. Probably sensing an emptiness on the left, Picasso now introduced there a foreshortened rider seen from behind, a counterpart to the motif seen on the left of Gauguin's *Riders on the Beach* (fig. 49). In Picasso's first rendering of the composition with this new rider, however, the motif is placed almost in the picture plane, where, cut off by the lower framing edge of the picture, it functions as a spatial *repoussoir* (fig. 57). Shortly afterward, nevertheless, in both the definitive gouache study for *The Watering Place* (fig. 48) and in the etching based on that study (fig. 58), Picasso pushed this motif further into the space of the picture, to a depth roughly comparable to where it is in the Gauguin.

For reasons we do not know—perhaps some dissatisfaction with the composition of *The Watering Place*, perhaps an unwillingness to take on an enormous and time-consuming canvas at a moment when his style had begun rapidly to change—Picasso abandoned his horizontal multifigure project in favor of isolating its central motif in the form of *Boy Leading a Horse*, the grand scale of which probably measures the enormous ambition of the original *Watering Place* project. In any event, by isolating his main motif, Picasso not only focused in more sharply on the characteristically classical theme of mastery (mind over body through the metaphor of man over animal), but, by eliminating most of the anecdote of the scene, was also able to confirm a shift away from his heretofore storytelling mode in favor of a more frontal, isolated, and hence almost "iconic" presentation.[10]

The classical, more sculptural turn that Picasso's art was taking in early 1906 was in part influenced by Cézanne, thirty-one of whose paintings had been exhibited in the Salon d'Automne of 1904 and ten more at that of 1905. The rhythm of pairings and subgroupings of figures with horses, seen afoot or astride and from front and behind in *The Watering Place*, recalls some compositional devices in Cézanne's male Bathers. And the monumentality and plastic intensity given to P'tit Louis as he appears in *Boy Leading a Horse*—the sense of inwardness, and the projection of overriding will in the determined stride with which he possesses the earth—are Cézannean in spirit. Picasso's elimination of anecdote combines with the multi-accented "broken" contouring in the drawing further to evoke the world of the Master of Aix, especially as we see him in the monumental *Bather* (fig. 59), which Picasso doubtless saw in his visits to the dealer Ambroise Vollard's famous *cave*.[11]

But Picasso had also been looking at ancient Greek art in the Louvre, and under this influence he showed himself increasingly responsive to the kind of revelatory gesture that is the particular genius of classical sculpture. In the Baltimore Museum's study (fig. 55), in which Picasso introduced the motif of the boy leading (as against stroking) the horse, P'tit Louis's gesture is at first read as extending an arm to hold the reins or bridle. (Gauguin had

used a related motif for *In the Vanilla Grove, Man and Horse* [fig. 60], and Picasso also no doubt remembered it from the frieze of the Parthenon [fig. 61], from a plaster of which he had made drawings as a fourteen-year-old art student.)[12] The sketchiness of the Baltimore study might lead us to believe that the reins and bridle *implied* by the boy's gesture were omitted as being needlessly detailed. When, however, we perceive that in the monumental Paley Collection painting there is also no sign of these accoutrements, we realize that Picasso is up to something very different. He wants us to feel that the boy's gesture is of such sheer authority that in itself it almost magically compels the horse to follow. This "laureate gesture," as Meyer Schapiro has called it, draws attention by analogy to the power of the artist's hand.[13]

The almost shamanistic power of P'tit Louis's gesture is, then, an extension of his role, first seen in *Boy with a Pipe*, as the artist's surrogate. The allusion there to the classical laureate's wreath can be seen to be linked to the frontal, forward-stepping posture of Louis in *Boy Leading a Horse* to the extent that this latter motif has affinities with the Archaic and early Classical *kouroi* (fig. 62), such as Picasso had seen in the Louvre and probably knew through plaster casts as a student. These sculptures of idealized striding male nudes were given as prizes to the laureates, the winners of the ancient Olympic games.

Picasso's interest in classicism at this time was probably stimulated by the views of Jean Moréas, a leader in the neoclassical literary movement that developed out of, but finally reacted against, Symbolism. Moréas was a regular, along with Picasso's poet friends Guillaume Apollinaire and André Salmon, at the soirées the painter attended Tuesday evenings at the Closerie des Lilas. No doubt also influential for Picasso at the time was the dry, fresco-like palette of the Symbolist neoclassicist Puvis de Chavannes, whose work was featured along with that of Cézanne in the Salon d'Automne of 1904. But whatever affinities Picasso's work may have had with Puvis's in 1905 or earlier,[14] it is clear that with *Boy Leading a Horse*, his classical vision has been imbued with a personal and very characteristic *arête* that is entirely unvitiated by the *douceur* and nostalgia of Puvis's "rose-water Hellenism."[15]

Boy Leading a Horse expresses metaphorically Picasso's mastery of his natural creative forces. In it, he no longer makes concessions to charm. The shift of emphasis from the sentimental to the plastic—which anticipates Picasso's remarkable development during the year following—is heralded by a mutation of the Rose tonality to one of terra-cotta and gray, which accords well with the new sculptural character of the motif. Boy and horse are isolated in a kind of non-environment, which has been purged not only of anecdotal detail but of all standard cues to perspectival space. The rear leg of the horse dissolves into the back plane of the picture, and the background is brought up close to the surface by the bravura painterly effects in the upper regions of the canvas (see detail). As it embodies the power of gesture, this magnificent scumbling of the paint is in a sense a literalization of the motif's significance as a whole.

W.R.

Pablo Picasso

Nude with Joined Hands, 1906 (cat. 55)

In May 1906, a month or two after painting *Boy Leading a Horse,* Picasso left with his mistress Fernande Olivier for a trip to Spain. A few weeks were spent with the artist's family and friends in Barcelona en route to the Pyrenees village of Gósol, near the little border nation of Andorra, where Picasso and Fernande intended to pass their summer. The trip was very arduous, for though most of the distance from Barcelona to Gósol could be traversed by train, the last fifteen kilometers had to be negotiated on mule back. In Gósol, until their sudden departure in late summer following rumors of a cholera epidemic, Picasso and Fernande enjoyed what proved to be their most idyllic vacation. In the isolation of this primitive village, where Picasso was free from the constant interruptions of his many friends, the painter focused on his work with an astonishing intensity, turning increasingly to Fernande as an inspiration for his imagery.

Nude with Joined Hands is one of the many, highly variegated images inspired by Fernande that Picasso executed during the Gósol sojourn. The heroic mood of *Boy Leading a Horse* gives way here to a more intimate and lyrical classicism. The linear refinement with which he indicates the features of the face reflects, in the first instance, his interest in the neoclassicism of Ingres. But the high degree of simplification and abstraction probably also bears witness to Picasso's love of line drawings on Classical and Archaic Greek objects—especially those inscribed on mirrors and other decorated paraphernalia of the *toilette*—which he had been studying in the Louvre.

The pose for *Nude with Joined Hands* was studied in an exquisite conté crayon drawing (fig. 63, p. 168) and in a small oil study (fig. 64), the latter showing that Picasso had originally conceived of silhouetting his nude within the shadow of an arched doorway. In these studies, as in the definitive work, which was acquired almost immediately by the Steins (Gertrude keeping it for the rest of her life), Fernande is shown in three-quarter perspective stepping forward toward the viewer. The motif of the joined hands produces an impression of psychological enclosure and distancing, thus reinforcing the detachment expressed in the archaizing, almost orientalized visage.

The execution of *Nude with Joined Hands* is notable for the shimmering, almost watercolor-like transparency of the flesh tones and the background. The refinement and delicacy of the nude body make its materiality virtually melt away, seeming in places almost to fuse with the background, unseparated by a defining contour or, as in Fernande's right foot, slipping into the *non finito*. This supremely nuanced rendering projects onto Fernande an air of ineffable fragility. Her personality is finally communicated more by such formal aspects of the execution than by the depiction of her face, which is almost mask-like in its stylization. In that respect, it anticipates the more sculpturally mask-like visages Picasso made of her near the end of the Gósol stay (fig. 65). These, in turn, led directly into the dramatic repainting of the head in Gertrude Stein's portrait (fig. 66), which Picasso would rework from memory when he returned from Gósol.

<div align="right">W. R.</div>

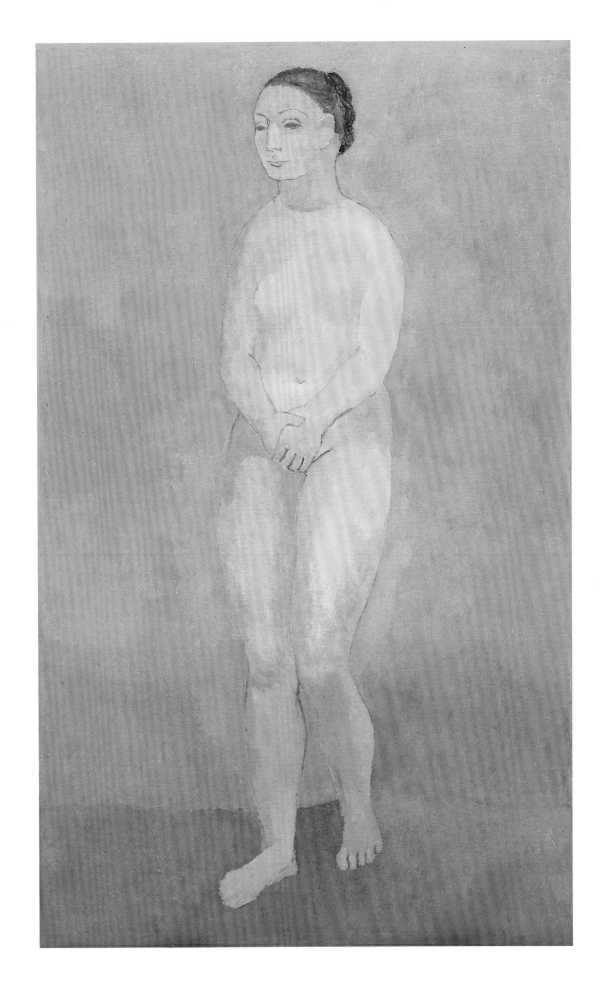

Pablo Picasso

The Architect's Table, 1912 (cat. 56)

This is one of the concluding masterpieces of the period spanning summer 1910 and spring 1912, during which Picasso and Braque, who were then working closely together, developed the style referred to as high Analytic Cubism. These paintings are difficult to read, for while they are articulated by the planes, lines, shading, space, and other vestiges of the traditional language of illusionistic representation, those constituents have been largely detached from their former descriptive functions. Thus disengaged, they are reordered to the expressive purposes of the pictorial configurations as autonomous entities.

This impalpable, almost abstract illusionism is the final stage of Cubism's metamorphosis from a sculptural into a painterly style, which had begun in 1910. In that year, the sculptural relief characteristic of Picasso's 1908–09 pictures began to dissolve, becoming, in works like *The Architect's Table,* a fabric of flat, shaded planes—often more transparent than opaque—which hover in an indeterminate, atmospheric space shimmering with tiny, almost Neo-Impressionist brushstrokes. If this seems finally a shallow rather than a deep space, it may be because we know it accommodates the painterly detritus of earlier Cubism's solid relief.

While the light in early Cubist paintings did not function in accordance with physical laws, it nevertheless alluded to the light of the real world. By contrast, the light in *The Architect's Table* and other high Analytic Cubist pictures is an internal one, seeming almost to emanate from the objects that have been pried apart. Accordingly, the term "analytic" must here be understood in a poetic rather than scientific sense, for this mysterious inner light is ultimately a metaphor for human consciousness. The Rembrandtesque way in which the spectral forms emerge and submerge within the "selective" lighting of the brownish monochromy, and the persistently searching, meditative spirit of the compositions, contribute to making these paintings among the most profoundly metaphysical in the Western tradition.

The degree of abstraction in *The Architect's Table* is about as great as it will ever be in Picasso's work, which is to say that while the picture approaches non-figuration, it maintains some ties, however tenuous or elliptical, with external reality. Let us inventory some of its motifs. Traversing the picture from the upper left is the carpenter's square that led Kahnweiler to name it *The Architect's Table*;[1] the "architect" is, of course, Picasso, and the remainder of the iconography is more familiarly his. Below the square is a liqueur glass paired with a bottle of Vieux Marc. To their left is the slightly truncated inscription MA JOLIE, above some lines of the musical staff; both are superimposed upon an album of music that has been folded open. Lying on this album is a pipe, and below, toward the bottom of the painting, emerges the horizontal edge of a table with a tassel-fringed runner. (The scroll-form just above is the terminal of the arm of a chair.) Lying obliquely on the table, at the lower right, is a calling card on which Picasso has written MIS [*sic*] GERTRUDE STEIN in script letters—a reference to a visit by Stein which found Picasso absent.[2] Toward

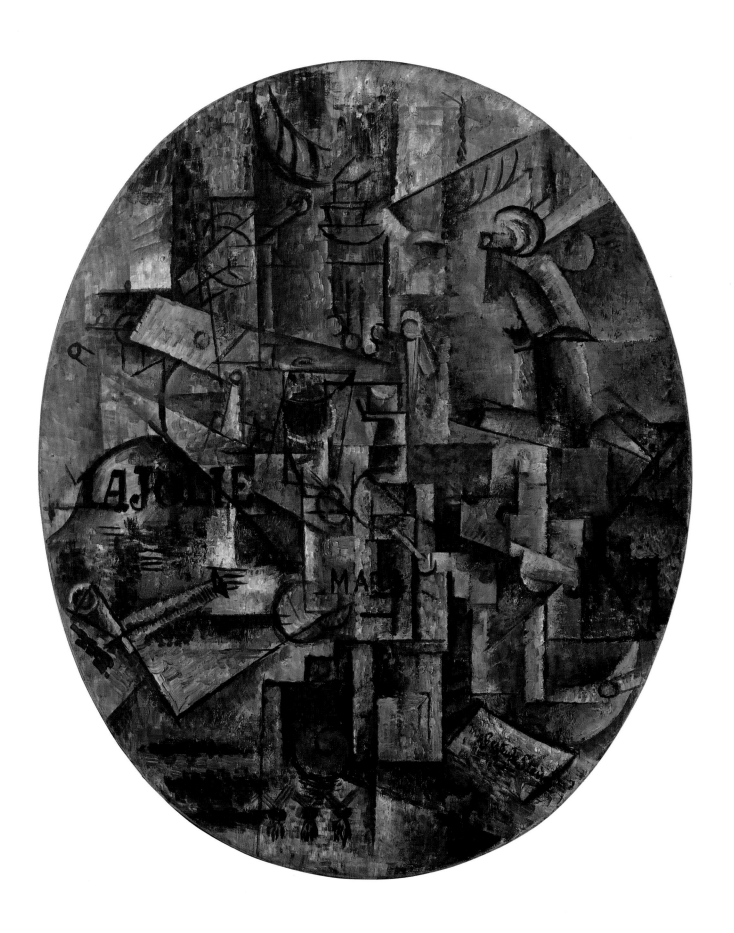

Detail of *The Architect's Table*

the top right of the field, below the fragment of a picture frame, are the scroll and peg of a stringed instrument; like the transparent linear mechanisms at the upper center and left— whose identities and whose locations in space remain ambiguous—this fragmentary instrument resembles the fantastic, often anthropomorphic constructions that Picasso began to imagine around this time (fig. 67, p. 169). The rope tie-back of a curtain at the upper left does not look out of place amid this weird machinery.

The oval form of *The Architect's Table* facilitated a centralized composition whose "fading" or dissolution at the edge would be equal on all sides of the composition, thus overcoming what Braque referred to as "the problem" of the corners.[3] The oval also enhanced the development of a compositional web that could be set floating in a weightless way, rather than being anchored to the bottom of the frame. That configuration, which was carried somewhat further by Braque than by Picasso, was the last major innovation of Analytic Cubist painting prior to the inventions of collage and *papier collé*, which brought about Synthetic Cubism.

Partly to draw attention by contrast to its luminous space, and thus reconfirm this highly abstract art as one of illusion, Picasso followed Braque in placing large trompe-l'oeil printed or stenciled letters on the surfaces of many pictures of this period.[4] Such frontal letters are sometimes handled so as to appear as silhouettes "on top" of the picture plane, neither moving in the space of the picture nor subject to its light, both of which are felt to be behind them. "They stop the eye at the literal plane . . . the imitation printing spells out the real paint surface and thereby pries it away from the illusion of depth."[5]

"Cubism," as Picasso observed, "is an art dealing primarily with forms." But its subjects, he added, "must be a source of interest." Lettering plays a crucial role in communicating these, and its often witty references to external reality relieve the pictures' formal asceticism. The words MA JOLIE, for example, are from the refrain of a popular song of 1911,[6] but they were also a reference to Picasso's new companion, Marcelle Humbert (known as Eva), about whom he wrote to his dealer Kahnweiler that he loved her very much and would write her name on his pictures.[7]

Speaking late in life of the transformations of motifs in this picture, Picasso observed that he probably could not have identified the point of departure in reality for all its shapes even at the time it was painted—and certainly could not in retrospect. "All its forms can't be rationalized," he told this author. "At the time, everyone talked about how much reality there was in Cubism. But they didn't really understand. It's not a reality you can take in your hand. It's more like a perfume—in front of you, behind you, to the sides. The scent is everywhere, but you don't quite know where it comes from."[8]

W.R.

Pablo Picasso

The Guitar, 1919 (cat. 57)

The range of Picasso's paintings between 1918 and 1921 reveals an uncanny ability to pursue strikingly distinct styles simultaneously. An object that would one day be described by the graceful yet inflated contours with which the artist at once celebrated and mocked the pretensions of neoclassical art would be treated the next in a variation of the penetrating, dismembering language of Cubism.

Though it retains the sharp edges and flat planes of Synthetic Cubism, the Paley Collection *Guitar* of 1919 is larger, lighter, and infinitely more readable than were most of Picasso's prewar Cubist compositions. The bifurcated guitar which dominates the painting is represented by a central oval divided into two chalky zones of pink and blue; a white trapezoid forms its sound hole, and the strings are white in the pink zone and black over brown in the blue, a configuration echoed at the instrument's neck; the head is itself bisected into blue and white halves. To the right of the guitar is a bottle with its label forward, to the left, a sheet of music; at the top, a small piece of picture molding cunningly suggests a fictive frame. Color can help identify other elements: the table is blue, the elusive tablecloth is red, the plush rug beneath the ensemble is yellow. The scaffolding of this composition is concentrated on the lower half of the picture, however, despite the fact that here the building blocks of color are smaller and layered with greater complexity than at the top. The piling-up of contradictory depth cues, suggestions of space, and the proliferation of small, dancing components nonetheless help balance the guitar between the upper and lower halves and the larger and smaller units of color.

The guitar had occupied a central role in the work of Picasso since his Blue Period in the first years of the century. It held a kind of totemic significance for the artist, at times appearing as the symbol of his native Spain and at others as a surrogate female. In its Cubist incarnations, however, the guitar was generally chosen for its visual complexity: the endless number of combinations in which Picasso could render its curves and straight lines, solids and voids, and the elaborate and peculiar details of its strings, pegs, frets, and sound hole made it the Cubist object par excellence and a focus for some of the most startling revisions in the history of representation.

M.A.

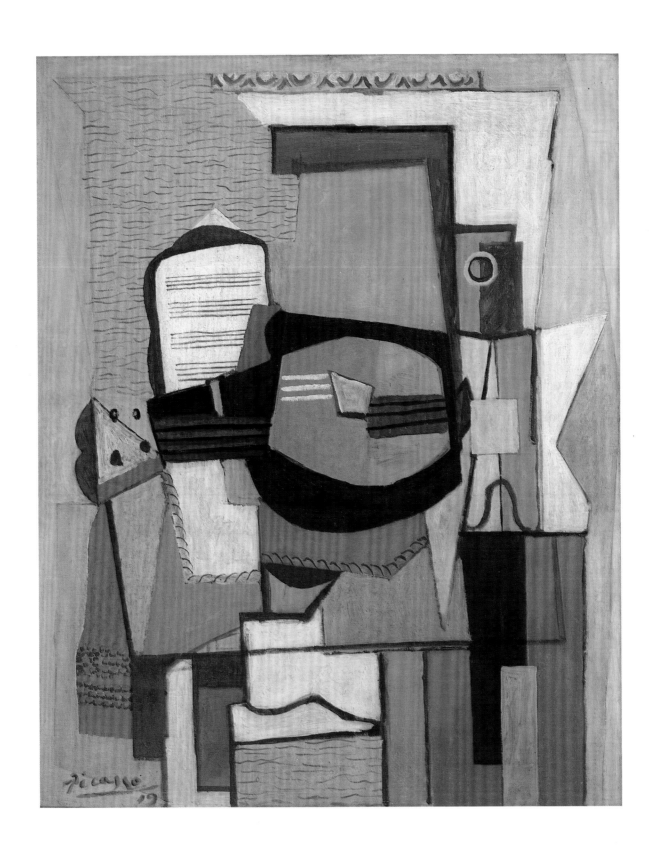

III

Jackson Pollock
American, 1912–1956

Untitled, 1944 (cat. 59)

"Pure psychic automatism," the imperative of European Surrealism, took on a primal, unbridled quality in America exemplified well by this small work on paper by Jackson Pollock. Unlike his more frankly illustrational ink drawings of the same year, the present work shows Pollock's leap into the "sacred disorder" of a peculiarly American, abstract Surrealism. It still retains Masson-like wisps and densely interweaving forms that carry vestigial representational allusions—what the artist called "veiled" references to the world. But its seemingly random distribution of forms and indeterminate suggestions of depth and solidity—while based on late Cubist drawing mingled with the gestural qualities of the major Surrealists, and encapsulating the American response at mid-century to European modernism—carry within them the seeds of Pollock's subsequent monumental "drip" paintings.

After his first public exhibition, in 1943, the next year was a transitional one for Pollock, as his work became increasingly abstract and calligraphic. In his small works on paper, drawing with the brush was especially useful; it allowed him to avoid the more linear, depictive qualities seemingly inherent in pencil or pen, and the ink could be applied to the ground with far greater freedom. For example, this fluent, animated work is composed without a dominant axis and is balanced by the heavy overlay of black arabesques encircled by swarming hieroglyphs of both black and white and thin washes of lime green and orange. The small double-circle shapes stamped across the surface were made by applying some handy object directly to the paper, much the way Pollock came to jam bits of studio detritus into his oil paintings at about the same time.

M. A.

Odilon Redon
French, 1840–1916

Vase of Flowers, 1914 (cat. 60)

For twenty years, until the early 1890s, Odilon Redon worked almost exclusively in black and white, primarily in charcoal on paper, or in the medium of lithography. Black and white, the "colors" in which most people dream, seemed to him the natural vehicle for an art of fantasy, which Redon encouraged, as he said, by "docilely submitting to the arrival of the 'unconscious.'" The soft edges of depicted things, as they were formed by drawing and rubbing soft charcoal into the paper, gave a characteristically Symbolist and peculiarly Mallarméan imprecision to Redon's imagery. (Mallarmé had spoken of liking "to see the world through a veil of smoke.")

With the arrival of color, Redon's art tended to become less phantasmagorical, its imagery provoked more perhaps by reverie than by dreams. The extreme of this seeming disengagement of Redon's painting from "unconscious" fantasies was marked by a series of floral still lifes, executed in the last six years of the artist's career, of which the Paley Collection picture is one of the most exquisite. The artist's inheritance in 1910 of a country house outside Paris played an important role in this. There Redon's wife cultivated an extensive garden from which she continually made floral arrangements that served him as motifs.

Set against the context of Redon's entire career, of an iconography that had been largely dominated by monsters, surreal hybrids, and mythical figures, the floral still lifes appear to us as virtually realistic. But the more we contemplate them, the more they seem to evoke a world with a spell on it. Redon's flowers "float in strangely disembodied and exotic harmonies of brilliant, jewel-like color so utterly intense as to seem artificial," writes John Elderfield. "The powdered pollen of the pastel realizes their fragile delicacy but is also the medium of their separation from the natural world."[1] Though picked by Mme Redon from real flower beds, the blossoms have been so transfigured by her husband's palette and the evanescence of the pastel medium that they seem to have been plucked from Klingsor's magic garden.

W. R.

Pierre-Auguste Renoir

French, 1841–1919

Strawberries, c. 1905 (cat. 61)

Nowhere is the pervasive optimism of Renoir's late work more subtly handled than in the still lifes he produced at the turn of the century. Works such as the Paley Collection *Strawberries* combine the buoyancy characteristic of his female nudes and the jubilance of his vibrant Impressionist landscapes with more refined touches of color in a modest, straightforward fashion. In fact, when the artist has included still lifes within his larger figural compositions, their seeming effortlessness and fluency has led at least one critic to observe that the best of his late work is "concentrated in the roses, peaches and berries that cluster along the edge of his canvases."[1]

The elegant informality of this small, simple arrangement is especially refreshing given Renoir's tendency toward elaboration and intricacy. The painter here suspends many of the strong light/dark contrasts used so often in the late still lifes and, by limiting his colors, is able to orchestrate a scintillating interplay between the fresh, moist, red berries and their green serrated leaves, and between the loose arrangement of the fruit (and the squat, sober little teacup) and the mild suggestions of regularity in the creases of the white linen upon which they rest. The strong color opposites of the strawberries are shown in contrast to the dainty accents of color in the milky blue and crimson line of the little china cup. And all of these small round objects are then played off against the flat wall of the background, a gentle wave of subtly modulated tones of beige, ocher, and silvery grays. The result is an arrangement far less crowded, less busy, than is another 1905 *Strawberries* (fig. 68, p. 170).

Though the febrile brushwork and elaborate composition he often used were growing more and more infrequent, at the same time he also resisted the rigorous structure and *gravitas* that were essential to the contemporaneous work of Cézanne. The compositional use of color was for Renoir—unlike Cézanne—devoid of analysis of the structural underpinnings of perception or a clear comprehension of volume. Renoir's still lifes are, instead, embodiments of lightness and seeming evanescence, of the poetry and gaiety of color.

M. A.

Georges Rouault

French, 1871–1958

The Clown, 1907 (cat. 66)

Artists have often invented or adopted surrogate forms through which to express themselves. For van Gogh, it was the sunflower, for Picasso, the minotaur or harlequin. The alter ego of Max Ernst was Loplop, a fantastic Surrealist bird. Georges Rouault presented himself through a more meager persona: a scrofulous, much abused street performer, a nameless, ragged clown.

This work dates from about 1907 and is among the first of Rouault's highly volatile close-up images. The tragicomic expression of the clown is revealed through the slashing black ribbons of brushstrokes—many of which never resolve into any specific physiognomic features—and vigorous touches of inky blue and red. The background, too, heaves with Sturm und Drang: it is an assault of scumbled, mottled colors, of scrubbed and precipitously applied paint. Compared to other clown pictures of the same period (fig. 69, p. 173), the Paley Collection *Clown* appears with greater freshness, the concentration on the face and the forward tilt of the head adding a directness that makes the others look, by comparison, studied. Pierre Courthion has written of Rouault's clowns: "Here there are no concessions to the viewer who asks to be diverted by art. Under the appearance of a public entertainer, here is a man who is prey to his own natural condition of wretchedness, to the hard life of working for remuneration. Beneath this hollow, frightened glance, over and beyond this expression of suffering, shines the perpetual glow of a love that forgives and never betrays."[1]

According to the artist, observation prompted him to choose the clown as his allegorical Everyman: "A gypsy wagon stopped along the road, an emaciated old horse grazing on thin grass, an old clown sitting on the corner of his wagon mending his bright many-colored costume. The contrast between his brilliant and scintillating things made to amuse us, and this infinitely sad life, if one looks at it objectively, struck me with great force. . . . I saw that the 'clown' was myself, ourselves, almost all of us. This spangled costume is given to us by life. We are all of us clowns, more or less, we all wear a 'spangled costume,' but if we are caught by surprise . . . then who would dare to claim he is not moved deeply by immeasurable pity?"[2]

Rouault also sought to make a connection between Everyman as clown and Everyman as Christ. The Paley Collection *Clown,* for example, bears considerable similarity to his Grünewald-like *Head of Christ* (fig. 70) from 1905, and the comparison reminds one that Rouault asserted, "The clown is Man, but he is also Christ—Christ mocked, Christ scoffed at."[3] In this sense it is a religious work, not because of overt theological symbology but because it is invested with a prophet's moral outrage, Rouault's uncompromising protest against human suffering.[4]

M.A.

118

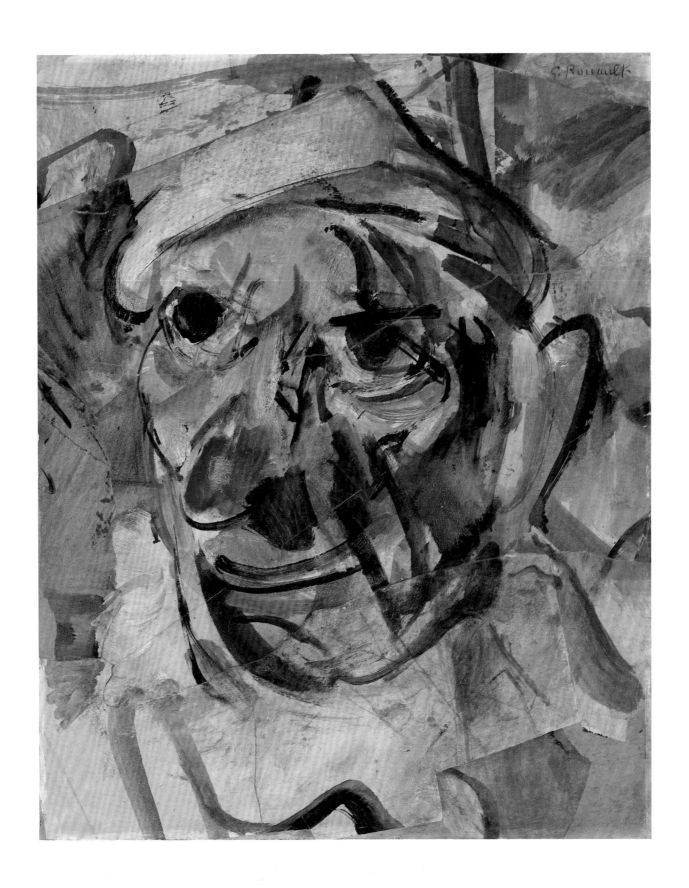

Georges Rouault

Portrait of Ambroise Vollard, 1925 (cat. 67)
Two Clowns, 1928 (cat. 68)
Little Peasant Girl, 1937 (cat. 69)
Profile of a Clown, 1938 (cat. 70)
Oasis (Mirage), 1944 (cat. 71)
Biblical Landscape with Two Trees, 1952 (cat. 72)

Motionless, hieratic, strongly religious, the paintings of Georges Rouault are among the most remarkable anomalies within twentieth-century art. For in an age when most painters shun formal religion, Rouault brought a vigorously devout Catholicism to everything he created. And Rouault might also be considered a true modern "primitive," though not in the same sense as Picasso or Derain—Rouault never showed any interest in the arts of tribal peoples, nor in *naïf* painters such as the Douanier Rousseau. Instead, Rouault's primitivism consisted of a modern reworking of older imagery, ranging from medieval icons to Rembrandt, with new expressive means.

After an apprenticeship to a stained-glass maker as a teenager, Rouault enrolled at the École des Beaux-Arts in 1890, where, the following year, he began studying under Gustave Moreau, whose guidance and independent spirit left a deep impression. Moreau's pictures were infused with Christian moralism, though presented through the most decorative and sumptuous displays of ancient Near Eastern exoticism—what Moreau referred to as "necessary richness." Rouault adapted these elements from Moreau and added to them his own strongly personal innovations and convictions. (Moreau's students also included Matisse and Albert Marquet, painters who later gained recognition as Fauves. Rouault initially exhibited with them but cannot seriously be considered a member of that group.) He became very close to the literary figures of the Catholic revival, among them J.-K. Huysmans, Jacques Maritain, and Léon Bloy, and their ideas informed much of his work, as did his youthful appreciation of the paintings of Rembrandt, Courbet, Manet, and other masters of the dark palette.

Rouault was rarely concerned with variations of hue or sensory responses to landscape, and certainly not with decor. His presentation of color hinged on strong oppositions of light and dark, and his colors flash and glint like jewels placed within aggressively rendered brushes of black; his paintings thus appear like panes of stained-glass, or, alternately, as a kind of scumbled primitivizing of Rembrandt's chiaroscuro. But that which most dynamically set Rouault apart was the emotional intensity of his subject matter, which varied little throughout his long career; his work is densely populated with clowns, prostitutes, saints, and the denizens of the *demi-monde,* the tragicomic outcasts of society. As Daumier had before him, Rouault sought out subject matter in jails, the halls of justice, slums, and back streets, finding inspiration in the garish countenances of down-at-heels prostitutes, corrupt magistrates, and destitute clowns.

Rouault's *Portrait of Ambroise Vollard* of 1925 shows his dealer, the legendary Vollard, who had defended Cézanne, Degas, and Pissarro when no one else would, and who had

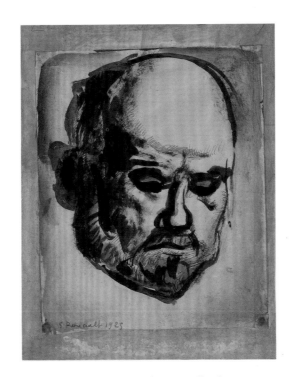

Portrait of Ambroise Vollard

Little Peasant Girl

Two Clowns

chosen to become Rouault's dealer in 1917, four years after purchasing Rouault's entire stock of paintings. The demands Vollard made on the artist were immense, and no small degree of tension existed between them. The dealer, said Rouault, "did not hesitate to burden the poor pilgrim with literary and art projects it would have taken three centuries to carry out."[1] Rouault, under Vollard's constant urging, nonetheless completed many series of lithographs, etchings to accompany texts (most notably *Les Réincarnations du Père Ubu*), and a vast, elaborate series of prints, issued under the title *Miserere,* on the theme of redemption. As had Picasso some years before, Rouault presents Vollard with eyes downcast, as if examining a work of art.

Rouault's early work, with its exceedingly diluted pigment—thinned almost to the consistency of watercolor, and brushed on impetuously—exudes a quality both violent and defiant. But in the 1920s, Rouault's work grew heavier in impasto, his dense, richly encrusted surfaces looking as if they have accreted over time. Moreover, there is a subtle shift in outlook, for while still strongly religious, Rouault's work grows less overt and abrasive. One has only to compare the highly expressionistic *Clown* of 1907 (p. 119) with the Paley Collection *Two Clowns* or *Profile of a Clown* twenty to thirty years later to see the difference. While continuing to treat the clown as an analogy for the sorrows of human life, and ignoring the bright lights and greasepaint on which another artist might have concentrated, the emotional quality created here is less outrage than, as Bernard Dorival has suggested, "a sad and despondent feeling of reverie."[2] The cadaverous expression and grave

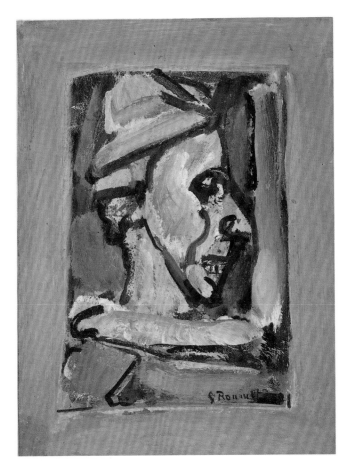

Profile of a Clown

immobility of the *Profile of a Clown* play discordantly off the fervor of the thick strokes of paint, yet the work has none of the manic intensity of the 1907 *Clown*. The *Two Clowns,* hieratic and isolated, suggests not so much torment as the ennui found in the saltimbanques of Watteau's *Gilles* or Picasso's "Blue Period" Harlequins.

The 1937 *Little Peasant Girl* was begun when Rouault was taken with the theme of female saints and devout servant women. The construction of this image, with its black lines and heavy impasto, is reminiscent of stained-glass windows. The girl's pose, eyes down and hands together over her heart, suggests the pious humility Rouault often gave his physically oppressed but spiritually enlightened figures.

As with his mentor Moreau and his idol Rembrandt, Rouault's biblical scenes show a love for exotic ornament long associated with the East. His lavishly colored Biblical Landscapes, begun in the late 1930s, became a focus of his work for the rest of his life. "When I escape into pictorial poetry," said Rouault, "the silence is filled with images and sounds, with unexplored vastness, and with delightful groves like those of Fra Angelico."[3] The *Oasis (Mirage)* of 1944 is an imposing scene before a domed building; *Biblical Landscape with Two Trees* of 1952 is but one of many canvases in which small but magnificent foreground figures in long robes act out unspecified rituals before dark, wide vistas while a setting sun or rising moon is discerned behind high-domed buildings and a pastoral countryside— a presentation as stately as a scene from a Passion play.

M. A.

Oasis (Mirage)

Biblical Landscape with Two Trees

Henri Rousseau

French, 1844–1910

Flowers in a Vase, 1901–02 (cat. 73)

In both subject matter and scale, Henri Rousseau's *Flowers in a Vase,* painted toward the end of his life,[1] is more intimate and less fanciful than his numerous and better-known exotic allegories and cheery representations of modern life. Rousseau's peculiar presentations, with their shallow spaces and seemingly labored draftsmanship, were vigorously championed by major figures in the avant-garde of prewar Europe, including writers such as Guillaume Apollinaire and Alfred Jarry and painters as diverse as Picasso, Delaunay, Léger, Miró, and Kandinsky, all of whom were examining the merits of production outside the canon of traditional post-Renaissance Western art—from tribal sculpture to children's art to trecento painting.[2]

That his work found such wide acceptance was due in great measure to the assumption that Rousseau—a *douanier* or toll collector—was an untrained and unworldly Sunday painter whose innate abilities were uncorrupted by the stultifying precepts of academic training. This was, to some extent, true, yet even a cursory inspection demonstrates how sophisticated his work actually was, however much he may have tried to disguise it.[3] The lines that indicate the folds of the heavy green curtain of the background were not painted with white paint—as a true naive would have done—but by abrading the surface with the handle of a brush or a turpentine-soaked rag. Moreover, the brushwork that makes up the center of the bouquet is fluid and nervous, having none of the clarified contours and simple colors of the surrounding lily, two-colored tulips, daisies, and peony.

The same vase and ivy appear in the Albright-Knox *Flowers in a Vase* of 1909 (fig. 71, p. 175), but there the sprig of ivy lies on top of the table; in the Paley work it appears like an ornamental frieze, flat against the surface of the picture.[4] In the traditional language of flowers, ivy represents love and faithfulness,[5] and both paintings may have been originally intended as gifts for a woman named Léonie, a Parisian salesclerk whose continual rebuffs contributed to Rousseau's long spells of melancholia.[6]

Much of the stubbornly naive quality of these still lifes comes from Rousseau's decision not to "imitate the traditional pattern of the structured, organized still life. Nor does he seem to have profited from the complex experiments of Cézanne or Gauguin. Yet there is a similar isolation of the motif, the same simplicity of presentation, as in van Gogh and Redon."[7] Nonetheless, a contemporaneous critic could proclaim that Rousseau "has the merit, a rare one today, of being completely himself. He is tending toward a new art."[8]

M.A.

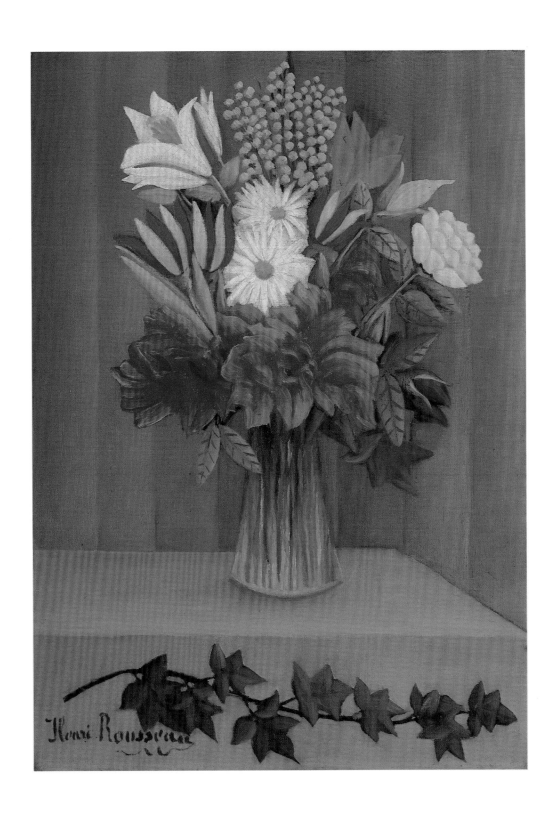

George Segal
American, born 1924

Girl Leaving Shower, 1974 (cat. 74)

Girl Leaving Shower is the most monumental of the several exceptionally sensual bas-reliefs George Segal completed in the early 1970s. In many respects, it is the obverse of the eerie, mummified tableaux upon which his reputation had initially been founded in the preceding decade. His early work, which combined plaster figures with actual objects (tables, chairs, shopping carts) satisfied his desire to fashion a sculpture that could be "a total aesthetic area which I could enter—as an intensely felt, internal experience."[1] These tableaux were, moreover, an antidote to many of the "excesses" of abstract art, which he felt had become divorced from life.[2] This rejection of pure abstraction and his choice to create sculpture which included actual everyday objects have led some to erroneously link his work to Pop art, but Segal's use of materials has always been antithetical to the garish cheerfulness of Pop, and his stark, disquieting visions of the introspection and loneliness—rather than the simple vulgarity—of modern American life are far more personal than the work of Warhol, Lichtenstein, or Wesselmann.

The figure in *Girl Leaving Shower* appears to be emerging from the tiled wall of a shower stall behind her, though its rumpled surface could also suggest an undulating shower curtain. Her relaxed, opalescent form is reminiscent of the dryads and nymphs of antiquity, yet her heavy-lidded eyes and indistinct face lend a certain air of silence and solemnity to her unrestrained, earnest nudity. The minimal nuances of her body language, her somewhat ambiguous pose, and the pervasive sense of quiet lend to the whole an air distinctly different from that of the more coquettish bathers of the same period, whose relatively animated forms resolve themselves into much more difficult, complex arrangements (figs. 72, 73, p. 175).

The often unsettling eroticism of the nudes of this series is a clear departure from the mundane subject matter of his "environmental" pieces of the 1960s. As with Degas's late pastels of women at their toilet, the poses in which are often strikingly similar, Segal's series as a whole encompasses a cinematic range of activity. There is also a direct link here to the work of Rodin, the first great modern sculptor to realize the enormous power of disparate fragments and partial views, based on a reevaluation of classical sculpture. Segal himself says that his use of fragments stemmed from "some kind of erotic or sensual impulse, to define bits of lips, fingers, breasts, folds of flesh."[3]

Segal's mastery of the partial nude remains the most successful recent development of a refined and complex tradition the roots of which can be traced back from Segal to Rodin, through the slaves of Michelangelo, to the gods and goddesses of Greek antiquity.[4]

M.A.

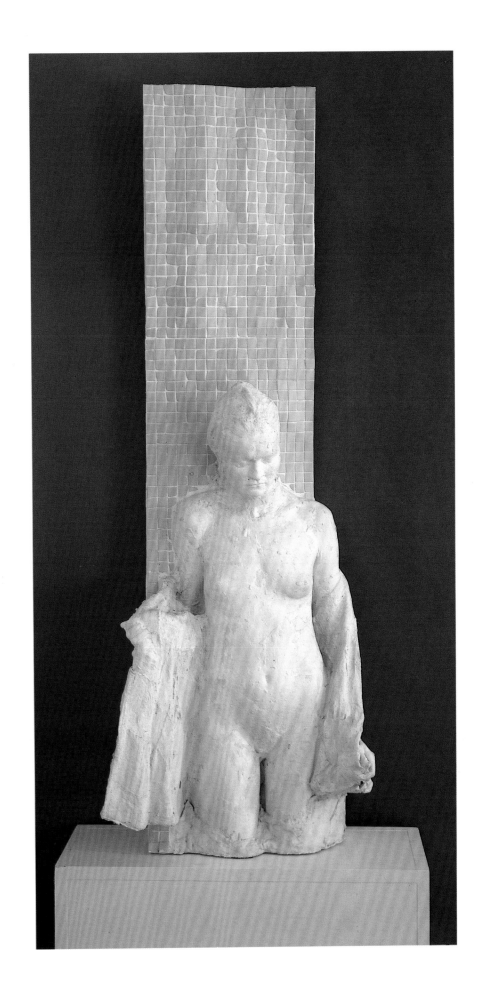

Ben Shahn

American, born Lithuania. 1898–1969. To U.S.A. 1906

Empty Studio (also called *Silent Music*), 1948 (cat. 75)

Commissioned in 1948 by William Golden of the Columbia Broadcasting System, *Empty Studio* quickly became Ben Shahn's best-known work. Its genteel calligraphic qualities anticipate the style Shahn was to perfect in the ensuing years, one which had an incalculable influence on American graphic design, providing legions of commercial artists, among them the young Andy Warhol, with an angular alternative to the plodding illustrational styles of the 1940s. This was also an image with which the artist himself was unusually pleased; with only slight alterations, it became the 1950 serigraph *Silent Music* (fig. 74, p. 176).

The drawing can, in an oblique fashion, be linked to Pop art's celebration of the ordinary. Shahn remarked that *Empty Studio* and his prints *TV Antennae* and *Supermarket*—all produced by deftly intersecting black lines—were "among the abiding symbols of American daily life, to be celebrated and brought into awareness."[1] Originally, *Empty Studio* served as an illustration to a four-page promotional folder which CBS had created for its sponsors, and was accompanied by a text reading: "No voice is heard now. The music is still. The studio audience has gone home. But the *work* of the broadcast has just begun. All through the week . . . *between* broadcasts . . . people everywhere are buying the things this program has asked them to buy. . . ."[2]

When asked why he had chosen to depict the television and radio network by the *absence* of studio musicians, Shahn's response was simply that "the emotion conveyed by great symphonic music happens to be expressed in semi-mathematical acoustical intervals and this cannot be transposed in terms of ninety portraits or caricatures of performers."[3] But Shahn, whose wit was as well known as his radical politics, was reported to have also quipped, "Don't you know the *real* title of that one? No? Well, it's 'Local 802 on Strike!'"

The artist's collaboration with William Golden, the art director of CBS who devised the "eye" logo for the corporation, had begun during World War II, when Shahn designed posters to help in the war effort.[4] Kenneth Prescott has written of their unique and fruitful working partnership: "Shahn prepared hundreds of drawings for CBS, some for newspaper ads, others for booklets. Many later found their way into paintings and prints. Together, the drawings testify to the sensitivity with which Shahn approached his subjects, and to the enthusiasm he must have felt for those assignments he accepted."[5]

M.A.

Ben Shahn

Edward R. Murrow Slaying the Dragon of McCarthy, 1954 (cat. 76)

Ben Shahn was a lifelong crusader against social injustice, and much of his graphic work was designed to help promote the Civil Rights movement and the A.C.L.U., or to aid victims of the Holocaust and racist violence. [1] He illustrated the Old Testament and received commissions for portraits of such humanitarians as Mahatma Gandhi, Dag Hammarskjöld, and Martin Luther King, Jr.

This presentation of the now legendary television journalist Edward R. Murrow is more jubilant in spirit than are most of Shahn's portraits. Murrow—here a modern-day Saint George—is shown slaying a hideous viper in the faintly disguised form of Joseph McCarthy. [2] The composition shows Shahn's ability to capture likenesses built up from a series of simple lines, a caricatural quality somewhat reminiscent of Paul Klee.

At this time, the fanatical search led by McCarthy, the Republican senator from Wisconsin, for supposed Communists was at its height, senselessly destroying the careers of many innocent people. Murrow saw McCarthy as inadvertently helping Communism by disregarding constitutionally guaranteed civil liberties and jeopardizing the Bill of Rights. [3] On March 9, 1954, CBS devoted an entire evening of its documentary news program *See It Now* to an analysis of McCarthy's ethics and tactics. [4] It was a courageous move, for to attack McCarthy was to become a target oneself. An assistant to Murrow said that Murrow "wanted McCarthy to convict himself out of his own mouth," [5] and the program therefore systematically displayed McCarthy's contradictions, his unsubstantiated allegations, and his arsenal of smears, slurs, half-truths, and blatant lies. The program was hugely successful and signaled the beginning of the Wisconsin senator's rapid tumble from power.

Shahn was so pleased with the program that he executed this drawing in homage to Murrow and the program's director, Fred W. Friendly. Shahn felt, as did Murrow, that the ability of the United States to promote stability abroad depended in part on its reputation as a liberal democracy—a reputation endangered by the McCarthy witch-hunts. "Our idea is Democracy," wrote Shahn, "and I believe that it is the most appealing idea that the world has yet known. But if we, by official acts of suppression, play the hypocrite toward our own beliefs, strangle our own liberties, then we can hardly hope to win the world's unqualified confidence." [6]

M.A.

Henri de Toulouse-Lautrec
French, 1864–1901
Mme Lili Grenier, 1888 (cat. 80)

Few artists are so closely linked to *fin-de-siècle* Paris and none have left as vivid an impression of its *demi-monde* as Henri de Toulouse-Lautrec. But in addition to his skill at satirical images of Paris cabaret life, Lautrec was also a gifted portraitist of the stylish and well-to-do. In both of the Paley Collection Lautrec portraits, the artist dispenses not only with mordant lampoons of those on the periphery of society, but also with many of the spatial and compositional devices he so often borrowed from Japanese art in his printmaking; here, he creates refreshingly straightforward if more traditionally painted portraits.

Mme Lili Grenier is one of two extant canvases Lautrec completed of the wife of René Grenier, a wealthy dilettante who had become friendly with Lautrec six years earlier when both studied at the atelier of Fernand Cormon. Lili, born of peasant stock, fled at the age of sixteen to Paris, where she became a highly sought-after model, posing, most notably, for Degas. Before her marriage, she was also the object of a spirited but friendly rivalry among the aspiring young artists of the atelier, who were entranced by her Rubensian proportions, her freckles, and her flame-red hair.[1] She and Lautrec became friendly and shared interests in exotic costume, elaborate fancy-dress balls, amateur photography, Oriental bric-a-brac, the opera, and the theater.[2] Lautrec often spent recuperative holidays with the Greniers and for the better part of 1885 shared their apartment. Moreover, it was through Lili Grenier that Lautrec met his idol Degas, the influence of whose work upon him was virtually incalculable and was to last the rest of his life.[3]

Despite this seemingly idyllic friendship—and his frequent requests—Mme Grenier rarely sat for Lautrec. She felt uncomfortable under his scrutiny since she knew that once under way, Lautrec's portraits would often veer away from a simple depiction of character toward something often highly caricatural, if not downright vicious. Twice during 1888, however, she consented, and the resulting images exhibit only a touch of the cutting derision of which Lautrec was capable (see fig. 75, p. 177).[4] The present work far more cogently sums up the particular personality of Mme Grenier, who is shown slouching in a high-back wicker chair, loosely wrapped in one of her treasured Japanese kimonos, one sleepy eye open, the other hidden behind a wisp of red hair; she toys with a pale blue ribbon and exudes an air of self-satisfied indolence. Lautrec has endowed her with a somewhat imperious mien, and one cannot help but think that Lautrec found the nouveau-riche pretensions of the former peasant girl a bit droll. In fact, writes Henri Perruchot, Lautrec "was amused by her vitality, by her delight in having made so good a marriage with such little trouble—she was just twenty—and in having money to throw about. . . . He was amused too by the social blunders she made, by her off-hand manner and the superb and peremptory airs she assumed."[5] The work is an impressive example of Lautrec's remarkable paint-handling, as evinced by the controlled but highly expressive, rich blacks, reds, and whites of her silk kimono, which are then overlaid with irregular patterns of pink flowers and counterpoised with the impetuous, vigorously brushed greens of the background.

M. A.

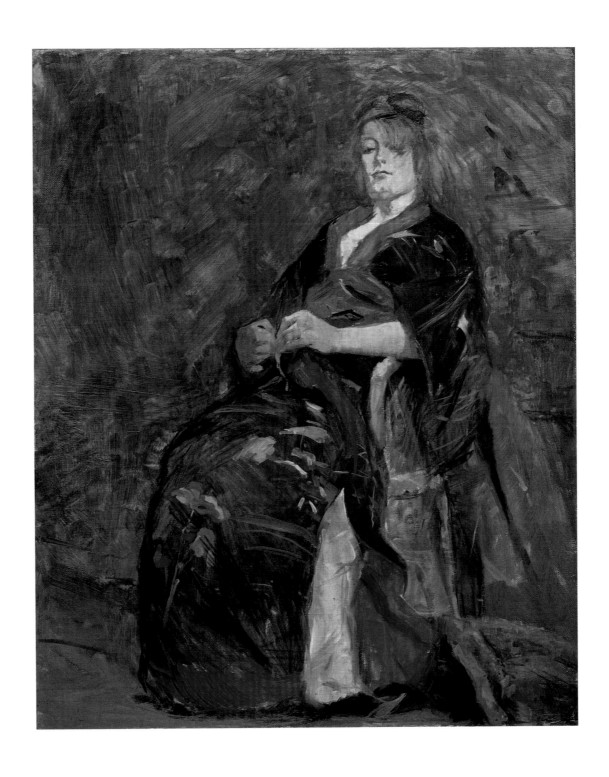

Henri de Toulouse-Lautrec

M. de Lauradour, 1897 (cat. 81)

Toulouse-Lautrec found more of interest in the idiosyncratic than in the commonplace, and while it is not unusual for artists to become bewitched by specific kinds of body types, physiognomies, habitual postures, and facial tics, Lautrec virtually hunted them down—often for little more than the opportunity to render a particular cast of eye in a passing woman, the crook in the nose of another, the bone structure, belly, brow, or bosom of a third. If part of Lautrec's enchantment with Lili Grenier had been her shock of red hair, the mysterious M. de Lauradour became the focus of fascination for the painter almost exclusively for his huge, bristling red beard. Indeed, Lautrec's portrait and the surname of the subject remain the only certain information about him, apart from the following story, originated by Lautrec and recounted by Henri Perruchot:

"Lautrec had painted M. de Lauradour because he had a splendid red beard and wore his top hat like no one else, but also because of an encounter which had delighted Lautrec, and which had proved M. de Lauradour to be 'even more insulting than [the cabaret owner and performer Aristide] Bruant.' As Lautrec and M. de Lauradour were crossing the Pont Caulaincourt one afternoon, they met Bruant, who asked the painter who was 'the pipe-smoking fellow who stank of Eau de Javel.' M. de Lauradour went for him as no one, in the whole of Bruant's career, had ever attacked him, and with a splendor of resounding epithet. Lautrec was delighted at the spectacle of this splendid beard pouring the insults of a fishwife over the disconcerted Bruant."[1]

Relaxed, leaning back in the ever-present wicker chair of Lautrec's studio, wearing a black coat and blue-gray trousers, gold cufflinks and top hat, M. de Lauradour appears to be the consummate dandy. But his breezy posture, the briar pipe in his mouth, his magnificent red beard and above all, the slightly malevolent charm of his face, show him also to be a man to be reckoned with—a gentleman, yes, but something of a rogue, too. Lauradour appears to be anticipating an imminent activity with seeming determination: he looks not out at the viewer, but forward, toward the bed, which is covered with a patchwork quilt and on which are strewn a pair of small, fine, pink, ladies' shoes. This understated but suggestive detail also acts as one of the decorative elements of the interior, as do the yellow paper lantern and the prints above the bed and the stacks of canvases behind the sitter.

The Lauradour portrait and Lautrec's portrait of Paul Leclercq (fig. 76, p. 178) were undertaken in the same year, and a comparison shows the strikingly different modes of presentation employed by the painter, depending upon the personality of the sitter.

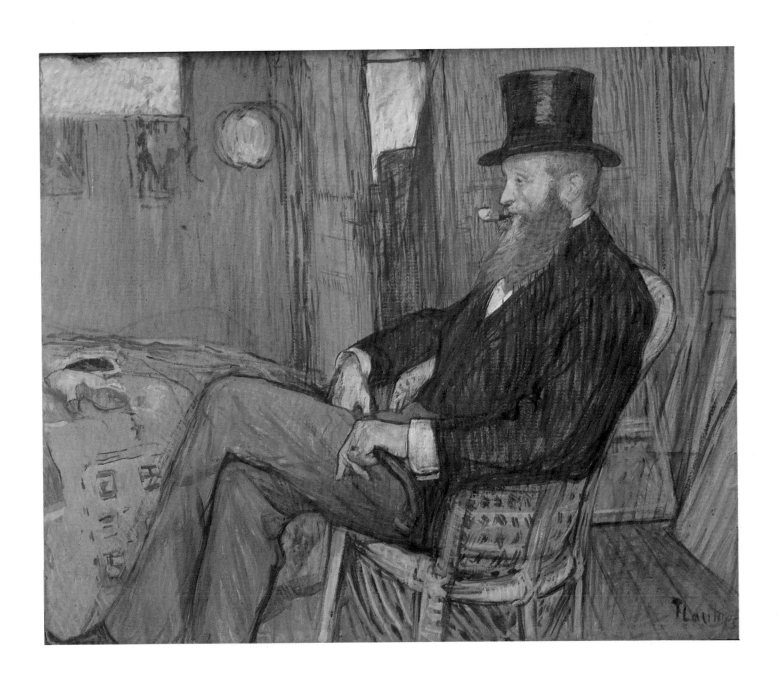

Detail of *M. de Lauradour*

Leclercq, fastidious and intense, is shown sitting at an oblique angle and gazes out pensively, his hands clasped, his legs locked in front of him; an image of self-control and solemnity. Lauradour, on the other hand, suggests an inexhaustible jocularity, his raffish profile adumbrated by his pipe and top hat.

Clearly in formal structure both images owe their inspiration to the "arrangements" of the American expatriate James A. McNeill Whistler, whose paintings had made such a strong impression on Lautrec that Joyant referred to Lautrec's late work as the artist's "Whistler period." Lautrec often visited Whistler in London in the 1890s,[2] and Whistler's portrait of his mother had been acquired by the Musée du Luxembourg in 1891. But the differences between the work of Lautrec and Whistler should not be minimized. The proto-Symbolist tonalities of Whistler's *Arrangement in Grey and Black, No. 2: Portrait of Thomas Carlyle* (fig. 77) are soft and harmonious, gently blended with purified, almost loving washes of oil so that the aged Carlyle is shown as a kind of tender embodiment of grays, blacks, and whites. How different is Lautrec's red-bearded Frenchman. This brisk and spirited composition is built up not from a melding of tones, but from a raucous display of purples, reds, navy blue, green, orange, and pasty whites, drawn, painted, and washed in oil and gouache.

By 1897, Lautrec's work had become inextricable from the city it illustrated; his posters and advertisements were everywhere and his designs for book jackets, sheet-music covers, lithographs, drawings, and works on canvas were highly influential within the avant-garde. He had also achieved some degree of success at the Goupil gallery, which had recently been bought by his friend, dealer, and later biographer, Maurice Joyant. Moreover, *Elles,* his collection of lithographs depicting daily life in Parisian brothels, had finally been published.

Yet Lautrec's late work is less ebullient than his earlier images; colors are more somber and sedate, and the vibrancy and movement that had become so much the hallmarks of his earlier images were now toned down in favor of closer psychological investigation. Lautrec's range of subject matter had always been similar to that of his idol Degas, encompassing the dissolution of café life, the ennui of bordellos, the peripheral worlds of the racetrack and the stage, and various kinds of people with strong characters and odd faces—alternatingly exuberant and bored dancers and musicians, coquettish models, as well as aristocrats and Japanophiles. Yet while Degas was keen to remain an observer of the scurrilous and vaguely criminal, Lautrec indulged whenever possible—which was often. His feverish bouts with alcoholism were increasing, straining his fragile health, his artistic output, and his already precarious relations with a number of friends. To make matters worse, the stipend from his family, upon which he depended—he never lived off the sale of his work—was growing thinner.[3]

Nonetheless, *M. de Lauradour,* among the last of Lautrec's completed portraits, ranks with his finest. The artist's acuity in capturing precise physiognomic detail lends the image a distinctive elegance, equipoise, and charm.

M.A.

Édouard Vuillard

French, 1868–1940

The Green Lamp, 1893 (cat. 82)
Still Life with Top Hat, 1893 (cat. 83)
The Window, 1893 (cat. 84)

Though receiving an initial inspiration from the work of Paul Gauguin, Édouard Vuillard's early paintings were based not on fantastic leaps of the imagination or modern reworkings of the mystical myths of tribal peoples, but on the recollection of quiet experiences from his relatively uneventful domestic life.[1] These three works by Vuillard in the Paley Collection nevertheless form a paradigm of those components of *fin-de-siècle* French painting which had been so successfully synthesized by Gauguin: the reliance on memory rather than direct perception; the use of high-keyed color combinations; and the alteration of perceived form into matrices of rich abstraction and flat, decorative pattern.[2] To these Vuillard added a pervasive sense of muffled quietude, even listlessness, qualities which permeate these small, delicate images and add to their peculiar emotional tensions.

The stifled, silent drama of *The Green Lamp* unfolds within a flurry of elaborately applied touches of faded blues and browns, matte black, muddied whites, and shades of rust; it centers on three shadowy figures grouped around a table, illuminated by artificial light. The artist's use of silhouette, the basis of both the formal balance and the disquieting effect of the image, is one of several schemas by which spatial depth and position are obfuscated.[3] "The room in which these women work appears shrouded in shadow and mystery, separate from any specific environment [and] this feeling of mystery is due, in part, to the dramatic shadows that make the room and its furnishings impenetrable and ominous."[4] The figure on the far side of the table may very well be Vuillard's mother, to whom he was exceptionally close.[5] She ran a dressmaking business in the home in which Vuillard continued to live and work; it has long been believed that Vuillard's living in a household crowded with seamstresses, silently laboring amidst a profusion of elaborate colors and dizzying patterns, was the single most powerful influence on his art.

Still Life with Top Hat is a modest work from the same year. It depicts the artist's top hat and green jacket bathed in lambent light and demonstrates Vuillard's growing mastery in the

The Green Lamp

Still Life with Top Hat

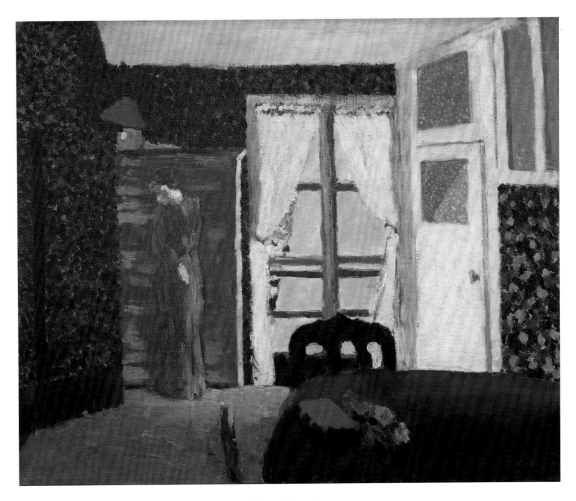

The Window

handling of tones and closely related values. As in all of Vuillard's work, detail is suppressed in the interest of a larger decorative expression of the whole. It was painted on cardboard in order to absorb the color and muffle the vibrancy which his contemporaries took such pains to display. The artist also wished to move away from the illusion of depth and volume that oil on canvas so often and so easily suggested, aiming rather to produce images of a dryness akin to fresco paintings, or to the work of the much admired Puvis de Chavannes.

The Window is an exceptionally compelling image.[6] Though the wide-angle perspective enables three adjoining walls, floor, and ceiling to be seen in a single glance, one's reading of recessional space is obviated by a modified pointillist application and the resolute planarity of almost all objects. This construction epitomizes what has been called the artist's "deliberate avoidance of representational clarity and apparent love for spatial ambiguity."[7] Within this somewhat oppressive interior a sense of malaise is implied by the twisting figure of an elliptical female whose substantiality is so minimal, she seems a disembodied spirit.

<div align="right">M.A.</div>

Catalogue and Notes

Dates given for works of art are inscribed on the works themselves unless enclosed in parentheses. In dimensions, height precedes width; a third dimension, depth, is given for some sculpture. For works on paper, dimensions refer to sheet size. The date when the work entered Mr. Paley's collection and the source of the acquisition, along with notable exhibitions and former owners, are cited, based on the records kept by Mr. Paley's office. The accession number assigned by the Museum is then given, followed by a page reference to the reproduction in the plates. All of the works in this list are now designated "The William S. Paley Collection" in the Museum's records, superseding any other wording formerly given for those accessioned earlier.

At the end of each entry, the notes appear for the relevant text in the plate section. The smaller illustrations reproduced in the margins are of supplementary works referred to in the texts.

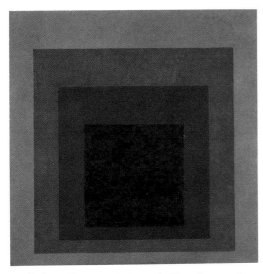

Josef Albers. *Homage to the Square in Green Frame*. 1963 (cat. 1)

Josef Albers
American, born Germany. 1888–1976. To U.S.A. 1933.

1. *Homage to the Square in Green Frame*. 1963.
Oil on Masonite, 48 × 48″ (122 × 122 cm).
Signed on reverse: "Albers 1963."
Acquired from Sidney Janis Gallery, New York, 1967.
Exhibited at "Forty New Paintings by Josef Albers," Sidney Janis Gallery, New York, 1964; "Twenty-ninth Biennial Exhibition of Contemporary American Painting," Corcoran Gallery of Art, Washington, D.C., 1965 (traveled to eighteen other American venues, 1965–67).
Acq. no. SPC 1.90
Plate, p. 3

[1]Josef Albers, *Interaction of Color* (New Haven,

Conn., and London: Yale University Press, 1963), p. 13.
[2]Josef Albers, *Search versus Research* (Hartford, Conn.: Trinity College Press, 1969), p. 13.

Armand P. Arman. *Almost Japanese*. 1970 (cat. 2)

Armand P. Arman
American, born France 1928. To U.S.A. 1963.

2. *Almost Japanese*. (1970).
Wood modeling tools in polyester resin, 48 × 48″ (122 × 122 cm).
Unsigned.
Acquired from Gene Tyson, Inc., New York, 1972.
Acq. no. SPC 48.90
Plate, p. 5

[1]Arman, quoted in Jan van der Marck, *Arman* (New York: Abbeville, 1984), p. 92.
[2]On Arman's indebtedness to Dada and Surrealist art, see Jacques Putman, *Les Moments d'Arman* (Paris: Galerie de l'Œil, 1972), n.p.
[3]Quoted in Pierre Descargues, "Arman: Accumulations et colères," *Tribune de Lausanne*, June 3, 1962.
[4]Jackson Pollock's all-over technique "left an indelible impression on him and, more than anything else, is responsible for a recurring tendency in Arman's work toward atomization of images and concurrent submergence in texture"; Jan van der Marck, "Logician of Form/Magician of Gesture," in *Arman: Selected Works, 1958–1974* (La Jolla, Calif.: La Jolla Museum of Contemporary Art, 1974), n.p.

Francis Bacon
British, born 1909.

3. *Study for Three Heads*. (1962).
Oil on canvas; triptych, each panel 14⅛ × 12⅛″ (36 × 31 cm).
Unsigned.

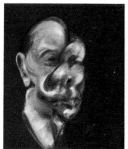
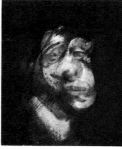
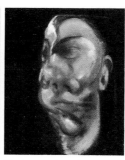

Francis Bacon. *Study for Three Heads.* 1962 (cat. 3)

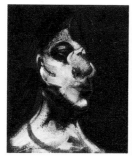
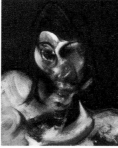
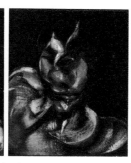

Francis Bacon. *Three Studies for the Portrait of Henrietta Moraes.* 1963 (cat. 4)

Fig. 1. Francis Bacon. *Three Studies of the Human Head.* 1953. Oil on canvas; triptych, each panel 24 × 20″ (61 × 51 cm). Private collection

Acquired from Marlborough Fine Art, Ltd., London, 1963.
Exhibited at "Contemporary Paintings in London," Stedelijk van Abbemuseum, Eindhoven, 1962; "Francis Bacon," Stedelijk Museum, Amsterdam, 1963; "Francis Bacon, Henry Moore," Marlborough–New London Gallery, London, 1963; "Francis Bacon," Solomon R. Guggenheim Museum, New York and Art Institute of Chicago, 1963–64; "Francis Bacon," Grand Palais, Paris, and Kunsthalle, Düsseldorf, 1971–72.
Acq. no. SPC 62.90
Plate, p. 7

[1]On Bacon and the use of the triptych, see David Sylvester, *The Brutality of Fact: Interviews with Francis Bacon* (1975; 3rd. ed., London: Thames & Hudson, 1987), pp. 83–86.
[2]The 1953 work had not originally been conceived as a triptych. Bacon's dealer was unable to place what would become the right-hand panel as a self-sufficient painting, and Bacon subsequently painted the panels which now accompany it (see Sylvester,

The Brutality of Fact, p. 84). Arguably, then, the Paley Collection triptych is the first "portrait-triptych" to have been undertaken, the success of which prompted the dozens of such images he made throughout the 1960s.

4. *Three Studies for the Portrait of Henrietta Moraes.* (1963).
Oil on canvas; triptych, each panel 14⅛ × 12⅛″ (36 × 31 cm).
Unsigned.
Acquired from Marlborough-Gerson Gallery, New York, 1963.
Exhibited at "Francis Bacon," Grand Palais, Paris, and Kunsthalle, Düsseldorf, 1971–72; "Four Contemporary Masters," circulated by the International Council of The Museum of Modern Art to Museo de Bellas Artes, Caracas, Museo de Arte Moderno, Bogotá, Museo de Arte Moderno, Mexico City, Museu de Arte de São Paulo, and Museu de Arte Moderna de Rio de Janeiro, 1973.
Acq. no. SPC 61.90
Plate, p. 9

[1]Though many have compared Bacon's disturbing images to both Expressionism and Surrealism, his art has neither the pronounced caricatural element of Expressionism nor the displacements of Surrealism. Sources for his dislocated figures have more successfully been traced to photographs of modern horrors—Nazi atrocities, for example—as well as to the studies of Eadweard Muybridge and the scumbling techniques of painters as disparate as Velázquez and Chaim Soutine.
[2]Quoted in Grey Gowrie, *Francis Bacon* (London: Marlborough Gallery, 1989), p. 6.
[3]Quoted in David Sylvester, *The Brutality of Fact: Interviews with Francis Bacon* (1975; 3rd. ed., London: Thames & Hudson, 1987), p. 40.
[4]To the art critic John Russell, Bacon confided that he never painted portraits of anyone except those close to him, since "if they were not my friends, I could not do such violence to them"; quoted in John Russell, *Francis Bacon* (Greenwich, Conn.: New York Graphic Society, 1971), p. 139.

Pierre Bonnard
French, 1867–1947.

5. *Reclining Nude.* (1897).
Oil on paper, mounted on cradled oak panel, 7⅜ × 16⅜″ (18.8 × 41.7 cm).
Unsigned.
Acquired from Wildenstein & Co., New York, 1955.

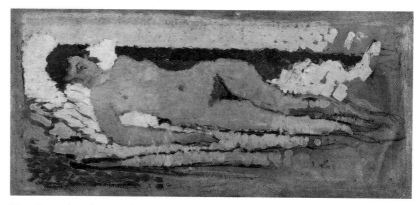

Pierre Bonnard. *Reclining Nude.* 1897 (cat. 5)

Formerly collection Édouard Vuillard, Paris; Jacques Roussel (nephew to Vuillard).
Exhibited at "Gauguin et ses amis," Galerie Kleber, Paris, 1949.
Acq. no. SPC 3.90
Plate, p. 11

[1]On the influence of Degas on Bonnard, see John Russell, *Pierre Bonnard* (New York: The Museum of Modern Art, 1948), p. 38; and Denys Sutton, Introduction to *Pierre Bonnard* (London: Royal Academy of Arts, 1966), p. 18. On Bonnard's knowledge of the work of Edvard Munch, see Steven Nash, "Tradition Revised," in Sasha Newman, ed., *Bonnard: The Late Paintings* (New York: Thames & Hudson, 1984), p. 26.
[2]See Sasha Newman, "Bonnard, 1900–1920," in Newman, ed., *Bonnard*, pp. 11–12.
[3]See Françoise Heilbrun and Philippe Néagu, *Pierre Bonnard Photographe*, Preface by Antoine Terrasse (Paris: Philippe Sers, Réunion des Musées Nationaux, 1987). See also Jean-François Chevrier, "Bonnard and Photography," in Newman, ed., *Bonnard*.

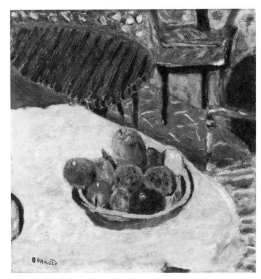

Pierre Bonnard. *Still Life (Table with Bowl of Fruit).* 1939 (cat. 6)

6. *Still Life (Table with Bowl of Fruit).* (1939).
Oil on canvas, 21 × 20⅞" (53.3 × 53 cm).
Signed lower left: "Bonnard."
Acquired from Sam Salz, Inc., New York, 1954.
Formerly collection Gaston Bernheim de Villers, Monte Carlo.
Acq. no. SPC 2.90
Plate, p. 13

[1]Matisse had surely been aware of Bonnard and the Nabis when he was still a student in the atelier of Gustave Moreau. Catherine Bock insists that many of Matisse's early interiors reveal a link to the work of Bonnard and Vuillard rather than to Neo-Impressionism, citing the lack of consistent complementary hues and a decorative use of color rather than a quasi-scientific theory; see Catherine C. Bock, *Matisse and Neo-Impressionism, 1898–1908* (Ph.D. dissertation, University of California at Los Angeles, 1977), pp. 13, 46, 122. Bonnard appears to have visited Matisse's studio shortly after Matisse painted *The Dance* in 1910; see Hans Purmann, "Aus der Werkstatt Henri Matisse," *Künstler*, 20 (February 1922), pp. 167–76.

[2]On the friendship between the two men, see Antoine Terrasse, "Matisse et Bonnard: Quarante ans d'amitié," *Revue de l'art*, 64 (1984), pp. 77–84. See also Jean Clair, "Correspondance Matisse-Bonnard," *Nouvelle Revue française*, nos. 211–212 (July–August 1970), pp. 27–34; and Steven Nash, "Tradition Revised: Some Sources in Late Bonnard," in Sasha Newman, ed., *Bonnard: The Late Paintings* (New York: Thames & Hudson, 1984), pp. 19–28.

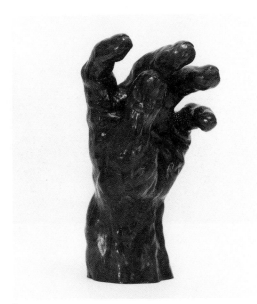

Émile-Antoine Bourdelle. *Hand.* 1888 (cat. 7)

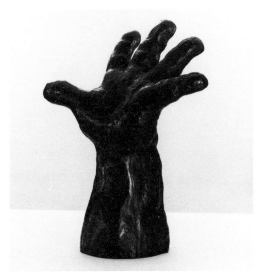

Émile-Antoine Bourdelle. *The Warrior's Hand.* 1889 (cat. 8)

Émile-Antoine Bourdelle
French, 1861–1929.

7. *Hand.* (1888).
Bronze, 13¾ × 7¼ × 8⅛" (34.9 × 18.5 × 20.7 cm).
Inscribed at base: "c Bourdelle VII."
Acquired from Charles E. Slatkin Galleries, New York, 1968.
Acq. no. SPC 41.90
Plate, p. 15

8. *The Warrior's Hand.* 1889.
Bronze, 22¾ × 16½ × 8½" (57.7 × 42 × 21.5 cm).
Inscribed at base: "c 89 Bourdelle."

Fig. 2. Émile-Antoine Bourdelle. *Adam.* 1888–89. Bronze, 25½" (64.7 cm) high. Whereabouts unknown

Fig. 3. Émile-Antoine Bourdelle. *Great Warrior of Montauban.* 1898–1900. Bronze, 70⅞ × 63 × 19¹¹⁄₁₆" (180 × 160 × 50.6 cm). Musée Bourdelle, Paris

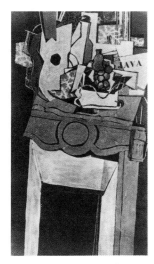

Fig. 4. Georges Braque. *The Mantelpiece*. 1921. Oil on canvas, 51³⁄₁₆ × 29⅛″ (130 × 74 cm). Private collection

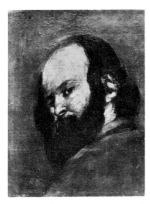

Fig. 5. Paul Cézanne. *Self-Portrait with Long Hair*. 1865–68. Oil on canvas, 16⅛ × 12⅝″ (41 × 32 cm). Whereabouts unknown. Formerly collection Josse Bernheim

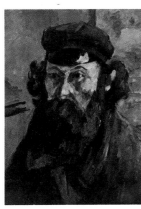

Fig. 6. Paul Cézanne. *Self-Portrait in a Cap*. 1873–75. Oil on canvas, 20⅞ × 14¹⁵⁄₁₆″ (53 × 38 cm). The Hermitage Museum, Leningrad

Acquired from Charles E. Slatkin Galleries, New York, 1968.
Acq. no. SPC 80.90
Plate, p. 15

¹The monument was to honor those who had died in the war of 1870. The work was commissioned from Bourdelle by the civic authorities of Montauban, his hometown, in 1893, the same year the sculptor began working for Rodin. Peter Cannon-Brookes writes that "In nineteenth-century France it was customary, when possible, for provincial communities to offer commissions for monuments to local or locally-born sculptors. Thus a little-known son of the town, who had gone to Paris to make his way, could be the recipient of a major commission which he would otherwise be unlikely to attract"; Peter Cannon-Brookes, *Émile Antoine Bourdelle: An Illustrated Commentary* (London: Trevail Books in association with the National Museum of Wales, 1983), p. 22; on the history of the commission and its reception by the town fathers, see pp. 23–27. The maquette of Bourdelle's final proposal for the monument was not approved until 1897, after some dispute, and the monument itself not unveiled until 1902.

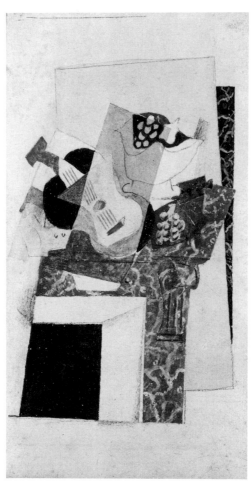

Georges Braque. *Still Life on a Mantelpiece*. 1920 (cat. 9)

Georges Braque
French, 1882–1963.

9. *Still Life on a Mantelpiece*. (1920).
Gesso, gouache, watercolor, and graphite pencil on paper, mounted on board, 10 × 5½″ (25.7 × 14 cm).

Signed on reverse: "G Braque."
Acquired from Pierre Matisse Gallery, New York, 1950.
Formerly collection Galerie L'Effort Moderne, Paris; Patricia Matisse.
Acq. no. SPC 4.90
Plate, p. 17

¹Georges Braque, in conversation with John Richardson; quoted in John Russell, *Georges Braque* (London: Phaidon, 1959), p. 24.

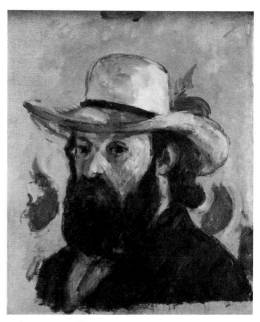

Paul Cézanne. *Self-Portrait in a Straw Hat*. 1875–76 (cat. 10)

Paul Cézanne
French, 1839–1906.

10. *Self-Portrait in a Straw Hat*. (1875–76).
Oil on canvas, 13¾ × 11⅜″ (35 × 28.9 cm).
Unsigned.
Acquired from Marie Harriman Gallery, New York, 1935.
Formerly collection Paul Cézanne (the artist's son).
Exhibited at "Paul Cézanne, André Derain . . . ," Marie Harriman Galleries, New York, 1936; "Paul Cézanne," San Francisco Museum of Art, 1937; "Great Portraits from Impressionism to Modernism," Wildenstein & Co., New York, 1938; "Portrait of the Artist," Metropolitan Museum of Art, New York, 1972.
Acq. no. SPC 5.90
Plate, p. 19

11. *Portrait of Mme Cézanne*. (1877–80).
Pencil on paper, sheet 7⅛ × 7½″ (18.2 × 19.2 cm).
Unsigned.
Inscribed: " + tel."
Acquired from Wildenstein & Co., New York, 1951.
Formerly collection Sir Kenneth Clark, London.
Acq. no. SPC 8.90
Plate, p. 21

¹An incomplete survey of Cézanne's pencil portraits of his wife can be found in Wayne Andersen, *Cézanne's Portrait Drawings* (Cambridge, Mass., and London: MIT Press, 1970), pp. 72–113.
²See also nos. 716, 717, and 718, in Adrien Chap-

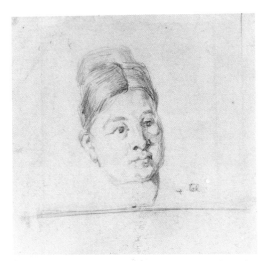

Paul Cézanne. *Portrait of Mme Cézanne.* 1877–80 (cat. 11)

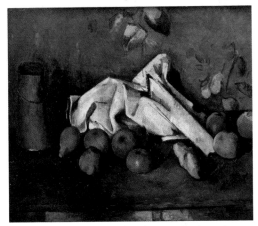

Paul Cézanne. *Milk Can and Apples.* 1879–80 (cat. 12)

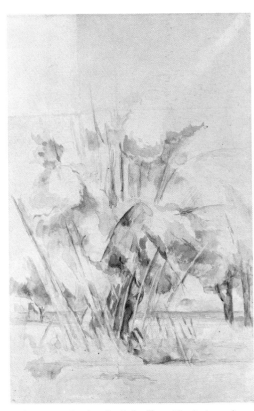

Paul Cézanne. *Reeds at Jas de Bouffan.* 1880–82 (cat. 13)

puis, *The Drawings of Paul Cézanne* (London: Thames & Hudson, 1973), p. 191.

12. *Milk Can and Apples.* (1879–80).
Oil on canvas, 19¾ × 24" (50.2 × 61 cm).
Unsigned.
Acquired from Wildenstein & Co., New York, 1937.
Formerly collection Durand-Ruel, Paris; Egisto Fabbri, Paris; Oscar Schmitz, Dresden.
Exhibited at "Oscar Schmitz Collection," Kunsthaus, Zurich, 1932; "Französische Malerei des 19. Jahrhunderts," Kunsthaus, Zurich, 1933; "Chardin and the Modern Still Life," Marie Harriman Gallery, New York, 1936; "Paul Cézanne," San Francisco Museum of Art, 1937; Wildenstein & Co., New York, 1951.
Acq. no. SPC 6.90
Plate, p. 23

[1]Lionello Venturi, *Cézanne: Son art, son oeuvre* (Paris: Paul Rosenberg, 1936), vol. 2, no. 338.
[2]John Rewald, *Cézanne and America: Dealers, Collectors, Artists and Critics, 1891–1921* (Princeton, N.J.: Princeton University Press, 1989), p. 17. Rewald points out (p. 11) that this work was one of the first two Cézanne paintings sent to America. Brought here in 1891 on consignment by Miss Sara Hallowell, a friend of Mary Cassatt and an advisor to a number of American collectors, it failed to sell and was eventually (1895) returned to Paris.

13. *Reeds at Jas de Bouffan.* (1880–82).
Watercolor, graphite, and pencil on paper, 18⅝ × 12⅛" (47.2 × 30.8 cm).
Unsigned.
Acquired in France, 1950.
Formerly collection Ambroise Vollard, Paris.
Exhibited at Country Gallery, Westbury, New York, 1954; Citizens' Committee for Children, New York, 1961.
Acq. no. SPC 7.90
Plate, p. 27

[1]A vivid description of the house and grounds can be found in Gerstle Mack, *Paul Cézanne* (New York: Knopf, 1936), pp. 51–54.
[2]Gerstle Mack writes: "The decision to dispose of the Jas de Bouffan may have been due in part to a sentimental reluctance on Cézanne's part to go on living in a house which was so intimately bound up with his memories [of his mother], but it was also due to a more prosaic desire to settle the estate, which was divided between his two sisters and himself"; Mack, *Paul Cézanne*, p. 53.
[3]The problems in dating Cézanne's works, particularly his watercolors, are multitudinous; only four out of some six hundred works on paper are dated. The handling and motif lead one to agree with John Rewald, who, in his catalogue raisonné, proposes a date of 1880–82. Venturi had originally proposed 1879–87, but in his revised catalogue dates it 1895–1900; see Rewald, *Paul Cézanne: The Watercolors—A Catalogue Raisonné* (Boston: Little, Brown, 1983), p. 107.
[4]Though common now, this notion was originally advanced by the British critic Roger Fry. See Fry's *Paul Cézanne: A Study of His Development* (New York: Macmillan, 1927), pp. 63 ff. See also Wayne V. Anderson, "Watercolor in Cézanne's Artistic Process," *Art International*, 7 (May 1963), pp. 23–26.
[5]Götz Adriani, *Cézanne Watercolors*, trans. Russell M. Stockman (New York: Abrams, 1983), p. 64.

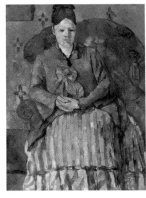

Fig. 7. Paul Cézanne. *Mme Cézanne in a Red Armchair.* 1877. Oil on canvas, 28½ × 22" (72.5 × 56 cm). Museum of Fine Arts, Boston. Bequest of Robert Treat Paine II

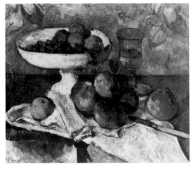

Fig. 8. Paul Cézanne. *Still Life with Fruit Dish.* 1879–80. Oil on canvas, 18⅛ × 21⅝" (46 × 55 cm). The Museum of Modern Art, New York. Mr. and Mrs. David Rockefeller Fund, promised gift

Fig. 9. Pierre-Auguste Renoir. *Rocky Crags at L'Estaque*. 1882. Oil on canvas, 26 × 32¼″ (66 × 82 cm). Museum of Fine Arts, Boston

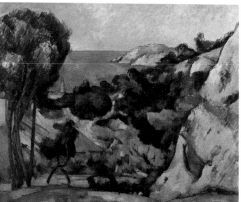

Paul Cézanne. *L'Estaque*. 1882–83 (cat. 14)

14. *L'Estaque*. (1882–83).
Oil on canvas, 31½ × 39″ (80.3 × 99.4 cm).
Unsigned.
Acquired from M. Knoedler & Co., Paris, 1935.
Formerly collection Ambroise Vollard, Paris; Claude Monet, Paris; Michel Monet, Giverny.
Exhibited at "Art in Our Time," The Museum of Modern Art, New York, 1939; "Living Heritage of French Literature & Thought Since the Revolution," Art Institute of Chicago, 1942; "Loan Exhibition of Paintings by Cézanne," Paul Rosenberg & Co., New York, 1942; "Corot to Picasso," American British Art Center, New York, 1944; "Cézanne," Wildenstein & Co., New York, 1947; "Cézanne: Paintings, Watercolors, and Drawings," Art Institute of Chicago and Metropolitan Museum of Art, New York, 1952; "Paintings from Private Collections," The Museum of Modern Art, New York, 1955; "Works of Art Given or Promised," The Museum of Modern Art, New York, 1958; Wildenstein & Co., New York, 1967; "Modern Masters: Manet to Matisse," The Museum of Modern Art, New York, and circulated by the International Council of The Museum of Modern Art to Art Gallery of New South Wales, Sydney, and National Gallery of Victoria, Melbourne, 1975.
Acq. no. 716.59
Plate, p. 29

[1] Lionello Venturi, *Cézanne: Son Art, son oeuvre* (Paris: Paul Rosenberg, 1936), vol. 2, p. 171, no. 492.
[2] Paul Cézanne, letter to Émile Zola, May 24, 1883; in *Paul Cézanne: Correspondance*, ed. John Rewald (Paris: Bernard Grasset, 1937), p. 194.
[3] Cited in *Renoir* (London: Arts Council of Great Britain, 1985), p. 233.
[4] Paul Cézanne, as recorded in Émile Bernard, *Souvenirs sur Paul Cézanne et lettres* (Paris: Le Rénovation Esthétique, 1921); cited in Richard Kendall, ed., *Cézanne by Himself: Drawings, Paintings, Writings* (London: Macdonald & Co., 1988), p. 229.
[5] See Lawrence Gowing, "The Logic of Organized Sensations," in William Rubin, ed., *Cézanne: The Late Work* (New York: The Museum of Modern Art, 1977), p. 62. We see this selecting out of sensations that contribute to structure marvelously at work in this landscape when we consider those parts of nature Renoir and Monet would have included and which Cézanne has omitted in the interest of his pictorial "logic."

Hilaire-Germain-Edgar Degas
French, 1834–1917.

15. *Portrait of a Woman*. (1866–68).
Pencil on paper, 13⅝ × 11⅝″ (34.7 × 29.6 cm).
Stamped in orange lower left: "Degas."
Acquired as a gift from John Hay Whitney, 1954.
Acq. no. SPC 63.90
Plate, p. 33

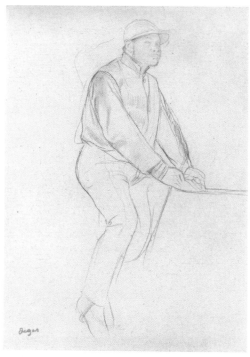

Hilaire-Germain-Edgar Degas. *Portrait of a Woman*. 1866–68 (cat. 15)

[1] The drawing was published in 1919, in the Degas studio auction catalogue, but not since; see *Atelier Edgar Degas* (Paris: Galerie Georges Petit, 1919), no. 90B.
[2] The twenty-year-old Degas had been advised by his idol, Ingres: "Draw lines, young man, many lines; from memory or from nature, it is in this way that you will become a good artist"; see John Rewald, *The History of Impressionism* (1946; 4th ed.,

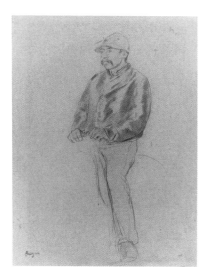

Fig. 10. Hilaire-Germain-Edgar Degas. *Jockey*. 1866–68. Graphite on paper, 12¹⁵⁄₁₆ × 9¹¹⁄₁₆″ (32.8 × 24.6 cm). The Art Institute of Chicago. Gift of Robert Allerton, 1922.5518

Hilaire-Germain-Edgar Degas. *The Jockey*. 1866–68 (cat. 16)

New York: The Museum of Modern Art, 1973), pp. 16, 35.

16. *The Jockey*. (1866–68).
Graphite pencil on paper, 12⅞ × 9¼" (32.7 × 23.5 cm).
Stamped in orange lower left: "Degas."
Acquired from Sam Salz, Inc., New York, 1952.
Formerly collection Atelier Degas, Paris; Albert S. Henraux, Paris.
Exhibited at "Renoir, Degas," Charles E. Slatkin Galleries, New York, 1958; "Drawings by Degas," City Art Museum of Saint Louis, Philadelphia Museum of Art, and Minneapolis Society of Fine Arts, 1967; "Degas' Racing World," Wildenstein & Co., New York, 1968.
Acq. no. SPC 64.90
Plate, p. 35

[1]On Degas and the French interest in the racetrack, see Ronald Pickvance, Introduction to *Degas' Racing World* (New York: Wildenstein & Co., 1968); also Denys Sutton, "The Sport of Kings," chapter 10 of *Edgar Degas: Life and Work* (New York: Rizzoli, 1986), pp. 135–60. Many of the jockey drawings were previously dated to the 1870s, but Ronald Pickvance has proven an earlier date; see Pickvance, *Degas, 1879* (Edinburgh: National Gallery of Scotland, 1979), p. 12.

[2]Despite his seemingly distanced attitude—Degas himself was never known to have ridden—images of the racetrack occupied him for almost forty years; his drawings alone number in the hundreds. Nonetheless, he never produced an equestrian portrait and his images of the horse are never the Romantic visions of Géricault or Delacroix, in which rearing steeds appear as embodiments of untamed energy. Neither famous racehorses nor their jockeys interested him, and his paintings of the track contain less a sense of grand spectacle than of quirky and peripheral events prior to the starting bell. Ronald Pickvance argues that the primary impulse to create images of the horse came initially from his infatuation with English sporting prints; see Pickvance, *Degas' Racing World*. Late in his life, Degas's interest in horses was revived when he saw the equestrian photographs of the American photographer Eadweard Muybridge; see Sutton, *Edgar Degas*, p. 151.

[3]Degas is known to have had his studio outfitted with a great deal of riding paraphernalia, including a full-sized dummy horse on which he fitted a saddle and posed his models; see Robert Gordon and Andrew Forge, *Degas* (New York: Abrams, 1988), p. 73.

17. *Two Dancers*. (1905).
Charcoal and pastel on tracing paper, mounted on wove paper, 43 × 32" (109.3 × 81.2 cm).
Signed in red crayon upper left: "Degas."
Acquired from Ambroise Vollard, Paris, 1935.
Acq. no. SPC 65.90
Plate, p. 37

[1]It has been suggested that the lack of such a tradition reflected the low state of classical ballet in nineteenth-century France; no high-minded academic artist of the nineteenth century would have bothered with its depiction. See Robert Gordon and Andrew Forge, *Degas* (New York: Abrams, 1988), pp. 176–215; and Lillian Browse, *Degas Dancers* (London: Faber, 1949), pp. 46–65.

[2]Quoted in Ronald Pickvance, *Degas, 1879* (Edinburgh: National Gallery of Scotland, 1979), p. 18.

[3]This dating is based on the vast number of varia-

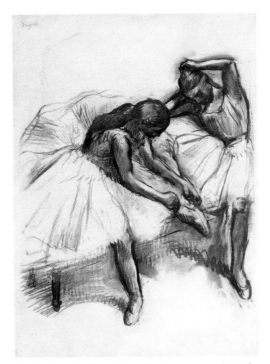

Hilaire-Germain-Edgar Degas. *Two Dancers*. 1905 (cat. 17)

tions on this composition published in Paul-André Lemoisne, *Degas et son oeuvre* (Paris: P. Brame and C. M. de Hauke aux Arts & Métiers Graphiques, 1946–48). See especially vol. 3, nos. 1241–1245, dated 1896; nos. 1324–1330, dated 1898; nos. 1409–1412, dated c. 1902; and nos. 1465–1466, dated c. 1906–08. William Paley bought this drawing in 1935 and, rarely exhibited either before or afterward, it was not included in Lesmoisne's catalogue.

[4]"Many of Degas' pastels and charcoal drawings were transferred to lightly moistened paper, on which they appeared as inverted proofs, in order to make them easier to correct and alter. These inversions provided a new point of view on the original subject, and so the 'print' was often reworked, while the 'original' was left untouched. Studies and their carefully traced copies were also occasionally used together in the same compositions"; Götz Adriani, *Degas: Pastels, Oil Sketches, Drawings*, trans. Alexander Lieven (New York: Abbeville, 1985), p. 96. On the inventiveness of Degas's techniques late in life, his method of drawing, tracing, transferring, and redrawing, see also Denis Rouart, *Degas: In Search of His Technique* (New York: Rizzoli, 1988), pp. 122–25.

[5]Gordon and Forge, *Degas*, p. 215.

André Derain
French, 1880–1954.

18. *Bridge over the Riou*. (1906).
Oil on canvas, 32½ × 40" (82.5 × 101.6 cm).
Signed lower right: "Derain."
Acquired from Christian de Galéa, Paris, 1954.
Exhibited at "Paintings from Private Collections," The Museum of Modern Art, New York, 1955; "Cézanne to Miró," circulated by the International Council of The Museum of Modern Art to Museo Nacional de Bellas Artes, Buenos Aires, Museo de Arte Contemporáneo, Universidad de Chile, Santiago, and Museo de Bellas Artes, Caracas, 1968; "The 'Wild Beasts': Fauvism and Its Affinities," The

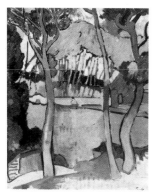

Fig. 11. André Derain. *Three Trees, L'Estaque*. 1906. Oil on canvas, 39½ × 31½" (100.3 × 80 cm). Private collection

Fig. 12. André Derain. *The Turning Road, L'Estaque*. 1906. Oil on canvas, 51" × 6'4⅞" (129.5 × 195.2 cm). The Museum of Fine Arts, Houston. The John A. and Audrey Jones Beck Collection

Fig. 13. André Derain. *Trees, L'Estaque*. 1906. Oil on canvas, 18⅛ × 14¹⁵/₁₆" (46 × 38 cm). Collection Gabriel Sabet, Geneva

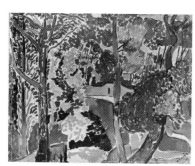

Fig. 14. André Derain. *L'Estaque*. 1906. Oil on canvas, 29½ × 36" (72.5 × 91.5 cm). Private collection, Switzerland

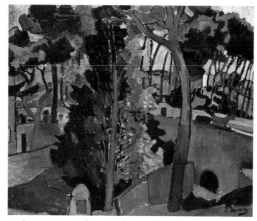

André Derain. *Bridge over the Riou*. 1906 (cat. 18)

Museum of Modern Art, New York, San Francisco Museum of Art, and Kimbell Art Museum, Fort Worth, 1976.
Acq. no. SPC 66.90
Plate, p. 39

[1]Guillaume Apollinaire, *Apollinaire on Art: Essays and Reviews, 1902–1918*, ed. Leroy C. Breunig, trans. Susan Suleiman (New York: Viking, 1972), p. 260.
[2]Daniel-Henry Kahnweiler, *The Rise of Cubism*, trans. Henry Aronson (New York: Wittenborn, Schultz, 1949), p. 4.
[3]It was Marcel Giry (*Fauvism: Origins and Development* [New York, Alpine Fine Arts, 1982], p. 158) who first realized the obvious link of the Paley and Beck (Houston) pictures' motifs to the titles of works in the catalogue list of the 1906 Salon d'Automne.

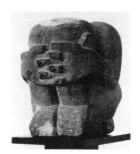

Fig. 15. André Derain. *Crouching Man*. 1907. Stone, 13 × 10¼ × 11⅛" (33 × 26 × 28.3 cm). Museum des 20. Jahrhunderts, Vienna

Fig. 16. André Derain. *Bathers*. 1907. Oil on canvas, 52" × 6'4¼" (132.1 × 195 cm). The Museum of Modern Art, New York. William S. Paley and Abby Aldrich Rockefeller Funds

[4]*The Collection of John A. and Audrey Jones Beck*, comp. Audrey Jones Beck (Houston: Museum of Fine Arts, 1986), p. 40.

19. *The Seine at Chatou*. (1906).
Oil on canvas, 29⅛ × 48¾" (74 × 123.8 cm).
Signed lower right: "Derain."
Acquired from Sam Salz, Inc., New York, 1956.
Formerly Patat collection, Paris.
Exhibited at "Derain Exhibition," L'Orangerie, Paris, 1946; Kunsthaus, Zurich, 1950; Tate Gallery, London, 1952; Federation of Jewish Philanthropies, New York, 1957.
Acq. no. SPC 9.90
Plate, p. 45

[1]See Judi Freeman, *The Fauve Landscape* (New York: Abbeville, 1990), p. 97, note 163; based on Ron Johnson, unpublished essay of 1969 on Derain's sculpture, cited in Jack D. Flam, "Matisse and the Fauves," in William Rubin, ed., *"Primitivism" in Twentieth-Century Art: Affinity of the Tribal and the Modern* (New York: The Museum of Modern Art, 1984), vol. 1, pp. 217–18. See also Edward Fry, "Cubism 1907–8: An Early Eyewitness Account," *The Art Bulletin*, 48 (March 1966), p. 73.
[2]For Derain's relationship to Cézannism, and for a discussion of the *Bathers* in particular, see the author's "Cézannisme and the Beginnings of Cubism," in *Cézanne: The Late Work* (New York: The Museum of Modern Art, 1977), p. 156 and passim.
[3]Daniel-Henry Kahnweiler, *André Derain* (Leipzig: Klinkhardt & Bierman, 1920), pp. 4–5.
[4]See Jean-Paul Crespelle, *Les Fauves* (Neuchâtel: Ides & Calendes, 1962), no. 27 under Derain listing; and Pier Carlo Santini, *Modern Landscape Painting* (London: Phaidon, 1972), no. 19.

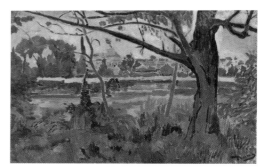

André Derain. *The Seine at Chatou*. 1906 (cat. 19)

20. *The Rehearsal*. (completed 1933).
Oil on canvas, 26⅞ × 30⅜" (68.4 × 77.2 cm).
Signed lower right: "Derain."
Acquired from the artist.
Exhibited at the New School for Social Research, New York, 1946.
Acq. no. SPC 49.90
Plate, p. 47

[1]Quoted in Denys Sutton, *André Derain, Disenchanted Optimist* (Tokyo: Takashimaya Gallery, 1981), p. 19.
[2]William S. Paley, *As It Happened: A Memoir* (Garden City, N.Y.: Doubleday, 1979), p. 99.

21. *Balzac*. (1950).
India ink on wove paper, 8¼ × 5¼" (21 × 13.4 cm).
Signed in pencil lower right: "Derain."

André Derain. *The Rehearsal.* 1933 (cat. 20)

Jean Dubuffet. *À La Réticence.* 1962 (cat. 22)

André Derain. *Balzac.* 1950 (cat. 21)

Paul Gauguin. *Washerwomen.* 1888 (cat. 23)

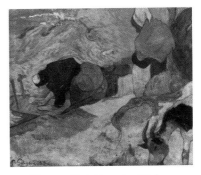

Fig. 17. Paul Gauguin. *Washerwomen at Arles.* 1888. Oil on canvas, 28¾ × 36¼″ (73 × 92 cm). Museo de Bellas Artes, Bilbao

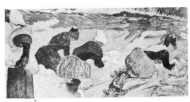

Fig. 18. Paul Gauguin. *Washerwomen at Arles.* 1889. Watercolor on silk, 4 × 8″ (10.1 × 20.3 cm). Collection Arthur Sachs, Paris

Inscribed on back: "Pour Barbara Paley, En souvenir de votre passage à Genève, 22 Juillet 1950, Albert Skira."
Acquired as a gift from Albert Skira, Geneva, 1950.
Acq. no. SPC 10.90

Jean Dubuffet
French, 1901–1985.

22. *À La Réticence.* 1962.
Tempera on paper, 27¾ × 23⅞″ (70.5 × 60.6 cm).
Signed and dated lower right "J.D. 62."
Acquired from Cordier & Ekstrom, New York, 1964.
Acq. no. SPC 11.90

Paul Gauguin
French, 1848–1903. In Tahiti and the Marquesas Islands, 1891–93, 1895–1903.

23. *Washerwomen.* 1888.
Oil on canvas, 29⅞ × 36¼″ (75.9 × 92.1 cm).
Signed and dated lower left: "P. Gauguin—1888."
Acquired from Wildenstein & Co., New York, 1958.
Formerly collection Gustave Fayet, Igny; Baron von Mutzenberker, Wiesbaden; Henckel collection, Berlin; Private collection, Germany.
Exhibited at Salon d'Automne, Paris, 1906; "Gauguin," Art Institute of Chicago and Metropolitan Museum of Art, New York, 1959; "Van Gogh in Arles," Metropolitan Museum of Art, New York, 1984.
Acq. no. SPC 15.90
Plate, p. 49

[1] Paul Gauguin, letter to Émile Bernard, November 3 or 4, 1888; *Correspondance de Paul Gauguin*, ed. Victor Merlhès (Paris: Fondation Singer-Polignac, 1984), p. 284.
[2] Vincent van Gogh, letter to Theo van Gogh, November 25, 1888; *The Complete Letters of Vincent van Gogh* (Greenwich, Conn.: New York Graphic Society, 1978), vol. 3, p. 97.
[3] Vincent van Gogh, letter to Theo van Gogh, December 4, 1888; *Complete Letters*, vol. 3, p. 102.

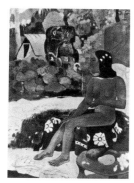

Fig. 19. Paul Gauguin. *Her Name Is Vaïraümati.* 1892. Oil on canvas, 35¹³⁄₁₆ × 23⅝" (91 × 60 cm). The Hermitage Museum, Leningrad

Fig. 20. Paul Gauguin. Page 46 of *Ancien Culte mahorie.* 1892–93. Watercolor on paper; page, 7 × 8½" (18 × 22 cm). Musée du Louvre, Paris

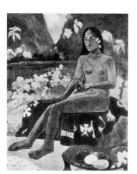

Fig. 21. Paul Gauguin. *The Seed of the Areoi (Te aa no areois)* (cat. 24) prior to cleaning

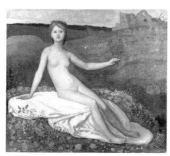

Fig. 22. Pierre Puvis de Chavannes. *Hope.* 1872. Oil on canvas, 27⅞ × 32¼" (70.7 × 82 cm). Musée du Louvre, Paris

Fig. 23. Paul Gauguin. Drawing after Puvis de Chavannes's *Hope.* 1894. Published in *Mercure de France,* February 1895

Fig. 24. Frieze from a tomb in Thebes (detail). c. 1500 B.C. The British Museum, London

Fig. 25. Paul Gauguin. *Standing Tahitian Nude.* 1892. Watercolor on paper, 15¼ × 12⅝" (40 × 32 cm). Musée de Peinture et de Sculpture, Grenoble

Fig. 26. Paul Gauguin. *Standing Tahitian Nude.* 1892. Charcoal on paper, 17¼ × 11¼" (43.8 × 28.5 cm). Private collection, Paris

Fig. 27. Buddhist temple relief (detail): *Meeting with an Ajīvaka-monk.* 9th century. Borobudur, Java

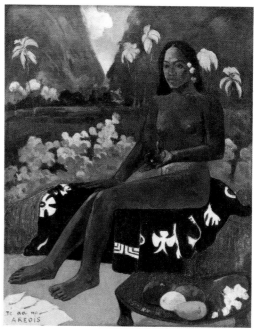

Paul Gauguin. *The Seed of the Areoi (Te aa no areois).* 1892 (cat. 24)

24. *The Seed of the Areoi (Te aa no areois).* 1892. Oil on burlap, 36¼ × 28⅜" (92.1 × 72.1 cm). Signed and dated lower center: "P. Gauguin 92." Inscribed lower left: "Te aa no AREOIS." Acquired from Jacques Seligmann & Co., Paris, 1936. Formerly collection A. Fontaine; Dr. Abel Desjardins; Desjardins collection. Exhibited at "Oeuvres récentes de Gauguin," Galerie Durand-Ruel, Paris, 1893; "Quatrième Exposition de La Libre Esthétique," Brussels, 1897; "Paul Gauguin," Kunsthalle, Basel, 1928; Le Portique, Paris, 1931; "Exposition de la décor de la vie sous la Troisième République," Musée du Louvre, Paris, 1933; "L'Impressionnisme," Palais des Beaux-Arts, Brussels, 1935; "Masterpieces of Art," New York World's Fair, 1940; "Art and the Stars," Demotte Galleries, New York, 1942; "Gauguin," Wildenstein & Co., New York, 1946; Jacques Seligmann & Co., New York, 1950; "Paintings from Private Collections," The Museum of Modern Art, New York, 1955. Acq. no. SPC 14.90 *Plate, p. 51*

[1]As, for example, in John Rewald, *Post-Impressionism: From van Gogh to Gauguin* (New York: The Museum of Modern Art, 1956), pp. 502–03.

[2]Gauguin's grip on the Tahitian language was, not surprisingly, very limited. In the case of the Paley Collection picture, Bengt Danielsson (*Gauguin in the South Seas* [Garden City, N.Y.: Doubleday, 1966], p. 109) notes that the artist has reproduced in his title a gross misspelling and a Frenchified plural "s" from Antoine Moerenhout's *Voyage aux îles du Grand Océan* (Paris, 1827), which was his primary source of information about Tahitian myths and beliefs.

[3]Most commentators do not attempt to identify the seed in Tehura's hand, although Danielsson (*Gauguin in the South Seas,* p. 109) declares it to be that of a coconut. The seed's size makes this unlikely, however, and Edward Dodd (*Polynesia's Sa-*

cred Isle [New York: Dodd, Mead, 1976], p. 117) states, correctly I believe, that "she is holding the sprouting seed of the hutu reva, the sacred marae tree" (which is a form of mango).

4The Areoi were, in effect, a religious secret society that was founded—at least a century before the Western discovery of Polynesia—on the island of Raiatea, whence it fanned out to the other islands. Although Oro, the deity to whom it was devoted, was primarily a war god, the activities of the society's itinerant members took the form of religious dancing and music-making. Within that context, they also carried on ritual copulation, independent of marital ties among the members. As a result of the "licentious" character of these activities, the clan was suppressed early on by Christian missionaries. For eighteenth- and nineteenth-century accounts, see Dodd, *Polynesia's Sacred Isle*, pp. 116–27.

5"Tehura spoke with a kind of religious dread of the sect or secret society of the Areoi, which ruled over the islands during the feudal epoch. Out of the confused discourse of the child I disentangle memories of a terrible and singular institution"; Paul Gauguin, *Noa-Noa*, trans. O. F. Theis (New York: Nicholas L. Brown, 1920), p. 114. In fact, Gauguin's account was lifted virtually verbatim from Moerenhout, *Voyages aux îles du Grand Océan*.

6According to Danielsson (*Gauguin in the South Seas*, p. 108), there still were a few people alive in the Tahiti of Gauguin's time who knew a good deal about its ancient lore. The most learned of these was the seventy-year-old mother of Queen Marau, Arü Taimai, who had married an Englishman named Salmon. She had earlier received both Robert Louis Stevenson and Henry Adams, to whom she recounted much of what she knew. For a variety of reasons, a poor Frenchman such as Gauguin would not have been received by her, and he was probably not even aware of her existence, not to speak of her special knowledge.

7Gauguin, *Noa-Noa*, pp. 114, 121.

8*Self-Portrait in Front of the "Yellow Christ"* (1889), reproduced in Michel Hoog, *Paul Gauguin: Life and Work* (New York: Rizzoli, 1987), pl. 52.

9The male figure has sometimes been identified, wrongly I believe, as the god Oro; for example, Jehanne Teilhet-Fisk, *Paradise Reviewed: An Interpretation of Gauguin's Polynesian Symbolism* (Ann Arbor: UMI Research Press, 1982), p. 44. Apart from the fact that this figure has none of the symbolic attributes we might expect of such a god, his gesture and expression are hardly believable as those of an austere and powerful deity. Moreover, in the myth, as Gauguin recounts it, Oro does not approach Vaïraümati upon first seeing her astonishing beauty, but sends an embassy of his sisters.

10There were no large stone Tikis on Tahiti, though Gauguin would see one *in situ* years later in the Marquesas. See Kirk Varnedoe, "Gauguin" (in *"Primitivism" in Twentieth-Century Art: Affinity of the Tribal and the Modern* [New York: The Museum of Modern Art, 1984], pp. 191–92), for the artist's "desultory" relationship with Polynesian art, which was based largely on photographs. The "double Tiki" in the background of Gauguin's picture may have been extrapolated from small Marquesan decorative objects of recent vintage sold in the shops of Papeete.

11There are about a dozen examples during Gauguin's Tahitian period of his having made two versions of a motif.

12In 1965, Paley noticed bits of flaking paint on the canvas and brought it to be repaired by painting conservators Sheldon and Caroline Keck, who discovered extensive repainting throughout. With Paley's approval, the Kecks removed almost all of what was not by the hand of Gauguin, and in doing so, rid the image of several inappropriate and iconographically confounding "adjustments": the expression of the eyes, a necklace, additional flowers in the figure's hair, several areas in the landscape, and lines which described the figure's breasts, navel, and limbs. Whoever had been responsible for the overpainting did not, thankfully, attempt to clean the picture and so the layer of overpainting plus several layers of varnish and a good deal of dirt, created a film which protected what was authentic, making the restoration laborious but uncomplicated. But while the Keck restoration of 1965 did away with what was obviously not genuine, it was not until the summer of 1991 that the Museum's Department of Conservation removed several additional layers of dirt and rather dark varnish, so that Gauguin's cooler tones, more matte colors, and unmistakably subtle application were revealed.

Unfortunately, many photographs of the vastly overpainted, pre-restored painting have been published thus far. Appearing in G. Wildenstein's catalogue raisoneé *Gauguin* (Paris: Les Beaux-Arts, 1964), that image continues to be assumed correct and can be found in monographs as recent and important as Françoise Cachin's *Gauguin* (Paris: Flammarion, 1988).

13Undated letter (November 1888) from Gauguin in Arles to Émile Bernard; *Correspondance de Paul Gauguin* (Greenwich, Conn.: New York Graphic Society, 1978), p. 274.

14For a discussion of the *pareu* cloth, see Varnedoe, "Gauguin," p. 208, note 60.

15Cited in Rewald, *Post-Impressionism*, p. 492.

25. *Two Tahitian Figures.* (1894).
Gouache and ink on paper, $9\frac{5}{8} \times 9\frac{1}{4}$" (24.5 × 23.5 cm).
Signed lower center: "P. Go."
Acquired from Wildenstein & Co., New York, 1941.
Formerly collection Gustave Fayet, Igny.
Exhibited at Pennsylvania Museum of Art, Philadelphia, 1933; "A Group of French Paintings Exhibited by Wildenstein," Pittsburgh Junior League Gallery, 1934; "Paul Gauguin," San Francisco Mu-

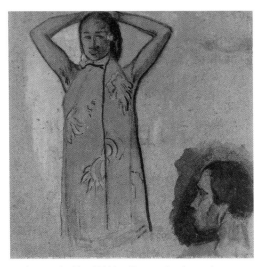

Paul Gauguin. *Two Tahitian Figures.* 1894 (cat. 25)

seum of Art, 1936; "The Art of Paul Gauguin," Art Institute of Chicago, 1988.
Acq. no. SPC 12.90

Paul Gauguin. *Tahitian Landscape*. 1899 (cat. 26)

26. *Tahitian Landscape*. (1899).
Oil on waxed burlap, 12⅛ × 18¼″ (31 × 46.5 cm).
Signed lower right: "P.Go."
Acquired in France, 1950.
Exhibited at "Gauguin," Wildenstein & Co., New York, 1956; "Cézanne to Miró," circulated by the International Council of The Museum of Modern Art to Museo Nacional de Bellas Artes, Buenos Aires, Museo de Arte Contemporáneo, Univer-

sidad de Chile, Santiago, and Museo de Bellas Artes, Caracas, 1968.
Acq. no. SPC 67.90
Plate, p. 57

[1]See Charles Estienne, *Gauguin* (Geneva: Skira, 1953), p. 71.

Alberto Giacometti
Swiss, 1901–1966. In Paris 1922–42, 1945–66; Switzerland 1942–45.

27. *Annette*. 1950.
Oil on canvas, 30⅜ × 15½″ (77.2 × 39.4 cm).
Signed and dated lower right: "Alberto Giacometti '50."
Acquired from Pierre Matisse Gallery, New York, 1950.
Exhibited at "Alberto Giacometti," Pierre Matisse Gallery, New York, 1950; "Alberto Giacometti," Solomon R. Guggenheim Museum, New York, 1955; "Trentesimo Esposizione Biennale Internationale d'Arte," Venice, 1962; "Alberto Giacometti," Kunsthaus, Zurich, 1962–63; Phillips Collection, Washington, D.C., 1963; "Alberto Giacometti," The Museum of Modern Art, New York, Art Institute of Chicago, Los Angeles County Museum of Art, and San Francisco Museum of Art, 1965–66; "Alberto Giacometti," L'Orangerie, Paris, 1969–70.
Acq. no. SPC 50.90
Plate, p. 59

[1]Jean-Paul Sartre, Introduction to *Alberto Giacometti: An Exhibition of Sculptures, Paintings, Drawings* (New York: Pierre Matisse Gallery, 1948), p. 30.

Juan Gris (José Victoriano González)
Spanish, 1887–1927. To France 1906.

28. *Mandolin and Grapes*. 1922.
Gouache and pencil on paper, 10 × 8″ (25.5 × 20.4 cm).

Alberto Giacometti. *Annette*. 1950 (cat. 27)

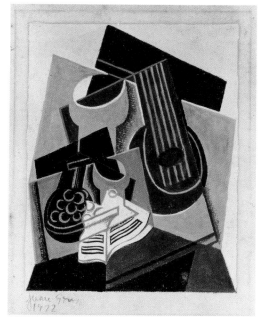
Juan Gris. *Mandolin and Grapes*. 1922 (cat. 28)

Signed and dated lower left: "Juan Gris 1922."
Acquired from Valentine Gallery, New York, 1954.
Acq. no. SPC 16.90
Plate, p. 61

[1] Daniel-Henry Kahnweiler, *Juan Gris: His Life and Work*, trans. Douglas Cooper (rev. ed., New York: Abrams, 1969), p. 134.
[2] Ibid., p. 144.
[3] Ibid., p. 16.

Al Held. *Black/White Roman XVII*. 1968 (cat. 29)

Al Held
American, born 1928.

29. *Black/White Roman XVII*. (1968).
Acrylic on canvas, 40¼ × 38¼" (102 × 97 cm).
Unsigned.
Acquired from André Emmerich Gallery, New York, 1969.
Exhibited at "Al Held," Institute of Contemporary Art of the University of Pennsylvania, Philadelphia, and Contemporary Arts Museum, Houston, 1968–69.
Acq. no. SPC 51.90
Plate, p. 63

[1] Irving Sandler, *Al Held* (New York: Hudson Hills, 1984), p. 73.
[2] Marcia Tucker, *Al Held* (New York: Whitney Museum of American Art, 1974), p. 15.

Edward Hopper
American, 1882–1967.

30. *Ash's House, Charleston, South Carolina*. (1929).
Watercolor and graphite pencil on wove paper, 14 × 20" (35.7 × 50.9 cm).
Signed lower right: "Edward Hopper Charleston S.C."
Acquired from Frank K. M. Rehn, Inc., New York, 1936.
Exhibited at "Edward Hopper Retrospective Exhibition," The Museum of Modern Art, New York, 1933; "Exhibition of Paintings by Edward Hopper," Arts Club of Chicago, 1934; "Thirteenth International Exhibition," Art Institute of Chicago, 1934; "Watercolors: Sheeler, Hopper, Burchfield," Fogg Art Museum, Harvard University, Cambridge,

Edward Hopper. *Ash's House, Charleston, South Carolina*. 1929 (cat. 30)

Massachusetts, 1934; "An Exhibition of Paintings, Watercolors and Etchings by Edward Hopper," Carnegie Institute, Pittsburgh, 1937; "Eighteenth International Exhibition," Art Institute of Chicago, 1939; "History of American Watercolor Painting," Whitney Museum of American Art, New York, 1942; "North Shore Arts Festival," World House Gallery, New York, 1964.
Acq. no. SPC 68.90
Plate, p. 65

[1] Edward Hopper, "Notes on Painting," in *Edward Hopper* (New York: The Museum of Modern Art, 1933), p. 17.

Jasper Johns. *Gray Alphabets*. 1968 (cat. 31)

Jasper Johns
American, born 1930.

31. *Gray Alphabets*. 1968.
Lithograph on paper, 59¹⁵⁄₁₆ × 41¹⁵⁄₁₆" (152.2 × 106.5 cm).
Signed and dated lower right: "J. Johns '68."
Inscribed lower left: "47/59."
Acquired from Leo Castelli Inc., New York, 1968.
Acq. no. SPC 52.90

John Kane. *Industry's Increase*. 1933 (cat. 32)

John Kane
American, born Scotland. 1860–1934. To U.S.A. 1880.

32. *Industry's Increase*. 1933.
Oil on canvas, 32¼ × 40¼" (81.9 × 102.2 cm).
Signed and dated lower right: "John Kane 1933."
Acquired from Valentine Gallery, New York, 1935.
Formerly collection the estate of John Kane.
Exhibited at "Thirty-first Annual International Exhibition of Paintings," Carnegie Institute, Pittsburgh, 1933; "John Kane Exhibition," Gallery 144 West Thirteenth Street, New York, 1934; "John Kane's Paintings," U.S. Department of Labor Building, Washington, D.C., 1935; "Kane Memorial Exhibition," Valentine Gallery, New York, 1935; "A Memorial Exhibition of the Paintings of John Kane," Department of Fine Arts, Carnegie Institute, Pittsburgh, 1936; Smith College Art Museum, Northampton, Massachusetts, 1936; "Masters of Popular Painting: Modern Primitives of Europe and America," The Museum of Modern Art, New York, 1938; "Trends in American Painting of Today," City Art Museum of St. Louis, 1940; "Survey of American Painting," Carnegie Institute, Pittsburgh, 1940; "Contemporary American Painting," Metropolitan Museum of Art, New York, and City Art Museum of Saint Louis, 1941–42 (also shown in Buenos Aires, Rio de Janeiro, and Montevideo); "Four Centuries of American Primitive Painting," Arts Club of Chicago, 1943; "American Painting," Tate Gallery, London, 1946; "American Painting in Our Century," Institute of Contemporary Art, Boston, Cleveland Museum of Art, J. B. Speed Art Museum, Louisville, M. H. De Young Memorial Museum, San Francisco, Albright-Knox Gallery, Buffalo, and Art Museum of Montreal, 1949; "Twelve Modern American Painters and Sculptors," Musée National d'Art Moderne, Paris, Kunsthaus, Zurich, Kunstsammlungen der Stadt Düsseldorf, Liljevalchs Konsthall, Stockholm, Taidehalli/Konsthallen, Helsinki, and Kunstnernes Hus, Oslo, 1953–54; "The Theater Collects American Art," Whitney Museum of American Art, New York, 1961.
Acq. no. SPC 53.90
Plate p. 67

[1] John Kane, *Sky Hooks: The Autobiography of John Kane, As Told to Marie McSwigan* (1938; rpt., Pittsburgh: University of Pittsburgh, 1971), p. 34.
[2] For a contemporaneous assessment of Kane's work *vis-à-vis* European modernism, see Alan Bur-

roughs, *Limners and Likenesses* (Cambridge, Mass.: Harvard University Press, 1936), pp. 212–13.
[3] Sidney Janis, *They Taught Themselves: American Primitive Painters of the Twentieth Century* (New York: Dial, 1942), p. 93.
[4] Kane, *Sky Hooks*, p. 82.

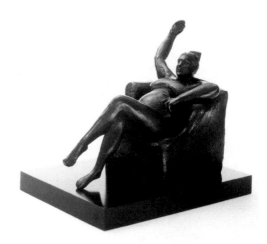

Gaston Lachaise. *Reclining Woman*. 1924 (cat. 33)

Gaston Lachaise
American, born France. 1882–1935. To U.S.A. 1906.

33. *Reclining Woman*. (1924).
Bronze on black marble base, 13¼ × 16¼ × 10" (33.7 × 41.3 × 25.4 cm); including base, 14¾ × 17½ × 11" (37.5 × 44.5 × 28 cm), cast 4/11.
Inscribed: "Lachaise Estate—4/11."
Inscribed on plinth: "G Lachaise."
Acq. no. SPC 47.90
Plate, p. 69

[1] See Gerald Nordland, *Gaston Lachaise: The Man and His Work* (New York: Braziller, 1974), p. 66.

Fig. 28. Morris Louis. *Third Element*. 1962. Synthetic polymer paint on unprimed canvas, 7'8¾" × 51" (207.5 × 129.5 cm). The Museum of Modern Art, New York. Blanchette Rockefeller Fund

Morris Louis. *Number 4-31*. 1962 (cat. 34)

Morris Louis
American, 1912–1962.

34. *Number 4-31.* (1962).
Oil on canvas, 6'10¾" × 58⅛" (210.2 × 147.7 cm).
Unsigned.
Acquired from Giacomina Dusio, Rapallo, Italy, 1968.
Acq. no. SPC 54.90
Plate, p. 71

[1]John Elderfield, *Morris Louis* (London: Hayward Gallery, Arts Council of Great Britain, 1974), n.p. See also Elderfield, *Morris Louis* (New York: The Museum of Modern Art, 1986), pp. 74–81.

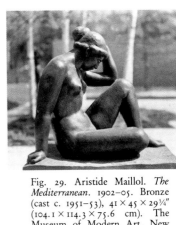

Fig. 29. Aristide Maillol. *The Mediterranean.* 1902–05. Bronze (cast c. 1951–53), 41 × 45 × 29¾" (104.1 × 114.3 × 75.6 cm). The Museum of Modern Art, New York. Gift of Stephen C. Clark

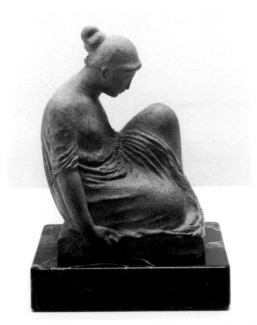

Aristide Maillol. *Seated Woman with Chignon.* 1900 (cat. 36)

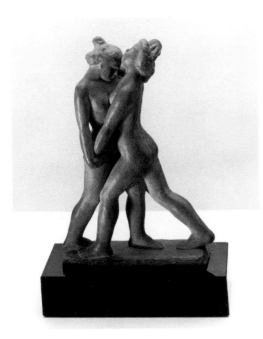

Aristide Maillol. *Two Women.* 1900 (cat. 35)

Acquired from Charles E. Slatkin Galleries, New York, 1957.
Acq. no. SPC 44.90
Plate, p. 73

[1]John Rewald, *Maillol* (London, Paris, and New York: Hyperion, 1939), p. 10.
[2]The best, if not the only, thorough survey of Maillol's early career is in Wendy Slatkin, *Aristide Maillol in the 1890s* (Ann Arbor, Mich.: UMI Research Press, 1982).
[3]Maillol, quoted in Andrew C. Ritchie, ed., *Aristide Maillol: An Introduction and Survey of the Artist's Work in American Collections* (Buffalo, N.Y.: Albright Art Gallery, 1945), p. 38.
[4]Ibid., p. 32.

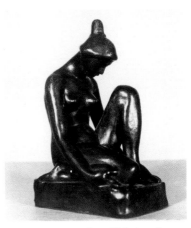

Fig. 30. Aristide Maillol. *Crouching Woman with Pointed Chignon.* 1900. Bronze, 7¼" (18.5 cm) high. Perls Galleries, New York

Aristide Maillol
French, 1861–1944.

35. *Two Women.* (1900).
Terra-cotta on black marble base, 7⅜ × 5¼ × 2⅜" (18.7 × 13.2 × 6.1 cm); including base, 8⅝ × 6 × 2½" (22 × 15.3 × 6.5 cm).
Inscribed on base: "M."
Acquired from Charles E. Slatkin Galleries, New York, 1957.
Formerly collection Albert Sarraut, Paris.
Acq. no. SPC 43.90
Plate, p. 74

36. *Seated Woman with Chignon.* (1900).
Terra-cotta on black marble base, 6⅞ × 4 × 5" (17.5 × 10.2 × 12.7 cm); including base, 8⅛ × 5⅞ × 4⅛" (20.6 × 15 × 10.5 cm).
Inscribed on base: "M."
Acquired from Charles E. Slatkin Galleries, New York, 1957.
Formerly collection Galerie Rosengart, Lucerne.
Acq. no. SPC 45.90
Plate, p. 75

37. *Seated Nude.* (1902).
Terra-cotta on black marble base, 6 × 8⅛ × 3½" (15.2 × 20.6 × 8.9 cm); including base, 7⅛ × 8½ × 3⅝" (8.1 × 21.5 × 9.2 cm).
Inscribed on base: "M."

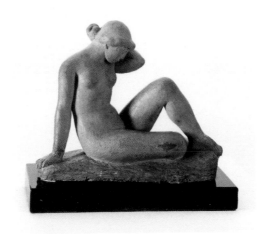

Aristide Maillol. *Seated Nude.* 1902 (cat. 37)

Édouard Manet
French, 1832–1883.

38. *Two Roses on a Tablecloth.* (1882–83).
Oil on canvas, 7⅝ × 9½" (19.3 × 24.2 cm).
Signed lower right: "Manet."
Acquired from Sam Salz, Inc., New York, 1951.

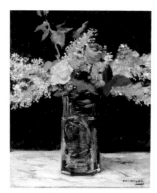

Fig. 31. Édouard Manet. *Vase of White Lilacs and Roses*. 1883. Oil on canvas, 22 × 18⅛" (55.9 × 46 cm). Dallas Museum of Art. The Wendy and Emery Reves Collection

Édouard Manet. *Two Roses on a Tablecloth*. 1882–83 (cat. 38)

Formerly collection Eugène Pertuiset, Paris; Auguste Pellerin, Paris; Gaston Bernheim de Villers, Monte Carlo.
Exhibited at "Manet," École Nationale des Beaux-Arts, Paris, 1884; "Manet," Galerie Matthiesen, Berlin, 1928; "Exposition d'Oeuvres de Manet au Profit des 'Amis du Luxembourg,'" Galerie Bernheim-Jeune, Paris, 1928.
Acq. no. SPC 17.90
Plate, p. 77

¹See Robert Gordon and Andrew Forge, *The Last Flowers of Manet* (New York: Abrams, 1986).
²Ibid., p. 10.
³Manet's ventures into still life fall into two very specific periods: the tabletop arrangements of 1864–65 and the late series done just prior to his death. The earlier, more allusive works, were rife with references to Manet's heroes, the Dutch and Venetian masters as well as Chardin. See Anne Coffin Hansen, *Manet and the Modern Tradition* (New Haven, Conn.: Yale University Press, 1977), pp. 69–73.

Agnes Martin
American, born Canada 1912. To U.S.A. 1933.

39. *Organ Note*. (1962).
Ink on wove paper, 12 × 9½" (30.5 × 24.1 cm).
Signed on reverse: "A. Martin."
Acquired from Robert Elkon Gallery, New York, 1969.
Acq. no. SPC 19.90

40. *Orchards of Lightning*. (1966).
Ink on wove paper, 12 × 9½" (30.5 × 24.1 cm).
Signed lower right: "A. Martin."
Inscribed in pencil along upper edge: "Flowers at the Window."
Acquired from Robert Elkon Gallery, New York, 1969.
Acq. no. SPC 18.90

Henri Matisse
French, 1869–1954.

41. *Lucien Guitry as Cyrano de Bergerac*. (1903).
Oil on canvas, 31¾ × 23½" (85.6 × 59.7 cm).
Signed lower right: "H. Matisse."
Acquired from Sam Salz, Inc., New York, 1957.
Formerly collection Ambroise Vollard, Paris; de Galéa collection.
Exhibited at "Le Theatre," Galerie Georges Petit,

Fig. 32. Photograph of Lucien Guitry. c. 1925

Fig. 33. Henri Matisse. *Male Model*. 1900. Oil on canvas, 39⅛ × 28⅝" (99.3 × 72.7 cm). The Museum of Modern Art, New York. Kay Sage Tanguy and Abby Aldrich Rockefeller Funds

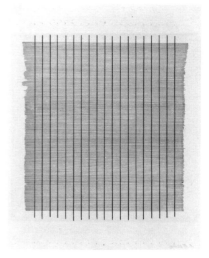

Agnes Martin. *Organ Note*. 1962 (cat. 39)

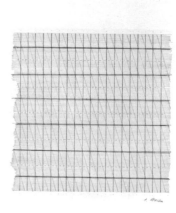

Agnes Martin. *Orchards of Lightning*. 1966 (cat. 40)

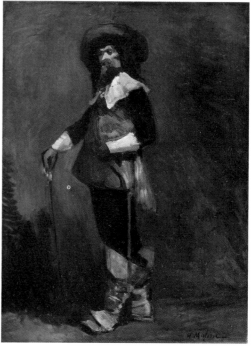

Henri Matisse. *Lucien Guitry as Cyrano de Bergerac*. 1903 (cat. 41)

Paris, 1905; L'Orangerie, Paris, 1948; North Shore Guidance Center, L.I., New York, 1961; North Shore Women's Auxiliary, L.I., New York, 1969.
Acq. no. SPC 70.90
Plate, p. 79

[1]Guitry was among the first actors to have played Cyrano (his contemporary Constant-Benoît Coquelin was the first) and became immensely popular in the role in 1900. By all accounts, Guitry was one of the best actors of his time and was reputed to be "greatest in parts that show an elemental man, a man who is brutal, rugged, rough shouldered, habituated to conquest and never stopping for anything moral or material"; "The Greatest Living Actor," *Chicago Tribune*, April 25, 1909.
[2]In 1903, Matisse was financially strapped, estranged from his family, unrecognized by critics, and suffering from terrifying self-doubt about his chosen career. See Alfred H. Barr, Jr., *Matisse: His Art and His Public* (New York: The Museum of Modern Art, 1951), pp. 40–41; and Pierre Schneider, *Matisse*, trans. Michael Taylor and Bridget Strevens Romer (New York: Rizzoli, 1984), p. 726.
[3]Barr, *Matisse*, pp. 38–39.
[4]"I have a different idea of elegance. I don't dress like a fop, it's true, but my moral grooming is impeccable. . . . I may not cut a stylish figure, but I hold my soul erect. I wear my deeds as ribbons, my wit is sharper than the finest moustache, and when I walk among men I make truths ring like spurs"; from Act I, scene iv, of Edmond Rostand, *Cyrano de Bergerac*, trans. Lowell Bair (New York: Penguin, 1972), p. 42.

42. *Landscape*. (1918).
Oil on panel, 13½ × 16½" (34.2 × 41.9 cm).
Signed lower right: "Henri Matisse."
Acquired from Valentine Gallery, New York, 1937.
Acq. no. SPC 71.90
Plate, p. 81

[1]"At no previous time," writes Jack Cowart, "would physical location or environment play so large and so long a role in contributing to the appearance of the resulting art. . . . Everything that is the Côte d'Azur conditioned Matisse's vision and personal spirit"; Cowart, "The Place of Silvered Light: An Expanded, Illustrated Chronology of Matisse in the South of France, 1916–1932," in Cowart and Dominique Fourcade, *Henri Matisse: The Early Years in Nice, 1916–1930* (Washington, D.C.: National Gallery of Art; New York: Abrams, 1986), p. 15. Matisse wrote, "Most people come here for the light and its picturesque quality. As for me, I come from the north. What made me stay are the great colored reflections . . . the luminosity of daylight"; cited in Cowart, "The Place of Silvered Light," p. 19.
[2]The most cogent analysis of the crucial importance of Renoir to Matisse's work can be found in Jack D. Flam, *Matisse: The Man and His Art, 1869–1918* (Ithaca, N.Y., and London: Cornell University Press, 1986), pp. 468–73.
[3]See Nicolas Watkins, *Matisse* (New York: Oxford University Press, 1985), p. 146.
[4]"Ah! Nice is a beautiful place. What a gentle and soft light in spite of its brightness! I don't know why I often compare it to that of the Touraine. Touraine light is a little more golden. Here it is silvered. Even the objects that it touches are very colored, such as the greens for example. I have often fallen on my face. After having written this declaration, I am

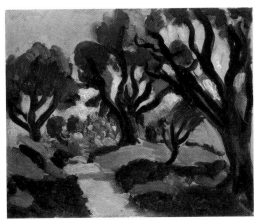
Henri Matisse. *Landscape*. 1918 (cat. 42)

Fig. 34. Henri Matisse. *Landscape of the Midi*. 1918. Oil on board, 13 × 16⅞" (33 × 42.9 cm). The Columbus Museum of Art, Ohio. Gift of Ferdinand Howald

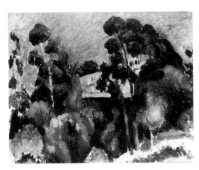
Fig. 35. Henri Matisse. *Eucalyptus, Mont Alban*. 1918. Oil on canvas, 12⅞ × 16⅛" (32.7 × 40.8 cm). The Baltimore Museum of Art. The Cone Collection

looking around the room where some of my daubs are hanging and I think I've hit it sometimes . . ."; Matisse, letter to Charles Camoin, May 23, 1918; cited in Cowart, "The Place of Silvered Light," p. 22.

43. *Woman with Anemones*. (1923).
Oil on canvas, 9⅝ × 7⅞" (24.5 × 20 cm).
Unsigned.
Acquired from Pierre Matisse Gallery, New York, 1951.
Formerly collection Mrs. Kenneth Wagg, New York.
Acq. no. SPC 20.90
Plate, p. 83

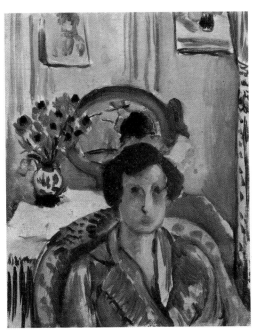
Henri Matisse. *Woman with Anemones*. 1923 (cat. 43)

44. *Odalisque with a Tambourine*. 1926.
Oil on canvas, 29¼ × 21⅞" (74.3 × 55.7 cm).
Signed and dated lower right: "Henri Matisse 26."
Acquired from Pierre Matisse, 1936.
Exhibited at "Henri Matisse," Galerien Thannhauser, Berlin, 1930; "The Thirtieth Carnegie Institute International Exhibition," Carnegie Institute, Pittsburgh, 1931; "Paul Cézanne, André Derain . . . ," Marie Harriman Gallery, New York, 1936; "Twentieth Anniversary Exhibition," Cleveland

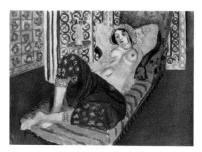

Fig. 36. Henri Matisse. *Odalisque in Red Culotte*. 1921. Oil on canvas, 26⅜ × 33⅛" (67 × 84 cm). Musée National d'Art Moderne, Centre Georges Pompidou, Paris

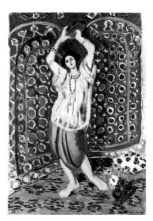

Fig. 37. Henri Matisse. *Odalisque with a Tambourine (Harmony in Blue)*. 1926. Oil on canvas, 36¼ × 25½" (91.4 × 64.8 cm). Norton Simon Art Foundation, Los Angeles

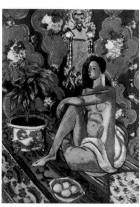

Fig. 38. Henri Matisse. *Decorative Figure on an Ornamental Background*. 1925. Oil on canvas, 44½ × 38⁹⁄₁₆" (131 × 98 cm). Musée National d'Art Moderne, Centre Georges Pompidou, Paris

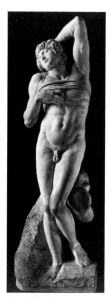

Fig. 39. Michelangelo Buonarroti. *Dying Slave*. 1513–16. Marble, 7′5″ (226 cm) high. Musée du Louvre, Paris

Fig. 40. Henri Matisse. *Large Seated Nude*. 1923–25. Bronze, 31¼ × 30½ × 13¾" (79.4 × 77.5 × 34.9 cm). The Museum of Modern Art, New York. Gift of Mr. and Mrs. Walter Hochschild (by exchange)

Fig. 41. Matisse's studio, place Charles-Félix, Nice. 1925

Henri Matisse. *Odalisque with a Tambourine*. 1926 (cat. 44)

Museum of Art, 1936; "Les Maîtres de l'art indépendant 1895–1937," Petit Palais, Paris, 1937; "Picasso, Henri Matisse," Institute of Modern Art, Boston, 1938; "Exhibition of Paintings by Henri Matisse," Arts Club of Chicago, 1939; "Art in Progress: Fifteenth Anniversary Exhibition," The Museum of Modern Art, New York, 1944; "Henri Matisse," The Museum of Modern Art, New York, Cleveland Museum of Art, Art Institute of Chicago, and San Francisco Museum of Art, 1951–52; "Henri Matisse: 64 Paintings," The Museum of Modern Art, New York, 1966; "Henri Matisse: Exposition du centenaire," Grand Palais, Paris, 1970.
Acq. no. SPC 21.90
Plate, p. 85

¹On the Odalisque series, see Jean Guichard-Meili, "The Odalisques," in *Homage to Henri Matisse* (New York: Tudor, 1970), pp. 63–69; Alfred H. Barr, Jr., *Matisse: His Art and His Public* (New York: The Museum of Modern Art, 1951), pp. 211–15; Jack Cowart and Dominique Fourcade, *Henri Matisse: The Early Years in Nice, 1916–1930* (Washington, D.C.: National Gallery of Art; New York: Abrams, 1986), pp. 32–36. See also Janet Hobhouse, "Odalisques: What Did These Sensuous Images Really Mean to Matisse?" *Connoisseur*, 217 (January 1987), pp. 60–67.
²"By 1925," writes Watkins, "a note of ennui had entered Matisse's work: he produced fewer canvases and with greater difficulty. His subject matter no longer reflected his sensuous enjoyment of surface appearances and light. Light ceased to have the same unifying power. The atmosphere of his paintings became heavier, the patterns more dense, and the paint surface reflected his constant changes of mind. His models, who had previously been treated as a central point of focus setting the mood of an interior, were enlarged to fill the canvas format. It was as though he was taking on—without sacrificing the qualities of either—both the sculptural monumentality of Picasso's contemporary nudes in a neoclassic style and the profuse patterning seen in the

majority of the pavilions at the giant Exposition des Arts Décoratifs, held in Paris in 1925"; Nicolas Watkins, *Matisse* (New York: Oxford University Press, 1985), p. 163.

Barr suggested that this shift in treatment "was primarily an internal and self-generating reaction such as he had undergone in 1897 when he repudiated his own early academic success for the arduous career of the independent pioneer—not, of course, that Matisse faced such risks in 1925 as he had in 1897, since his reputation was by now more secure than that of any living artist"; Barr, *Matisse*, p. 200.

[3]The best summary of this picture remains Barr's (*Matisse*, pp. 213–14). On the transformation of the studio into Matisse's theatrical setting, see Cowart and Fourcade, *Henri Matisse*, pp. 30–32.

[4]With the exception of the 1915 *Head of Marguerite* and three minor and unresolved bronzes begun during his first days in Nice, Matisse had done no work in sculpture since 1912. See Albert Elsen, *The Sculpture of Henri Matisse* (New York: Abrams, 1972), pp. 136–53.

[5]On the frustration and ennui which threatened to overcome the artist in 1925–26, see Watkins, *Matisse*, pp. 163–64.

[6]The influence of Michelangelo on Matisse had a long gestation but cannot really be discerned until almost six years after Matisse began his study. The painter wrote to Charles Camoin in 1918: "I am working at the École des Arts Décoratifs directed by Audra, a former student of Moreau—I am drawing the *Night* and modelling it. I am also studying the *Lorenzo de Medici* of Michelangelo. I hope to instill in myself the clear and complex conception of Michelangelo's construction"; Matisse, letter to Camoin, April 10, 1918; quoted in Jack Cowart, "The Place of Silvered Light," in Cowart and Fourcade, *Matisse*, p. 21. Watkins cautions, however, that Matisse's conception of Michelangelo be understood as that of an artist looking to unite the volumetric bathers of Renoir and the faceted planes of Cézanne with the poses of Michelangelo; see Watkins, *Matisse*, p. 164.

[7]Schneider writes on the articulation of the ambitious *Large Seated Nude* that "the model's musculature posed a problem. In his paintings, Matisse was able to integrate without much trouble . . . the body in a relaxed position—flesh—into his by now irreversible decorative style. However, the tensed body—flexed muscles—seemed to require realist modelling, and this was incompatible with the abstract style. . . . His Michelangelesque figures are the result of, on the one hand, an exaggeration of anatomical structures and, on the other, a heightening of abstract construction"; Pierre Schneider, *Matisse*, trans. Michael Taylor and Bridget Strevens Romer (New York: Rizzoli, 1984), p. 527.

45. *Woman with a Veil*. (1927).
Oil on canvas, 24¼ × 19¾" (61.5 × 50.2 cm).
Signed lower left: "Henri-Matisse."
Acquired from the artist, 1936.
Exhibited at Salon d'Automne, Grand Palais, Paris, 1927; "Henri Matisse," Galerien Thannhauser, Berlin, 1930; Galerie Pierre Loeb, Paris, 1930; "Henri Matisse: Exposition organisée au profit de l'Orphelinat des Arts," Galerie Georges Petit, Paris, 1931; "Henri Matisse: Retrospective Exhibition," The Museum of Modern Art, New York, 1931; "Henri Matisse," Kunsthalle, Basel, 1931; "Henry Matisse," Arthur Tooth & Sons, London, 1933; "Ancient Chinese and Modern European Paintings,"

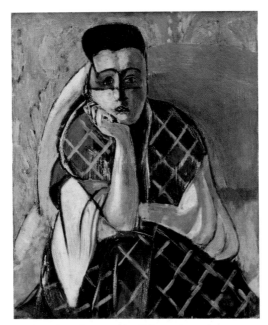

Henri Matisse. *Woman with a Veil*. 1927 (cat. 45)

Bignou Gallery, New York, 1943; "Henri Matisse: Retrospective Exhibition of Paintings, 1898–1939," Pierre Matisse Gallery, New York, 1943; "Henri Matisse: Retrospective Exhibition of Paintings, Drawings, and Sculpture," Philadelphia Museum of Art, 1948; "Matisse," Hayward Gallery, London, 1968; "Henri Matisse: The Early Years in Nice, 1916–1930," National Gallery of Art, Washington, D.C., 1986–87.
Acq. no. SPC 22.90
Plate, p. 89

[1]"My models, human figures are never just 'extras' in an interior. They are the principal theme in my work. I depend entirely on my model, whom I observe at liberty, and then I decide on the pose which best suits *her nature*"; Henri Matisse, "Notes d'un peintre sur son dessin," *Le Point* (Paris), no. 21 (July 1939), as translated in *Matisse on Art*, ed. Jack D. Flam (London: Phaidon, 1973), p. 82.

[2]See William S. Paley, *As It Happened: A Memoir* (Garden City, N.Y.: Doubleday), p. 100.

[3]Henriette Darricarrère was Matisse's primary model during the 1920s. On the way she incarnated "the artistic and psychological atmosphere of these *niçoise* years, 1920 to 1927," see Jack Cowart, "The Place of Silvered Light: An Expanded, Illustrated Chronology of Matisse in the South of France, 1916–1932," in Cowart and Dominique Fourcade, *Henri Matisse: The Early Years in Nice, 1916–1930* (Washington, D.C.: National Gallery of Art; New York: Abrams, 1986), p. 26–27.

[4]See Jack D. Flam, "Matisse and the Fauves," in William Rubin, ed., *"Primitivism" in Twentieth-Century Art: Affinity of the Tribal and the Modern* (New York: The Museum of Modern Art, 1984), vol. 1, pp. 230–31.

[5]The model's expression here has led Pierre Schneider to conclude that in this painting, "one can surely detect a reminiscence" of Michelangelo's figure of Lorenzo de' Medici, who also has his head covered and rests his thought-beclouded head upon his hand; see Pierre Schneider, *Matisse*, trans. Michael Taylor and Bridget Strevens Romer (New York: Rizzoli, 1984), p. 528. John Jacobus suggests that the pose is "especially typical" of the work of

Fig. 42. Henri Matisse. *Mme Matisse*. 1913. Oil on canvas, 57⅜ × 38¼" (146.4 × 97.1 cm). The Hermitage Museum, Leningrad

Fig. 43. Henri Matisse. *Odalisque, Half-Length (The Tatoo)*. 1923. Oil on canvas, 13¾ × 9⁷⁄₁₆" (35 × 24 cm). National Gallery of Art, Washington, D.C. Chester Dale Collection

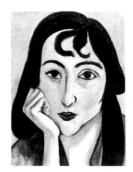

Fig. 44. Henri Matisse. *Head of Laurette*. 1917. Oil on panel, 13¾ × 10⅜" (34.9 × 26.4 cm). Collection Mr. and Mrs. William R. Acquavella, New York

Fig. 45. Pablo Picasso. *Girl Before a Mirror*. 1932. Oil on canvas, 64 × 51¼" (162.3 × 130.2 cm). The Museum of Modern Art, New York. Gift of Mrs. Simon Guggenheim

Ingres, which, he asserts, Matisse was then studying; see John Jacobus, *Henri Matisse* (New York: Abrams, 1973), p. 39.

46. *Seated Woman with a Vase of Narcissus*. 1941.
Oil on canvas, 13 × 16⅛″ (33.1 × 41 cm).
Signed and dated upper right: "Henri Matisse 6/41."
Acquired from Valentine Gallery, New York, 1948.
Formerly collection Pierre Matisse, New York.
Acq. no. SPC 69.90
Plate, p. 93

Henri Matisse. *Seated Woman with a Vase of Narcissus*. 1941 (cat. 46)

Joan Miró. *Figures and Star*. 1949 (cat. 47)

Joan Miró
Spanish, 1893–1983. In Paris 1919–40.

47. *Figures and Star*. 1949.
Oil and pastel on canvas, 5⅝ × 9½″ (14.3 × 24.1 cm).
Signed and dated on reverse: "Miró 1949."
Acquired from Pierre Matisse Gallery, New York, 1950.
Acq. no. SPC 23.90

Robert Motherwell
American, 1915–1991.

48. *In Black with Pink*. (1966).
Oil and collage on canvas board, 20 × 16″ (50.8 × 40.6 cm).
Unsigned.
Acquired from Marlborough Gallery, New York, 1970.
Acq. no. SPC 24.90
Plate, p. 95

Robert Motherwell. *In Black with Pink*. 1966 (cat. 48)

Ben Nicholson
British, 1894–1982.

49. *Rhodos (Variation on a Theme, No. 4)*. 1965.
Gouache, ink, and pastel on paper, mounted on Masonite, sheet 6⅛ × 6″ (15.5 × 15.2 cm); masonite 11⅜ × 11″ (28.9 × 28 cm).
Signed and dated on reverse of drawing: "Rhodos no. 4 Nicholson 65."
Signed and dated in pencil on reverse of board: "Nicholson 1965 Rhodos no. 4—."
Acquired from Marlborough–New London Gallery, London, 1968.
Exhibited at "Ben Nicholson," Marlborough–New London Gallery, London, 1968.
Acq. no. SPC 25.90

Ben Nicholson. *Rhodos (Variation on a Theme, No. 4)*. 1965 (cat. 49)

Kenneth Noland
American, born 1924.

50. *Sounds in the Summer Night*. (1962).
Acrylic on canvas, 69¾ × 70″ (177.3 × 177.7 cm).
Unsigned.

Kenneth Noland. *Sounds in the Summer Night.* 1962
(cat. 50)

Acquired from Lawrence Rubin, New York, 1968.
Acq. no. SPC 72.90
Plate, p. 97

[1] Kenneth Noland, quoted in Philip Leider, "The Thing in Painting Is Color," *New York Times,* August 25, 1968.
[2] Kenneth Noland, quoted in "Hitting the Bullseye," *Newsweek,* April 16, 1962, p. 108; cited in Kenworth Moffett, *Kenneth Noland* (New York: Abrams, 1977), p. 49.

Pablo Picasso
Spanish, 1881–1973. To France 1904.

51. *Circus Rider.* (1905).
Ink and watercolor on wove paper, 8¾ × 5⅛"
(22.2 × 13.1 cm).
Signed upper right: "Picasso."
Acquired as a gift from Barbara Paley, 1953.
Formerly collection Galerie Kahnweiler, Paris.
Acq. no. SPC 57.90

52. *La Coiffure.* (1905).
Ink and graphite pencil on brown paper sugar wrapping, 6¾ × 4¼" (17.1 × 10.8 cm) irregular.
Signed lower right: "Picasso."
Acquired from Pierre Matisse Gallery, 1950.
Formerly collection Maurice Level.
Acq. no. SPC 28.90

53. *Boy Leading a Horse.* (1905–06).
Oil on canvas, 7'2⅞" × 57⅝" (220.6 × 131.2 cm).
Signed lower right: "Picasso."
Acquired through Albert Skira, Geneva, 1936.
Formerly collection Ambroise Vollard, Paris; Gertrude and Leo Stein, Paris; Paul von Mendelssohn-Bartholdy, Berlin; Justin Thannhauser, Munich; Siegfried Rosengart, Lucerne.
Exhibited at "French Painting," Marie Harriman Gallery, New York, 1937; "Twenty Years in the Evolution of Picasso, 1903–23," Jacques Seligmann & Co., New York, 1937; "Picasso, Henri Matisse," Institute of Modern Art, Boston, 1938; "Art In Our Time," The Museum of Modern Art, New York, 1939; "Picasso: Forty Years of His Art," The Museum of Modern Art, New York, Art Institute of Chicago, City Art Museum of Saint Louis, Museum of Fine Arts, Boston, San Francisco Museum of Art, Cincinnati Museum of Art, Cleveland Museum of Art, Isaac Delgado Museum, New Orleans, Minneapolis Institute of Arts, and Carnegie

Fig. 46. Kenneth Noland. *Turnsole.* 1961. Synthetic polymer paint on unprimed canvas, 7'10⅛" × 7'10⅛" (239 × 239 cm). The Museum of Modern Art, New York. Blanchette Rockefeller Fund

Pablo Picasso. *Circus Rider.* 1905 (cat. 51)

Pablo Picasso. *La Coiffure.* 1905 (cat. 52)

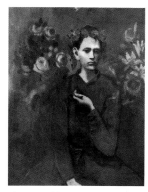

Fig. 47. Pablo Picasso. *Boy with a Pipe*. 1905. Oil on canvas, 39⅜ × 32″ (100 × 81.3 cm). Collection Mrs. John Hay Whitney, New York

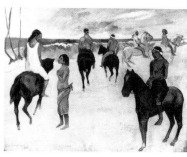

Fig. 48. Pablo Picasso. *The Watering Place*. 1905–06. Gouache on pulp board, 14⅞ × 22⅛″ (37.7 × 57.9 cm). The Metropolitan Museum of Art, New York. Bequest of Scofield Thayer

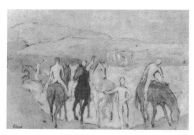

Fig. 49. Paul Gauguin. *Riders on the Beach*. 1902. Oil on canvas, 28¹⁵⁄₁₆ × 36″ (73.5 × 91.5 cm). Private collection

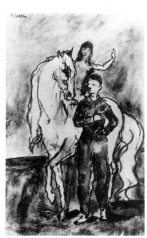

Fig. 50. Pablo Picasso. *Girl on Horseback and Boy on Foot*. 1906. Watercolor on paper, 20¹⁄₁₆ × 13⁹⁄₁₆″ (51 × 34.5 cm). Whereabouts unknown

Fig. 51. Pablo Picasso. *Boy and Horse*. 1906. Watercolor on paper pasted on wood, 19¹¹⁄₁₆ × 12⅝″ (50 × 32 cm). Tate Gallery, London

Fig. 52. El Greco. *Saint Martin and the Beggar*. 1597–99. Oil on canvas, 6′3⅛″ × 38⅝″ (190.8 × 98.1 cm). National Gallery of Art, Washington, D.C. Widener Collection

Fig. 53. Pablo Picasso. *The Boy with the Horse*. 1905–06. Watercolor on paper, 19¾ × 12¹⁵⁄₁₆″ (50.1 × 32.8 cm). The Baltimore Museum of Art. The Cone Collection

Fig. 54. Pablo Picasso. *The Watering Place*. 1906. Watercolor on paper, 12³⁄₁₆ × 19⁵⁄₁₆″ (31 × 49 cm). Whereabouts unknown. Formerly collection Baron Alain de Rothschild

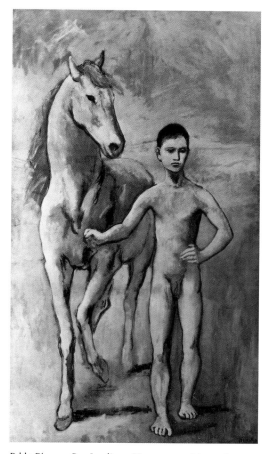

Pablo Picasso. *Boy Leading a Horse*. 1905–06 (cat. 53)

Institute, Pittsburgh, 1939–41; "Masterpieces of Picasso," The Museum of Modern Art, New York, 1941; "Loan Exhibition of Great Paintings in Aid of Merchant Seamen," Art Gallery of Toronto, 1944; "Picasso," Sociedad de Arte Moderno, Mexico City, 1944; "Picasso," Denver Art Museum, 1945; "Early Picasso," M. Knoedler & Co., New York, 1947; "Pictures for a Picture of Gertrude Stein as a Collector and Writer on Art and Artists," Yale University Art Gallery, New Haven, Connecticut, 1951; "Paintings from Private Collections," The Museum of Modern Art, New York, 1955; "Picasso: Seventy-fifth Anniversary Exhibition," The Museum of Modern Art, New York, Art Institute of Chicago, and Philadelphia Museum of Art, 1957–58; "Works of Art Given or Promised," The Museum of Modern Art, New York, 1958; "Signposts of the Twentieth Century," Dallas Museum for Contemporary Arts, 1959; M. Knoedler Gallery, New York, 1961; "Picasso: Eightieth Birthday Exhibition," The Museum of Modern Art, New York, 1962; "Picasso: An American Tribute," nine galleries, New York, 1962; "Four Americans in Paris: The Collections of Gertrude Stein and Her Family," The Museum of Modern Art, New York, Baltimore Museum of Art, and San Francisco Museum of Art, 1970–71; "Picasso in the Collection of The Museum of Modern Art," The Museum of Modern Art, New York, 1972; "Pablo Picasso: A Retrospective," The Museum of Modern Art, New York, 1980.

Acq. no. 575.64
Plate, p. 99

166

[1]This is meant in the broad affective sense conventionally signified by these colors, as in "feeling blue" and "seeing the world through rose-colored glasses" (*la vie en rose*).

[2]Picasso met the first important love of his life, Fernande Olivier, in the summer of 1904 and thirteen months later she moved into his studio for what would be seven years.

[3]It was in spring 1906, while Picasso was still working on the *Watering Place* project, that Vollard completed a deal to purchase *en bloc* thirty works, mostly of the Rose Period, for 2,000 francs. It was Picasso's first large-scale sale.

[4]On P'tit Louis, see John Richardson, *A Life of Picasso* (New York: Random House, 1991), vol. 1, p. 340.

[5]Ibid.

[6]During a discussion of a painting whose heretofore unreadable motif was identified by the artist as a group of long-stemmed Javanese pipes (see the author's *Picasso in the Collection of The Museum of Modern Art* [New York: The Museum of Modern Art, 1972], p. 11), Picasso told me of the avidity with which he collected pipes. Joking about the ("amateurish") way I treated my own meerschaum, Picasso revealed a detailed knowledge of pipe lore.

[7]Gauguin's *Riders on the Beach* was shown by Vollard in 1903 and remained in his possession at least several years more, perhaps even until 1911. Picasso, who had almost as much interest in Gauguin's work as in Cézanne's, surely saw it in the dealer's *cave*, probably more than once, in 1904–06.

[8]Picasso's sense of competitiveness with Matisse, especially in the early years of their acquaintance, has been frequently noted. Long ago, Alfred Barr ("Matisse, Picasso, and the Crisis of 1907," *Magazine of Art*, 44 [May 1951] pp. 163–70) suggested that Picasso's 1907 *Les Demoiselles d'Avignon* was intended as a reply to Matisse's large *Bonheur de vivre*, shown in the April 1906 Salon des Indépendants and probably seen by Picasso at the Steins' some months earlier. While that remains true in the most profound sense, Picasso's more immediate reaction to the Matisse was, I believe, his own projected monumental pastoral, *The Watering Place*. This work would have done battle with Matisse more on the latter's own home ground (in conceptual and stylistic terms) and its huge size would have made even *Bonheur de vivre* look puny. It is Picasso's good fortune that he gave up this project, allowing his desire for a monumental "reply" to evolve into the *Demoiselles*, a work that surely challenged Matisse's vanguard supremacy however much it failed to impress Matisse himself. It is not accidental, I think, that *Boy Leading a Horse*, the survivor, so to say, of *The Watering Place*, should have been bought by the Steins, who had also acquired *Bonheur de vivre*.

[9]Richardson, *A Life of Picasso*, pp. 426–27.

[10]For Picasso's tendency to move increasingly in the years 1905–07 toward a frontal, more "iconic" image, see William Rubin, "From Narrative to 'Iconic' in Picasso: The Buried Allegory in *Bread and Fruitdish on a Table* and the Role of *Les Demoiselles d'Avignon*," *The Art Bulletin*, 65 (December 1983), pp. 615–48.

[11]From June 1901, Picasso was for many years a frequent visitor to Vollard's *cave*. He told the author of various occasions when Vollard notified him of having something special there to see.

[12]This is pointed out by S. Mayer in "Ancient Mediterranean Sources in the Works of Picasso,

Fig. 55. Pablo Picasso. Sketch for *Boy Leading a Horse*. 1905–06. Watercolor on paper, 9¼ × 6⅛″ (23.5 × 16.7 cm). The Baltimore Museum of Art. The Cone Collection

Fig. 56. Pablo Picasso. Sketch for *Boy Leading a Horse*. 1906. Drawing, 9⁷⁄₁₆ × 6⁵⁄₁₆″ (24 × 16 cm). Whereabouts unknown

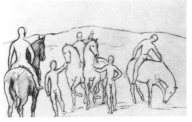

Fig. 57. Pablo Picasso. Sketch for *The Watering Place*. 1906. Pencil drawing, 11½ × 17½″ (29.2 × 44.5 cm). The Chrysler Museum, Norfolk, Virginia

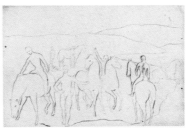

Fig. 58. Pablo Picasso. *The Watering Place*. 1905. Drypoint, 4¹³⁄₁₆ × 7⅜″ (12.2 × 18.7 cm). The Museum of Modern Art, New York. Gift of Abby Aldrich Rockefeller

Fig. 59. Paul Cézanne. *The Bather*. 1885. Oil on canvas, 50 × 38⅛″ (127 × 96.8 cm). The Museum of Modern Art, New York. The Lillie P. Bliss Collection

Fig. 60. Paul Gauguin. *In the Vanilla Grove, Man and Horse* (detail). 1891. Oil on burlap, 28¾ × 36¼″ (73 × 92 cm). Solomon R. Guggenheim Museum, New York. Justin K. Thannhauser Collection

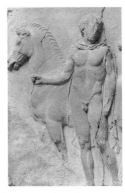

Fig. 61. *Youth with Horse* (Parthenon Frieze, west wall). c. 445 B.C. The British Museum, London

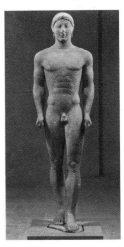

Fig. 62. *Kouros* from Attica. c. 540–530 B.C. Staatliche Antikensammlungen und Glyptothek, Munich

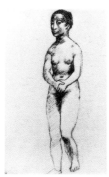

Fig. 63. Pablo Picasso. *Nude Standing with Joined Hands.* 1906. Conté crayon on paper, 24½ × 18⅝" (62.2 × 47.3 cm). Whereabouts unknown. Formerly collection of Mr. and Mrs. Leigh B. Block, Chicago

Fig. 64. Pablo Picasso. *Nude Standing at Red Arch.* 1906. Oil on canvas, 10¼ × 7⅟₁₆" (26 × 18 cm). The Barnes Foundation, Merion, Pennsylvania

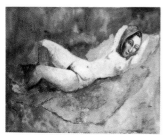

Fig. 65. Pablo Picasso. *Reclining Nude.* 1906. Gouache on paper, 18⅝ × 24⅛" (47.3 × 61.3 cm). The Cleveland Museum of Art. Gift of Mr. and Mrs. Michael Straight

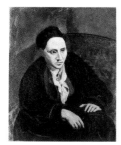

Fig. 66. Pablo Picasso. *Gertrude Stein.* 1906. Oil on canvas, 39⅜ × 32" (100 × 81.2 cm). The Metropolitan Museum of Art, New York. Bequest of Gertrude Stein

1892–1937" (Ph.D. dissertation, New York University, 1980), Pt. 1, p. 199.

[13]Meyer Schapiro, lectures at Columbia University.

[14]Puvis's work was of considerable interest to Picasso, as it had been for many other vanguard artists beginning with Seurat. In 1902 Picasso had made drawings after Puvis's frescoes in the Panthéon and used one of his figures for *The Old Guitarist* of 1903. On Puvis and Picasso, see Anthony Blunt and Phoebe Pool, *Picasso: The Formative Years—A Study of His Sources* (Greenwich, Conn.: New York Graphic Society, 1962), pp. 25–26.

[15]"Rose-water Hellenism" is a term employed in the literary criticism of the late nineteenth century. Meyer Schapiro was the first to apply it to Puvis.

54. *Girl with Scarf (Andorran Peasant).* (1906).
Brown ink on wove paper, 8¾ × 6¼" (22.1 × 15.9 cm).
Signed lower right: "Picasso."
Acq. no. SPC 56.90

Pablo Picasso. *Girl with Scarf (Andorran Peasant).* 1906 (cat. 54)

Pablo Picasso. *Nude with Joined Hands.* 1906 (cat. 55)

55. *Nude with Joined Hands.* (1906).
Oil on canvas, 60½ × 37⅛" (153.7 × 94.3 cm).
Unsigned.
Acquired from Succession Gertrude Stein, Paris, 1968.
Formerly collection Gertrude Stein, Paris.
Exhibited at "Picasso, 1900–1914," Maison de la Pensée Française, Paris, 1934; "Picasso, deux Périodes," Maison de la Pensée Française, Paris, 1954; "Picasso," Musée Cantini, Marseilles, 1959; "Four Americans in Paris: The Collections of Gertrude Stein and Her Family," The Museum of Modern Art, New York, Baltimore Museum of Art, and San Francisco Museum of Art, 1970–71; "Paris/New

York," Musée National d'Art Moderne, Paris, 1977.
Acq. no. SPC 27.90
Plate, p. 105

56. *The Architect's Table.* (early 1912).
Oil on canvas, 28⅜ × 23½" (72.6 × 59.7 cm).
Signed on reverse: "Picasso."
Acquired from Succession Gertrude Stein, Paris, 1968.
Formerly collection Galerie Kahnweiler, Paris; Gertrude Stein, Paris; Succession Gertrude Stein, Paris.
Exhibited at "Oeuvres choisies du vingtième siècle," Galerie Max Kaganovitch, Paris, 1951; "Four Americans in Paris: The Collections of Gertrude Stein and Her Family," The Museum of Modern Art, Baltimore Museum of Art, and San Francisco Museum of Art, 1970–71; "Gertrude Stein Estate," National Gallery of Canada, Ottawa, 1971; "Picasso in the Collection of The Museum of Modern Art," The Museum of Modern Art, New York, 1972; "Paris/New York," Musée National d'Art Moderne, Paris, 1977; "Pablo Picasso: A Retrospective," The Museum of Modern Art, New York, 1980; "Pablo Picasso, 1881–1973; Exposicion Antológica," Museo Español de Arte Contemporáneo, Madrid, and Museu Picasso, Barcelona, 1981–82; "Contrasts of Form: Geometric Abstract Art, 1910–1980," The Museum of Modern Art, New York, 1985–86; Sammlung E. G. Bührle, Zurich, 1989–90; "Picasso und Braque: Die Geburt des Kubismus," Kunstmuseum, Basel, 1990.
Acq. no. 697.71
Plate, p. 107

[1]This picture is identified in Zervos (II, 321) as *La Bouteille de Marc (Ma Jolie).* Margaret Potter (*Four Americans in Paris* [New York: The Museum of Modern Art, 1970], p. 171) points out that in a letter to Gertrude Stein, Picasso called it simply "*votre nature morte (ma jolie),*" while Kahnweiler's letter to

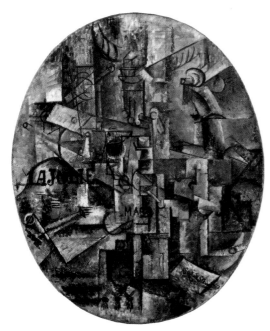

Pablo Picasso. *The Architect's Table*. 1912 (cat. 56)

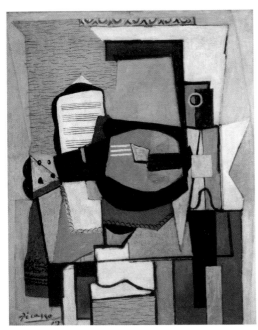

Pablo Picasso. *The Guitar*. 1919 (cat. 57)

Stein regarding the sale of the painting referred to it as *The Architect's Table*.

²Margaret Potter drew to my attention the passage in Gertrude Stein's *Autobiography of Alice B. Toklas* ([New York: Harcourt, Brace, 1933], p. 136) that mentions a visit of Stein and Toklas to Picasso's studio on the rue Ravignan early in 1912. As the painter was not at home, Stein left her calling card, and a few days later discovered that Picasso had worked a reference to it into *The Architect's Table*, then in progress. Her subsequent purchase of this picture was the first Picasso acquisition she made independently of her brother.

³Georges Braque to John Richardson in conversation, 1952.

⁴Braque described the letters as "forms which could not be distorted because, being themselves flat, the letters were not in space, and thus by con-

trast their presence in the picture made it possible to distinguish between objects situated in space and those that were not"; in Dora Vallier, "Braque: La Peinture et nous," *Cahiers d'art*, 29 (October 1954), p. 16.

⁵Clement Greenberg, "The Pasted-Paper Revolution," *Art News*, 57 (September 1958), reprinted as "Collage" in his *Art and Culture: Critical Essays* (Boston: Beacon Press, 1961), p. 73. This brilliant formal analysis is devoted to the crucial transitional period of 1912–14.

⁶The refrain of "Dernière chanson" begins "O Manon, ma jolie, mon coeur te dit bonjour." Maurice Jardot (*Picasso* [Paris: Musée des Arts Décoratifs, 1955], no. 26) identifies it as a well-known song of 1911 composed by Fragson and based upon a motif from a dance by Herman Finck; see Jeffrey S. Weiss, "Picasso, Collage, and the Music Hall," in Kirk Varnedoe and Adam Gopnik, eds., *Modern Art and Popular Culture: Readings in High and Low* (New York: The Museum of Modern Art; Abrams, 1990), especially pp. 83, 106 (note 4), and fig. 81.

⁷Letter to Kahnweiler, June 12, 1912; cited in Jardot, *Picasso*, no. 30. In some paintings of 1912 Picasso went beyond the allusion involved in the inscription MA JOLIE, writing J'AIME EVA on the surface.

⁸The image of pictorial reality as perfume—which, though it can be sensed, is insubstantial and cannot be located in space—seems particularly appropriate to some of the spectral forms of the pictures from the winter of 1911–12. Picasso would not have used such an image for the more tactile Cubism of 1908–10.

57. *The Guitar*. 1919.
Oil on canvas, 39½ × 32″ (100.3 × 81.3 cm).
Signed and dated lower left: "Picasso/19."
Acquired from Pierre Matisse, New York, 1946.
Formerly collection of Lee Ault, New York.
Exhibited at "Picasso," Pierre Matisse Gallery, New York, 1943.
Acq. no. SPC 55.90
Plate, p. 111

Pablo Picasso. *Still Life with Guitar*. 1920 (cat. 58)

Fig. 67. Pablo Picasso. *Study for a Construction*. 1912. Ink on paper, 6¾ × 4⅞″ (17.2 × 12.4 cm). The Museum of Modern Art, New York. Purchase

58. *Still Life with Guitar.* (1920).
Gouache and pencil on paper, 11 × 8⅞" (28 × 22.6 cm).
Signed lower right: "Picasso."
Acquired from Valentine Gallery, New York, 1948.
Acq. no. SPC 26.90

Jackson Pollock. *Untitled.* 1944 (cat. 59)

Jackson Pollock

American, 1912–1956.

59. *Untitled.* 1944.
India ink and watercolor on mulberry paper, 12½ × 10⅛" (31.8 × 25.7 cm).
Signed and dated lower left: "J Pollock 44."
Acquired from Robert Elkon Gallery, New York, 1975.
Formerly collection Sidney Janis Gallery, New York; Mr. and Mrs. Douglas McKelvy, New York.
Exhibited at "Drawings by Pollock," Sidney Janis Gallery, New York, 1957; "Initial Exhibition," David Herbert Gallery, New York, 1959; "Jackson Pollock," Marlborough-Gerson Gallery, New York, 1964; "Two Hundred Years of Watercolor Painting in America," Metropolitan Museum of Art, New York, 1966–67.
Acq. no. SPC 29.90
Plate, p. 113

Odilon Redon

French, 1840–1916.

60. *Vase of Flowers.* (1914).
Pastel on paper, 28¾ × 21⅛" (73 × 53.7 cm).
Signed lower right: "Odilon Redon."
Acquired from Jacques Seligmann & Co., New York, 1937.
Formerly collection Ari Redon (son of the artist), Paris; Marcel Bernheim, Paris.
Exhibited at "Art in Our Time," The Museum of Modern Art, New York, 1939; "Masterpieces of Art," New York World's Fair, 1940; "Children's Festival of Modern Art," The Museum of Modern Art, New York, 1942; "Twenty-fifth Anniversary Exhibition," The Museum of Modern Art, New York, 1954–55; "Odilon Redon," Paul Rosenberg

Odilon Redon. *Vase of Flowers.* 1914 (cat. 60)

& Co., New York, 1959; "Odilon Redon, Gustave Moreau, Rodolphe Bresdin," The Museum of Modern Art, New York, 1961–62; "The Modern Drawing," The Museum of Modern Art, New York, 1983–84.
Acq. no. 553.54
Plate, p. 115

[1]John Elderfield, *The Modern Drawing: One Hundred Works on Paper from The Museum of Modern Art* (New York: The Museum of Modern Art, 1983), p. 74.

Pierre-Auguste Renoir

French, 1841–1919.

61. *Strawberries.* (c. 1905).
Oil on canvas, 14⅛ × 23⅝" (37.2 × 60 cm).
Signed lower right: "Renoir."
Acquired from Albert Skira, Geneva, 1952.
Exhibited at North Shore Art Festival, L.I., New York, 1959.
Acq. no. SPC 30.90
Plate, p. 117

Pierre-Auguste Renoir. *Strawberries.* c. 1905 (cat. 61)

[1]Denis Rouart, *Renoir,* trans. James Emmons (Paris: Skira, 1959), p. 96.

62. *Girl in a Straw Hat.* n.d.
Charcoal and pencil on laid paper, 17¼ × 12⅛"

Fig. 68. Pierre-Auguste Renoir. *Strawberries.* 1905. Oil on canvas, 11 × 18⅛" (28 × 46 cm). Musée de l'Orangerie, Paris. Jean Walter and Paul Guillaume Collection

Pierre-Auguste Renoir. *Girl in a Straw Hat*. n.d. (cat. 62)

(43.8 × 30.7 cm) irregular.
Signed in pencil center right edge: "Renoir."
Acquired from Charles E. Slatkin Galleries, New
York, 1959.
Formerly collection Bruno Cassirer, Berlin.
Exhibited at "Paintings from Private Collections,"
Metropolitan Museum of Art, New York, 1959;

Pierre-Auguste Renoir. *Study for Bath*. 1884 (cat. 63)

"The Nineteenth Century: 125 Master Drawings,"
University Art Museum, University of Minnesota,
and Solomon R. Guggenheim Museum, New York,
1962.
Acq. no. SPC 32.90

63. *Study for Bath*. (1884).
India ink and graphite pencil on laid paper,
18⅛ × 13" (46.1 × 33 cm).
Signed lower right: "Renoir."
Acquired from Sam Salz, Inc., New York, 1951.
Formerly collection Ambroise Vollard, Paris.
Acq. no. SPC 31.90

Auguste Rodin. *Iris*. n.d. (cat. 64)

Auguste Rodin
French, 1840–1917.

64. *Iris*. n.d.
Bronze, 7" (17.8 cm) high.
Inscribed on base: "A Rodin."
Acq. no. SPC 42.90

65. *The Burghers of Calais*. n.d.
Bronze; five sculptures, 18⅛ × 11½ × 6" (46.1 ×
29.1 × 15.2 cm), 18½ × 6⅛ × 6" (47 × 15.6 × 15.2
cm), 18¾ × 10½ × 7¾" (47.7 × 26.7 × 19.7 cm),
17¾ × 8⅛ × 8½" (45.1 × 20.6 × 21.6 cm), 17 ×
9⅝ × 9½" (43.2 × 21.9 × 24.2 cm).
Inscribed on base: "A Rodin."
Acquired from the estate of Samuel Paley (father of
William S. Paley), who died in 1963.
Acq. no. SPC 46.90A-E

Georges Rouault
French, 1871–1958.

66. *The Clown*. (1907).
Oil, india ink, watercolor, and paper collage on
cardboard, 16 × 12¾" (40.1 × 32.4 cm).
Signed upper right: "G. Rouault."
Acquired from Pierre Matisse, New York, 1937.
Exhibited at "Georges Rouault," Pierre Matisse
Gallery, New York, 1937; "Georges Rouault," The

171

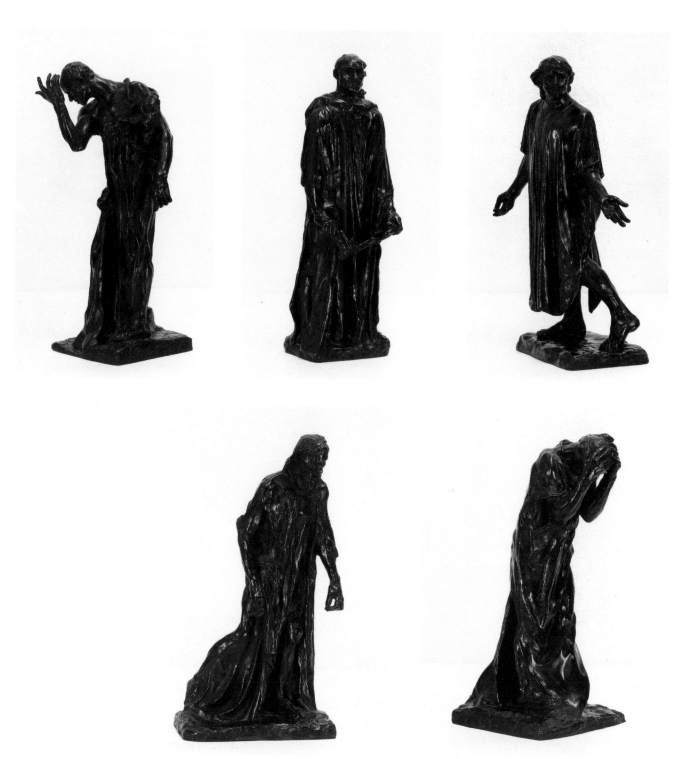

Auguste Rodin. *The Burghers of Calais*. n.d. (cat. 65)

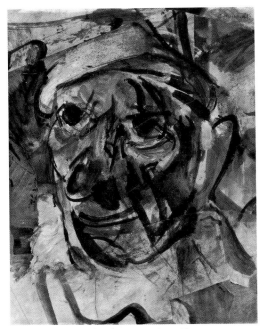

Georges Rouault. *The Clown.* 1907 (cat. 66)

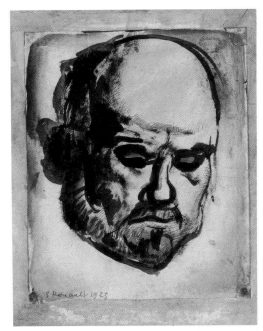

Georges Rouault. *Portrait of Ambroise Vollard.* 1925 (cat. 67)

Georges Rouault. *Two Clowns.* 1928 (cat. 68)

Museum of Modern Art, New York, 1945.
Acq. no. SPC 58.90
Plate, p. 119

[1]Pierre Courthion, *Georges Rouault* (New York: Abrams, 1962), p. 107.
[2]Georges Rouault, letter to Édouard Schuré; cited in William A. Dryness, *Rouault: A Vision of Suffering and Salvation* (Grand Rapids, Mich.: Erdmans, 1971), p. 149.
[3]Danielle Molinari, *Georges Rouault, 1871–1958* (Paris: Musée d'Art Moderne de la Ville de Paris, 1983), p. 31.
[4]For an elaboration of this idea, see Lionello Venturi, Introduction to *Georges Rouault* (Boston: Institute of Modern Art, 1940), p. 16.

67. *Portrait of Ambroise Vollard.* 1925.
Ink and watercolor, oil (mount), mounted on paper, 11⅞ × 9¼" (30.3 × 23.5 cm).
Signed and dated lower left: "G. Rouault 1925."
Acquired in France 1950.
Acq. no. SPC 76.90
Plate, p. 121

68. *Two Clowns.* (1928).
Oil and ink on paper, mounted on wood cradle, 7¾ × 8⅜" (19.7 × 21.2 cm).
Signed lower right: "G. Rouault."
Acquired from Valentine Gallery, New York, 1947.
Acq. no. SPC 75.90
Plate, p. 122

69. *Little Peasant Girl.* (1937).
Oil on cardboard, 15½ × 11⅜" (39.4 × 28.9 cm).
Signed lower right: "G. Rouault."
Acquired in France, 1950.
Acq. no. SPC 77.90
Plate, p. 121

70. *Profile of a Clown.* (1938).
Oil and gouache on paper, 13¾ × 10¼" (35 × 26.1 cm).
Signed lower right: "G Rouault."

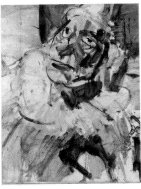

Fig. 69. Georges Rouault. *Clown.* 1907. Oil on paper, 23⅝ × 18½" (60 × 47 cm). Dumbarton Oaks Research Library and Collection, Washington, D.C. Robert Woods Bliss Collection

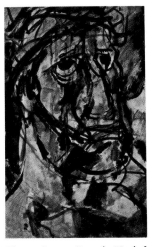

Fig. 70. Georges Rouault. *Head of Christ.* 1905. Oil on canvas, 39 × 24¾" (99 × 62.8 cm). The Chrysler Museum, Norfolk, Virginia

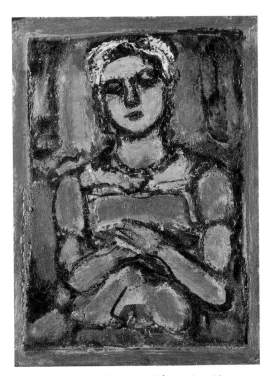

Georges Rouault. *Little Peasant Girl.* 1937 (cat. 69)

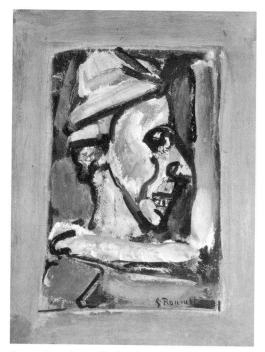

Georges Rouault. *Profile of a Clown.* 1938 (cat. 70)

Inscribed on reverse: "Tete Clown."
Acquired from Pierre Matisse Gallery, New York, 1938.
Acq. no. SPC 33.90
Plate, p. 123

Georges Rouault. *Oasis (Mirage).* 1944 (cat. 71)

71. *Oasis (Mirage).* (1944).
Oil on canvas, 42¼ × 30³⁄₁₆″ (107.3 × 76.8 cm).
Signed lower left: "G Rouault."
Acquired from Pierre Matisse Gallery, New York, 1946.
Acq. no. SPC 73.90
Plate, p. 124

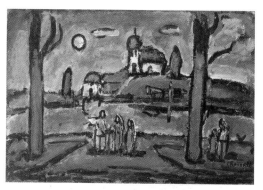

Georges Rouault. *Biblical Landscape with Two Trees.* 1952 (cat. 72)

72. *Biblical Landscape with Two Trees.* (1952).
Oil on paper, mounted on canvas, 26¾ × 40¼″ (68 × 102.2 cm).
Signed lower right: "G Rouault."
Acquired from Albert Skira, Geneva, 1954.
Acq. no. SPC 74.90
Plate, p. 125

[1]Georges Rouault, quoted in Pierre Courthion, *Georges Rouault* (New York: Abrams, 1962), p. 186.
[2]Bernard Dorival, "Rouault," *Le Bulletin des Musées de France*, no. 5 (May–June 1947), p. 20; cited in William A. Dryness, *Rouault: A Vision of Suffering and Salvation* (Grand Rapids, Mich.: Erdmans, 1971), p. 154.
[3]Pierre Courthion, *Georges Rouault* (New York: Abrams, 1962), p. 294.

Henri Rousseau
French, 1844–1910.

73. *Flowers in a Vase.* (1901–02).
Oil on canvas, 18¼ × 13″ (46.4 × 33 cm).
Signed lower left: "Henri Rousseau."
Acquired from Valentine Gallery, New York, 1937.
Formerly collection Paul Guillaume, Paris.
Exhibited at Salon des Indépendants, Paris, 1902; "Collection Paul Guillaume chez Bernheim-Jeune," Galerie Berheim-Jeune, Paris, 1929; "Henri Rousseau," Marie Harriman Gallery, New York, 1931; "Henri Rousseau," Kunsthalle, Basel, 1933; "Chefs-d'oeuvre du Musée de Grenoble," Petit Palais, Paris, 1935; "Peintres instinctifs," Galerie des Beaux-Arts, Paris, 1936; "Masters of Popular Painting: Modern Primitives of Europe and America," The Museum of Modern Art, New York, 1938; "Henri Rousseau," Art Institute of Chicago and The Museum of Modern Art, New York, 1942; "Collector's Choice," Paul Rosenberg & Co., New York, 1953; "Henri Rousseau," Galerie Charpentier, Paris, 1961.
Acq. no. SPC 34.90
Plate, p. 127

[1]Dora Vallier, in her catalogue raisonné of the artist, dates this work to 1909. Recent scholarship, however, has shown that the work dates from 1901–02 and that the version in the Albright-Knox Art Gallery is the artist's own copy done some seven or eight years later. See Dora Vallier, *Henri Rousseau* (New York: Abrams, 1964), p. 143; and Henry Certigny, *Le Douanier Rousseau en son temps: Bio-*

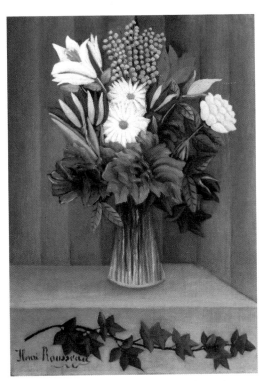

Henri Rousseau. *Flowers in a Vase.* 1901–02 (cat. 73)

George Segal

American, born 1924.

74. *Girl Leaving Shower.* (1974).
Plaster and ceramic tile, 6′ 1¼″ × 25¼ × 18″ (186 × 64.1 × 45.8 cm).
Unsigned.
Acquired from Sidney Janis Gallery, New York, 1976.
Acq. no. SPC 81.90
Plate, p. 129

[1] George Segal, quoted in Carole Nelson, "Ghostly Presences: Sculptor 'Mummifies' Subjects in Wet Plaster," *Baltimore Sun,* November 28, 1978; cited by Sam Hunter and Don Hawthorne, *George Segal* (New York: Rizzoli, 1984), p. 23, note 18.
[2] George Segal, "Commentaries on Six Sculptures," in Martin Friedman and Graham W. J. Beal, *George Segal: Sculptures* (Minneapolis: Walker Art Center, 1979), p. 44.
[3] George Segal, quoted in Richard Bellamy, *Excerpts from a Conversation: "Girl on a Chair"* (New York and London: Alecto, 1970), n.p.
[4] On Segal, Rodin, and antique fragments, see Albert Elsen, "Mind Bending with George Segal," *Art News,* 76 (February 1977), pp. 34–37.

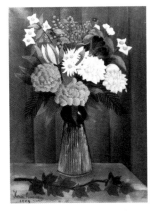

Fig. 71. Henri Rousseau. *Flowers in a Vase.* 1909. Oil on canvas, 18⅜ × 13¼″ (46.7 × 33.6 cm). Albright-Knox Art Gallery, Buffalo. Room of Contemporary Art Fund

graphie et catalogue raisonné (Tokyo: Bunkazai Kenkyujyo, 1984), vol. 2, p. 380.
[2] Rousseau's influence on the Parisian avant-garde and subsequent generations of painters is treated at length in Carolyn Lanchner and William Rubin, "Henri Rousseau and Modernism," in Lanchner and Rubin, *Henri Rousseau* (New York: The Museum of Modern Art, 1985).
[3] Some critics have argued that despite final appearances, Rousseau was grounded in the rules of the academy, and since he was "not too sure of himself when he set out to produce a creation, he took intricate precautions and gathered ample documentation. . . . He endeavored to penetrate the spirit of the academic rules in order to submit his own pictorial ways to them. This will to identify with a world which is utterly alien to him presided over all his creations"; Dora Vallier, *Henri Rousseau, the Douanier* (New York: Crown, 1979), p. 31.
[4] Rousseau most probably used printed sources, encyclopedias or books such as Pierre Zaccone's *Nouveau langage des fleurs,* Kate Greenaway's *The Language of Flowers,* and Anaïs de Neuville's *La Véritable Langage des fleurs,* all of which had been immensely popular since the middle of the preceding century. See Michel Hoog, note to no. 52, in Lanchner and Rubin, *Henri Rousseau,* p. 218.
[5] The symbolic meanings of flowers were widely known (see preceding note). In 1909, Rousseau painted his friend the poet Guillaume Apollinaire with a bunch of narcissus flowers, traditionally known as "the poet's flower"; see Yann Le Pichon, *The World of Henri Rousseau,* trans. Joachim Neugroschel (New York: Viking, 1982), p. 232.
[6] Ibid., pp. 233–34.
[7] Michel Hoog, note to no. 21, in Lanchner and Rubin, *Henri Rousseau,* p. 146.
[8] Louis Roy, "Un Isolé: Henri Rousseau," *Mercure de France,* March 1895; cited in Lanchner and Rubin, *Henri Rousseau,* p. 121. This review, arguably the only important one devoted to the painter's work in his lifetime, was inspired by Alfred Jarry.

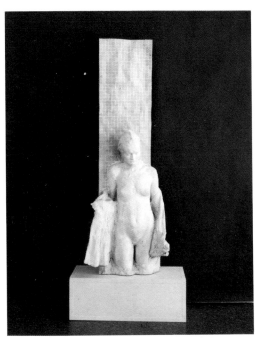

George Segal. *Girl Leaving Shower.* 1974 (cat. 74)

Ben Shahn

American, born Lithuania. 1898–1969. To U.S.A. 1906.

75. *Empty Studio* (also called *Silent Music*). (1948).
India ink on paper, 26 × 40″ (66 × 101.6 cm).
Signed lower right: "Ben Shahn."
Acq. no. SPC 59.90
Plate, p. 131

[1] Ben Shahn, quoted in Kneeland McNulty, *The Collected Prints of Ben Shahn* (Philadelphia: Philadelphia Museum of Art, 1967), p. 114.
[2] Cipe Pineles Golden, Kurt Weihs, and Robert Strunsky, eds., *The Visual Craft of William Golden* (New York: Braziller, 1962), p. 119.

Fig. 72. George Segal. *Girl in Shower with Washcloth.* 1975. Plaster and chrome, 37 × 26 × 17″ (93.9 × 66 × 43.2 cm). Sidney Janis Gallery, New York

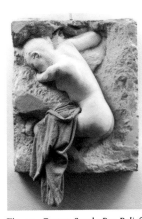

Fig. 73. George Segal. *Bas-Relief: The Blue Robe.* 1974. Plaster and cloth, 49 × 36¾ × 14½″ (124.5 × 93.4 × 36.8 cm). Sidney Janis Gallery, New York

Fig. 74. Ben Shahn. *Silent Music.* 1950. Serigraph, 25¼ × 38⅝" (64.1 × 98.1 cm). New Jersey State Museum, Trenton

Ben Shahn. *Empty Studio.* 1948 (cat. 75)

[3]Quoted in Kenneth W. Prescott, *Prints and Posters of Ben Shahn* (New York: Dover, 1982), p. xvi.

[4]For the relations between Shahn and William Golden, see Shahn's eulogistic "Bill," in Golden, Weihs, and Strunsky, eds., *The Visual Craft of William Golden,* p. 127. Included in this memorial publication are all the images Shahn completed for CBS.

[5]Kenneth W. Prescott, *The Complete Graphic Works of Ben Shahn* (New York: Quadrangle/New York Times Book Co., 1973), p. xx.

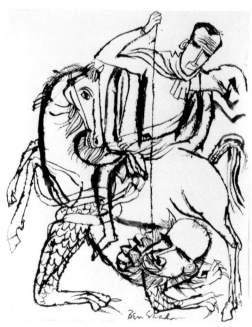

Ben Shahn. *Edward R. Murrow Slaying the Dragon of McCarthy.* 1954 (cat. 76)

76. *Edward R. Murrow Slaying the Dragon of McCarthy.* (1954).
Gouache on paper, 12¼ × 10" (31.1 × 25.3 cm).
Signed lower center: "Ben Shahn."
Acquired from Kennedy Galleries, New York, 1973.
Exhibited at "On the Air: Pioneers of American Broadcasting," National Portrait Gallery, Washington, D.C., 1988–89.
Acq. no. SPC 35.90
Plate, p. 133

[1]On the history of Shahn's political affiliations, see Frances K. Pohl, *Ben Shahn: New Deal Artist in a Cold War Climate, 1947–1954* (Austin, Tex.: University of Texas Press, 1989), pp. 110–52.

[2]For an account of Murrow's dealings with McCarthy, see Anne M. Sperber, *Murrow: His Life and Times* (London: Michael Joseph, 1987), pp. 426 ff.
[3]Broadcast of *Edward R. Murrow with the News* for April 6, 1950; quoted in Sperber, *Murrow,* p. 333.
[4]See Sperber, *Murrow,* pp. 429–56.
[5]Mili Bonsignori, quoted in Sperber, *Murrow,* p. 433.
[6]Ben Shahn, "The Artist and the Politicians," cited in Pohl, *Ben Shahn,* p. 134.

Frank Stella
American, born 1936.

77. *Empress of India.* 1968.
Lithograph on paper, 16¼ × 35½" (41.3 × 90.2 cm).
Signed and dated lower right: "F. Stella 68."
Acquired from Leo Castelli, New York.
Acq. no. SPC 36.90

Frank Stella. *Triple Stack, Newport Beach.* 1969 (cat. 78)

78. *Triple Stack, Newport Beach.* 1969.
Synthetic polymer paint on paper, 42⅜ × 32" (107.7 × 81.3 cm).
Signed and dated lower right: "F. Stella '69."
Inscribed lower left: "Triple Stack—Newport Beach."
Acquired from Lawrence Rubin, New York, 1969.
Acq. no. SPC 78.90

Clyfford Still
American, 1904–1980.

79. *Untitled.* 1945.
Oil on black construction paper, 18 × 12¼" (45.7 × 31 cm).
Signed and dated in pencil lower right: "Clyfford 45."
Incised lower left: "Clyfford 45."
Signed in pencil on reverse: "Clyfford Still."
Acquired from Robert Elkon Gallery, New York, 1974.

Frank Stella. *Empress of India*. 1968 (cat. 77)

Clyfford Still. *Untitled*. 1945 (cat. 79)

Formerly collection Peggy Guggenheim, Art of This Century Gallery, New York; Fred Olsen, Guilford, Connecticut.
Exhibited at "Twentieth-Century Masters," Robert Elkon Gallery, New York, 1972.
Acq. no. SPC 37.90

Henri de Toulouse-Lautrec
French, 1864–1901.

80. *Mme Lili Grenier*. (1888).
Oil on canvas, 21¾ × 18″ (55.3 × 45.7 cm).
Unsigned.
Acquired from Galerie des Arts Anciens et Modernes, Schaan, Liechtenstein, 1958.
Formerly collection Franz Koenigs, Haarlem.
Exhibited at "Van Gogh," Stedelijk Museum, Amsterdam, 1930; "French Painting in the Nineteenth Century," Musée du Prince Paul, Belgrade, 1939; "Henri de Toulouse-Lautrec," Kunsthalle, Basel, 1947; "Toulouse-Lautrec," Stedelijk Museum, Amsterdam, and Palais des Beaux-Arts, Brussels, 1947;

"Toulouse-Lautrec," Wildenstein & Co., New York, 1964; "World Cultures and Modern Art," Haus der Kunst, Munich, 1972.
Acq. no. SPC 38.90
Plate, p. 135

[1]A very high proportion of Lautrec's models had red hair, which appears to have been one of his idiosyncratic prerequisites for female beauty. See Henri Perruchot, *Toulouse-Lautrec*, trans. Humphrey Hare (Cleveland and New York: World Publishing, 1960), p. 105.

[2]"A personal *Comédie Française* was enacted around Lili, who had a taste for fancy dress, and the game was a source of great amusement to Lautrec. . . . After lunch everyone would dress up and group themselves in costumed tableaux. Then they would take great delight in photographing these masquerades"; François Gauzi, *Lautrec et son temps* (Paris: David Perrett, 1954), p. 54. A fascinating collection of photographs of Lautrec, the Greniers, and their friends enjoying theatrical high jinks can be found in P. Huisman and M. G. Dortu, *Lautrec by Lautrec* (New York: Viking, 1964), pp. 42–45.

[3]Douglas Cooper writes that "Degas opened Lautrec's eyes to a range of modern subjects—women at their toilet, dancers, scenes in cafés and music halls, or on the race-course, laundresses ironing—and at the same time demonstrated un-

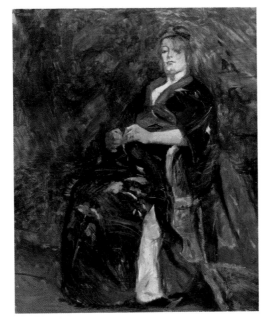

Henri de Toulouse-Lautrec. *Mme Lili Grenier*. 1888 (cat. 80)

Fig. 75. Henri de Toulouse-Lautrec. *Mme Lili Grenier*. 1888. Oil on canvas, 21¾ × 18⅛″ (55 × 46 cm). Collection Yasuo Suita

Fig. 76. Henri de Toulouse-Lautrec. *Paul Leclercq.* 1897. Oil on board, 21¼ × 25¼" (54 × 64 cm). Musée du Louvre, Paris. Gift of Paul Leclercq

Fig. 77. James A. McNeill Whistler. *Arrangement in Grey and Black, No. 2: Portrait of Thomas Carlyle.* 1872–73. Oil on canvas, 67⅜ × 56½" (171 × 143.5 cm). Glasgow Art Gallery and Museum

conventional methods of handling them. Indeed from 1886 onwards one finds Lautrec constantly using compositional devices which had been invented by Degas"; Douglas Cooper, *Henri de Toulouse-Lautrec* (New York: Abrams, 1956), pp. 25–26. On the meeting between the two artists, see Lawrence and Elisabeth Hanson, *The Tragic Life of Toulouse-Lautrec* (New York: Random House, 1956), pp. 66–71.

⁴Lautrec's feelings toward her and his caricatural inclinations were sublimated here but found expression in a series of pornographic drawings undertaken at precisely the same time. See M. G. Dortu, *Toulouse-Lautrec et son oeuvre* (New York: Collectors Editions, 1971), vol. 6, E.14–42.

⁵Perruchot, *Toulouse-Lautrec,* pp. 85–86.

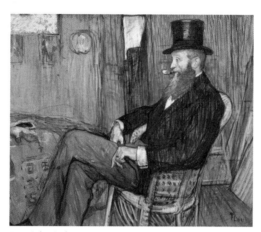

Henri de Toulouse-Lautrec. *M. de Lauradour.* 1897 (cat. 81)

81. *M. de Lauradour.* (1897).
Oil and gouache on cardboard, 26¾ × 32½" (68 × 82.5 cm).
Signed lower right: "T Lautrec."
Acquired from Jakob Goldschmidt, New York, 1939.
Formerly collection Paul Gallimard, Paris; Paul Cassirer, Berlin.
Exhibited at "Henri de Toulouse-Lautrec," Galerie Durand-Ruel, Paris, 1902; "Toulouse-Lautrec Rétrospective," Galerie Manzi-Joyant, Paris, 1914; "Toulouse-Lautrec, Trentenaire," Musée des Arts Décoratifs, Paris, 1931; "Toulouse-Lautrec," Knoedler & Co., New York, 1937; "Masterpieces of Art," New York World's Fair, 1940.
Acq. no. SPC 79.90
Plate, p. 137

¹Henri Perruchot, *Toulouse-Lautrec,* trans. Humphrey Hare (Cleveland and New York: World Publishing, 1960), p. 234.

²See Gerstle Mack, *Toulouse-Lautrec* (New York: Knopf, 1938), p. 322.

³"His financial independence may also have been restricted as a result of the depressed state of the French vineyards, which were badly infested with phylloxera towards the end of the century. He had never attempted to live by the sale of his pictures or posters, and the limitation on financial assistance from his family may well have circumscribed the freedom of action which he prized so highly"; P. Huisman and M. G. Dortu, *Lautrec by Lautrec* (New York: Viking, 1964), p. 178.

Édouard Vuillard. *The Green Lamp.* 1893 (cat. 82)

Édouard Vuillard
French, 1868–1940.

82. *The Green Lamp.* (1893).
Oil on board, 8¼ × 10¼" (20.9 × 26 cm).
Signed lower left: "ev."
Acquired from Sam Salz, Inc., New York, 1954.
Formerly collection Gaston Bernheim de Villiers, Monte Carlo.
Exhibited at "Vuillard Exhibition," Galerie Bernheim-Jeune, Paris, 1906; "E. Vuillard," Musée du Louvre, Paris, 1938.
Acq. no. SPC 39.90
Plate, p. 141

Édouard Vuillard. *Still Life with Top Hat.* 1893 (cat. 83)

83. *Still Life with Top Hat.* (1893).
Oil on cardboard, mounted on panel, 10¼ × 7¼" (26 × 18.5 cm).
Signed lower right: "E. Vuillard."
Acquired from Sam Salz, Inc., New York.
Acq. no. SPC 60.90
Plate, p. 142

Édouard Vuillard. *The Window*. 1893 (cat. 84)

84. *The Window*. (1893).
Oil on canvas, 14⅞ × 17⅞" (37.9 × 45.5 cm).
Signed lower left: "E Vuillard."
Acquired from Sam Salz, Inc., New York, 1957.
Formerly collection the estate of Édouard Vuillard.
Exhibited at L'Orangerie, Paris, 1948; "Édouard Vuillard," Kunsthalle, Basel, 1949; "Vuillard," Wildenstein & Co., New York, 1964.
Acq. no. SPC 40.90
Plate, p. 143

¹In 1888 Vuillard had joined the Nabis, a group of young painters whose ranks included Pierre Bonnard, Maurice Denis, Paul Sérusier, and Félix Vallotton, among others. They sought to synthesize ideas from various strains of Eastern philosophy with the structure of Cézanne's work and the colors and mystical overtones of Gauguin, Pierre Puvis de Chavannes, and Odilon Redon, among others. Vuillard, however, probably joined the group more for companionship than from commitment to its intellectual program. On the overwhelming effect of Gauguin, see Maurice Denis's "The Influence of Paul Gauguin" (1903), reprinted in John Russell, *Édouard Vuillard, 1868–1940* (Toronto: Art Gallery of Ontario; London: Thames & Hudson, 1971), pp. 72–74. Belinda Thompson suggests that Vuillard's mysterious images of the seemingly mundane, and his fascination with repetition and memory, link him to Marcel Proust and Maurice Maeterlinck; see Thompson, *Vuillard* (New York: Abbeville, 1988), p. 44. The most insightful analysis of Vuillard's work of the 1890s is Elizabeth Wynne Easton, *The Intimate Interiors of Édouard Vuillard* (Houston: Museum of Fine Arts; Washington, D.C.: Smithsonian Institution Press, 1989).

²Thadée Natanson, an early admirer of Vuillard's, also linked his images to those of Japanese artists, particularly Utamaro, of whom he wrote that the artist undertook an intense study of forms "in minute detail with love and patience, only so he could express their decorative significance"; Thadée Natanson, "Exposition Hiroshighe et Outamaro," *La Revue Blanche*, 4 (1893), p. 144; cited in Easton, *The Intimate Interiors of Édouard Vuillard*, 1989, p. 46.

³On Vuillard's use of silhouette, see Easton, *The Intimate Interiors of Édouard Vuillard*, p. 44. See also Ursula Perrucchi-Petri, *Die Nabis und Japan: Das Frühwerk von Bonnard, Vuillard und Denis* (Munich: Prestel, 1976), p. 114.

⁴Easton, *The Intimate Interiors of Édouard Vuillard*, p. 42.

⁵According to Jacques Salomon (Vuillard's nephew by marriage), Vuillard considered his mother the muse of his life's work; see Salomon, "Vuillard Remembered," in John Russell, *Édouard Vuillard, 1868–1940* (Toronto: Art Gallery of Ontario; London: Thames & Hudson, 1971), p. 125.

⁶Though often reluctant to exhibit his work publicly, Vuillard had recently come to be highly regarded by critics and courted by patrons who commissioned him to create large decorative panels for their homes. The first such commission was undertaken in 1892 for Paul Desmaris, a cousin of his friends and patrons Alexandre and Thadée Natanson. On this and other early large-scale commissions, see Belinda Thompson, *Vuillard*, pp. 36–44.

⁷Easton, *The Intimate Interiors of Édouard Vuillard*, p. 30.

Trustees of
The Museum of Modern Art